D1156938

MICHAEL
SNOW

MICHAEL
SNOW
Lives and Works

James King

DUNDURN
TORONTO

Publisher: Scott Fraser | Editor: Dominic Farrell
Cover designer: Laura Boyle | Interior designer: Sophie Paas-Lang
Cover image: Craig Boyko. *Michael Snow*. 2012. Photograph.
Back cover image: Michael Snow. *Mixed Feelings*. Acrylic on canvas. 253 x 150.6 cm.
Vancouver Art Gallery.
Author photo: Julie Thompson
Printer: Friesens

Library and Archives Canada Cataloguing in Publication
Title: Michael Snow : lives and works / James King.
Names: King, James, 1942- author.
Description: Includes bibliographical references and index.
Identifiers: Canadiana (print) 20190140666 | Canadiana (ebook) 20190140682 | ISBN 9781459741348 (hardcover) | ISBN 9781459741355 (PDF) | ISBN 9781459741362 (EPUB)
Subjects: LCSH: Snow, Michael, 1928- | LCSH: Snow, Michael, 1928-—Criticism and interpretation. | LCSH: Artists—Canada—Biography. | LCSH: Self-perception in art.
Classification: LCC N6549.S64 K56 2019 | DDC 709.2—dc23

1 2 3 4 5 23 22 21 20 19

We acknowledge the support of the Canada Council for the Arts and the Ontario Arts Council for our publishing program. We also acknowledge the financial support of the Government of Ontario, through the Ontario Book Publishing Tax Credit and Ontario Creates, and the Government of Canada.

Printed and bound in Canada.

VISIT US AT

 dundurn.com | @dundurnpress | dundurnpress | dundurnpress

Dundurn
3 Church Street, Suite 500
Toronto, Ontario, Canada
M5E 1M2

In memory of my father, James Raymond King (1909–1966)

CONTENTS

LIST OF FIGURES

CHAPTER FOUR: A Man Drawing Lines

CHAPTER FIVE: Intimations

CHAPTER SIX: Gestures

CHAPTER NINE: Surveying

CHAPTER ELEVEN: Eye and Ear Control

CHAPTER TWELVE: More Snowgirls

CHAPTER EIGHTEEN: The Canadian Wilderness

CHAPTER NINETEEN: A Giant Sentence

CHAPTER TWENTY: No Longer in Play

CHAPTER TWENTY-FOUR: Audiences

CHAPTER TWENTY-SIX: Sound Shaping

CHAPTER TWENTY-SEVEN: A New Painterliness

CHAPTER THIRTY-ONE: Smoke and Mirrors

INTRODUCTION

Michael Snow is Canada's most celebrated contemporary artist. In a lengthy and productive career, he has, in many genres, asked (and often answered) some of the most vexing and important questions raised in the history of art. During this time, the definition of what a work of art is has undergone many changes, and he has been in the vanguard of those seeking to explore new possibilities.

In many ways, he is the visual artist as intellectual: his images and films are vibrant and compelling but so are the ideas behind them. Ultimately, his work is about perception. What do we really see when we look at a work of art? What is the act of looking all about? What exactly is a work of art?

Since Michael Snow is an unorthodox, experimental artist, it is appropriate that a biography of him be unconventional. In this book, the outer shell (life events) are described and analyzed, but the emphasis is on the inner shell (the lives of the objects he has created). Within those artifacts resides the life of Michael Snow. He once observed that the artist is a biography of his art,[1] and this is a particularly apt way to describe this book. The existences of many artists are dominated by their paintings, sculptures, photographs, films, and installations, and this is especially true of Snow. For him, much of the meaning of his life resides in the variety of pursuits that constitute his career.

Although this artist rejects the label "conceptual" because he feels that any such term sets limits on what an artist is trying to accomplish, much of his work is cerebral and must be understood as such.

He has frequently blended several genres together. He once famously said:

> My paintings are done by a filmmaker, sculpture by a musician, films by a painter, music by a film-maker, paintings by a sculptor, sculpture by a film-maker, films by a musician, music by a sculptor ... sometimes they all work together. Also, many of my paintings have been done by a painter, sculpture by a sculptor, films by a filmmaker, music by a musician. There is a tendency toward purity in all of these media as separate endeavours.[2]

The "purity" of which Snow speaks is actually present in all his work because he constantly asks the same questions: What is it that makes an artifact a work of art? How does one make *meaningful* art? How does a work of art come into being? What is the place of art in human existence? In other words, his art tends to question the nature of its own existence. In many ways, his art is about form, and the best way to understand Snow's works is to explore their organic wholeness. The artist in 1984 told John Bentley Mays:

> Most art starts when the artist is moved by other work, and gets the ambition to do *that* for other people, but not in the way it was done for you. It's the desire for originality — not novelty — but originality based on the depths of what was important to you. I'm aston-ished at the lack of knowledge (today) about the most amazing adventure of the last 100 years, abstraction. Kandinsky and Mondrian — especially Mondrian — were absolutely unique, opening something, an inves-tigation of ideas, that had never been done before.[3]

Snow's use of an eclectic assortment of genres — his relentless search for what "had never been done before" — is crucial to understanding

his work. The resulting plurality of approaches is pragmatic: at a particular time, he will employ a form that best encapsulates his vision. So catholic is the nature of his investigations that he moves readily among, for example, painting, sculpture, film, installations, and sound recordings. Often he combines several forms. In consistently challenging himself to produce innovative works, he has pushed back against traditional notions of the nature of art. As an artist, he has had several lives, and his works are in many genres.

He may create works of art that are about works of art, and he sometimes appears in those works, but Snow is neither a social nor an autobiographical artist. He avoids commenting on historical or contemporary events. He once said, "I'm interested in making art that adds to life more than it comments on life."[4] In the same way, although he is a person deeply aware of his family ancestry and of being Canadian, he does not usually reveal much more about himself in his work.

Nevertheless, clues to Michael Snow the person are sometimes present in his art. Defining concerns include presence and absence; finding and losing; the experience of the Wilderness; the meaning of surface and texture and, thus, the exploration of the haptic; seeing and blindness; the relationship between the contemporary artist and the history of art; and the various shapes and framings that works of art can take.

He has strong opinions on the nature versus nurture debate. "There's a fashionable idea now, especially among academic theorists, that the person — the subject, as they say these days — is totally culturally shaped. I don't believe that at all. I think somebody is born, that there is an organism that has functions. It can be twisted; it can be hurt, but there's still a specific person there."[5] He certainly investigates the nature of his own subjectivity.

In addition, Snow has, in exploring the themes mentioned above, consistently questioned the nature of truth. Is there such a thing? Aren't we always searching for truth but find it evading us just as we get close to it? Doesn't truth disappear just as we are about to touch it? Is memory real or false? Snow is fascinated with the importance of the past, but, at the same time, he is aware of how difficult it is to remember and thus know the past. The artist Robert Fones has spoken of how his

friend "presents visual material in a way that makes viewers question the nature of what they are looking at and become aware of the process of cognitive understanding." As part of this process, Snow "deliberately sprinkles his work with misleading clues and visual puns to make it harder to resolve some of these questions, therefore encouraging closer scrutiny."[6]

For Snow, there are no certain truths. So, although his work does reflect a search for truth, it is a series of reflections on the human condition in which certitude is absent. Since humanity is cast adrift in the universe, the artist explores the nature of that condition. Since much of Snow's work is interrogative, this biography asks many questions.

Snow's work is consistent in its addressing of the aims listed above, but there are important turning points. There is an emphasis in his early paintings and sculptures on surfaces and framing that leads to a series of variations centring on the *Walking Woman* figure. He then focuses on how subjects, once considered to exist only in the traditional fine arts, can find new life in other forms of art. From there, he turned to examining how the appearances of works of art can take on extraordinarily deceptive aspects. Finally, he returned to the question of how painterliness can find new forms of expression.

Each of the above elements coexists with the others in the works produced throughout his entire career — it is the emphases that change. The subjects of his work, as he observes, are quotidian: doors, windows, rooms, sofas, chairs, sinks, curtains, mirrors, fire, and people: "If the 'subject' as a class is familiar," he has noted, "it hopefully makes it easier for the spectator to see what has been done with it to make it art."[7]

For example, in the dry coupler photograph *Red*[5] (1974), Snow took a snapshot of the coloured rectangle that occupies the entire area of the photograph; he then took three more shots — each, respectively, containing one, two, and three photographs taken against the coloured rectangle. The resulting image shows four photographs placed at various points on top of the rectangle. At first glance, the result *appears* to be a series of additions to the original rectangle. This is true. However, this image can be said to be about loss because the viewer never sees the complete rectangle except in the first small image placed on top

FIGURE 1. Michael Snow, *Red⁵*, 1974.

of it. This process might be seen as a commentary on how the revered tradition of framing a canvas in order to create a space in which to represent has been disrupted in contemporary art.

Overall, Snow's work is ontological in nature — it is about being, and, in this regard, the artist asks the same questions that Paul Gauguin did in 1897 in the oil painting he titled *Where Do We Come From? What Are We? Where Are We Going?* Snow's great task was to create modernist works that respond to those questions from the nineteenth century.

This account describes the importance of his parents in Snow's coming into being as an artist; his deep-seated, abiding love for Quebec; his romance with Georgine Ferguson; his marriage to Joyce Wieland and its breakup; and his happy second marriage to Peggy Gale and the birth of their son, Alexander.

The narrative told here moves chronologically but frequently moves away from such concerns when dealing with works that are best discussed as a unit in order to avoid the constraints of placing works in the order in which they were made. The resulting storyline is divided into five sections.

Part One (1928–1962) recreates Snow's coming into being an artist, his use of painting and sculpture in a variety of representational and abstract forms and his invention of the *Walking Woman* figure. Part Two (1962–1970) is centred on the artist's prolonged stay in New York, where he further developed the *Walking Woman* and made a series of experimental films, including *Wavelength*. Part Three (1970–1979) begins with the retrospective *Michael Snow/A Survey* and then emphasizes the artist's growing interest in photography, his use of Canada as a setting for his work, and his "talking" picture *Rameau's Nephew by Diderot (Thanx to Dennis Young) by Wilma Schoen*. Part Four (1979–1994) emphasizes Snow's use of holography and discusses three large public commissions for the City of Toronto. Part Five (1994–present) begins with *The Snow Project* and then examines the extraordinary range in the projects developed by the artist since 1994 up to the present.

Although the artist has provided a detailed account of his career, that narrative differs markedly from *Michael Snow: Lives and Works*. In *Michael Snow — Sequences — A History of His Art*, he looks at his output genre by genre and explains in detail how those works came into existence. That narrative is subjective. *Lives and Works* — written from a more objective, biographical point of view — attempts to read and thus interpret the artist's accomplishments. In the process, this book becomes a critical overview of an artist whose ideas are paramount. Although this biography is written for the general reader and not intended as an "academic" account of Snow's career, I am indebted to the many important theoretical writings on him and have utilized them in writing my account.

In my meetings with him, Snow answered my many questions precisely, patiently, and fully. He knows all of his considerable body of work extremely well and can recall the circumstances that led to the creation of each. Like many artists, he leaves questions of interpretation

to others. Humility runs deep in his character, but at the same time he takes great pride in what he has accomplished. He is not a person who takes himself seriously, but as an artist he is well aware of his stature in Canadian art. One friend accurately observed: "He's got a zero-mega-lomaniacal reading on the ego dial." The same friend added: "He's not modest, but he is shy, which is kind of endearing."[8]

At the age of ninety, Snow is slightly stooped and he may look, to use his word, "ancient," but his blue eyes sparkle and twinkle with an unmistakably youthful vigour. He is reticent to speak about his marriage to Joyce Wieland and his various affairs, but otherwise he is candid in responding to a biographer's interrogation.

As one journalist observed, Snow remains "an inveterate scribbler. He writes in much the same way he plays piano: quickly and freely, ideas pinging off one another.... He keeps two rooms as offices on the top floor[s] of his house, and there are papers scrawled with notes and diagrams stacked on the desks, the floors and the shelves."[9] Once, when another journalist asked him if it was a bitch getting older, he quietly responded: "Only when I look in the mirror."[10] The *Globe*'s Kate Taylor had a different impression: "The artist regularly aims his little witticism at himself, sometimes approaching his work with a gee-shucks-isn't-it-neat-the-way-it-does-that attitude, sometimes cracking a joke at the art's expense. But like most self-deprecating people, he isn't modest." He talked about one piece of work, observing that it was really good, "If I do say so myself."[11] He "has never lacked for ideas."[12]

Or for a rigorous commitment. I once asked Snow why, in the 1960s, he abandoned the traditional forms of painting and sculpture — with which he had established his career — to pursue filmmaking and photography. I observed that those two forms of art were not particularly lucrative. Hadn't he taken a huge risk in doing so? He smiled. "I had no choice. I had to go in the direction my imagination led me."

For Snow, his feelings as an artist were — and remained — paramount. If he were not true to them, his art would be meaningless. In many ways, this narrative is about those feelings. Overall, this book is the story of an artist who, having relentlessly explored a wide variety of genres, has never come to a resting point. As an artist, he has had many lives and worked in many genres.

PART ONE
1928–1962

CHAPTER ONE:
ORIGINS

In Michael Snow's ancestry, the two solitudes of Canada are resolutely conjoined. His father, Gerald Bradley Snow, was of Anglo-Saxon lineage, his mother, Marie-Antoinette, was Quebecois.

Gerald Bradley Snow (1892–1964), later an engineer and a veteran of the First World War (he served in France as a lieutenant in the 48th Highlanders), attended high school at St. Andrew's in Aurora and then studied at the University of Toronto. More reserved than his classmates, Bradley (the name he used commonly) excelled in school. His

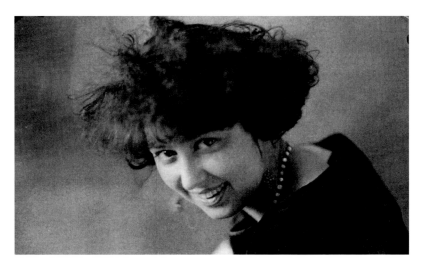

FIGURE 2. Marie-Antoinette Lévesque, 1921.

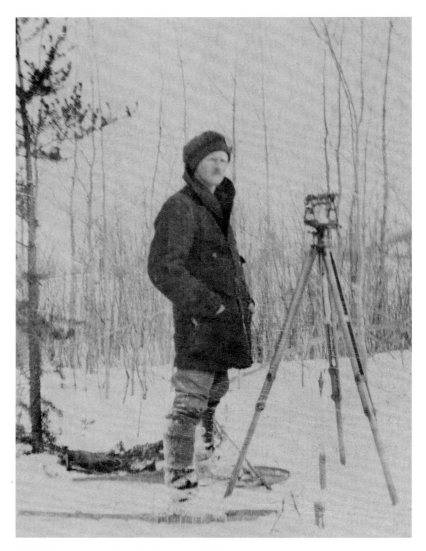

FIGURE 3. Gerald Bradley Snow, c. 1920.

son inherited what could be called his artistic side from his mother and his deep understanding of technological complexities and processes from his father. He had an excellent understanding of how things work, of how things fit together.

Bradley Snow was the son of A.J. Russell Snow (1857–1937) and his wife, Katie Beaty (1880–1940). A.J., who was born in Hull (now

Gatineau), Quebec, became a lawyer who argued many cases before the Privy Council, served on several royal commissions, and was "Registrar of Alien Enemies" during the Great War.

The father of A.J. Russell Snow was John Allen Snow (1823–78), who was the son of John Snow (1793–c.1823) and Barbara Allen (b. 1799). Barbara was born in Woburn, Massachusetts, and moved to Canada when she was a year old. The move to Canada was initiated by Philomen Wright, a cousin of the Allens. Having acquired the rights to a large parcel of land on the area of the Ottawa River now known as Gatineau, he developed a small colony there. In 1816, when Barbara was seventeen years old, Philomen sent his son Ruggles to England to acquire cattle and engage workmen. There, he hired John Snow, a wheelwright from Chittlehampton, Devon. John and Barbara married on January 4, 1820.

Their son John Allen Snow was educated at St. Lawrence Academy in Potsdam, New York, and trained as a surveyor after he returned to Canada. He married Emma Catherine Bradley in 1850. Three years earlier, he became deputy provincial surveyor and mapped portions of, among other places, Muskoka. He was later sent by John A. Macdonald to survey the land that was under dispute in Manitoba during the Riel Rebellion.

Katie Beaty was the daughter of James Beaty (1831–99), who had been born at Ashdale Farm in the township of Trafalgar in the county of Halton, Ontario. James's father, John (d. 1870), had immigrated to Canada from County Cavan in Ireland. James, who married his cousin Fanny Beaty in 1858, served as mayor of Toronto from 1879 to 1880 and was the founder of the newspaper, the *Toronto Leader*. He published one book, the Quaker-inspired *Paying the Pastor: Unscriptural and Traditional* (1885).

A.J. Russell and Katie Snow had seven children: Gerald Bradley, Kallie, Beaty, Geoffrey, Enid, Dimple, and Rhoda. When Geoffrey was killed in action at the Battle of the Somme during the Great War, Bradley might have been fundamentally shaken.

Early on, the Beaty side of Michael Snow's ancestry made a name for itself in journalism and politics. The Snow side also produced a very distinguished attorney. Similar claims hold true for the artist's mother's family.

FIGURE 4. Elzéar Lévesque with his son Robert, June 1918.

Marie-Antoinette Françoise Carmen Lévesque (1904–2004) was an outgoing and vibrant woman; a classically trained pianist, she had a passion for the arts. One of four children, she had two brothers, Marcel (1908–79) and Robert (1917–2005), and a younger sister, Pierette (c.1906–19), who died at a convent school (Saint Joseph Academy) in Fitchburg, Massachusetts. Along with her talent as a pianist, she was also particularly adept at languages: she taught herself Spanish, Portuguese, and Russian. She was so skilled in Spanish that she was later employed to host a Spanish-language radio program for the Spanish consulate in Toronto. Their father was Elzéar Lévesque

(1875–1937), the son of Delphine Tremblay and boat captain Elzéar Lévesque. The younger Elzéar studied at the Séminaire de Chicoutimi and law at Laval University. In 1884 he married Caroline Denechaud (1875–1942), daughter of Macaire Denechaud, a merchant, and Françoise Moreau.

Elzéar was a candidate in the provincial election of 1908 and the federal one of 1911. In 1922 he founded the Compagnie Autobus & Taxis 500. Later, he invested in the Compagnie Hydraulique du Saguenay; throughout his lifetime, he was active in the real estate development of Saint-Ambroise, Saint-Honoré, Chicoutimi, and Jonquière. He was the mayor of Chicoutimi from 1912 to 1922.

Caroline Denechaud was one of sixteen children born to Macaire and Françoise. Marie-Antoinette's paternal great-grandfather was the Hon. Claude Denechaud, a representative for Quebec City in the province's legislature. His father, Jacques Denechaud, a surgeon, arrived in Quebec from France in 1752 and was on duty at the hospital when the English won the Battle of the Plains of Abraham.

In Chicoutimi, Elzéar and Caroline's majestic house, a large brick structure on a hill, was surrounded by a low stone wall. Earlier, in 1912, Elzéar had built an island cottage at Lac Clair; when that burned down in 1918, he built a similar one, facing the other way, on the same island.

FIGURE 5. Lac Clair cottage.

Elzéar was a person who sought out the best. He had a superb wine cellar and assembled a large collection of books related to all things French.

After completing his studies in Toronto, Bradley worked as a surveyor in the Saguenay region of Quebec; his assignment was to prepare a report on the feasibility of building a rail line from Chibougamau to Chicoutimi (about 350 kilometres) — the project was not undertaken. A bit later, around 1924, he became the chief engineer and head of construction of two bridges in Chicoutimi, where he then resided.

He and Marie-Antoinette met at a ball given by Sir William Price, the Quebec-based lumber merchant. The two fell in love and decided to marry. When Marie-Antoinette told her father that she and Bradley intended to marry, Elzéar received communications and in-person visits from the local Catholic hierarchy, which threatened his daughter with excommunication if she married a Protestant. Despite the Church's warnings, she went to Toronto, and there she and Bradley wed on October 29, 1924, with his family in attendance.

FIGURE 6. Lévesque family home, 220 Racine Street, Chicoutimi, 1922.

The strong bond between the young couple was possibly triggered because each had lost a sibling. In Marie-Antoinette's case, her parents had taken her and her sister by train to the school in Massachusetts. When, after three months at the school, her sister was taken ill with the Spanish flu and died suddenly, her parents returned to the States to take their surviving daughter back to Chicoutimi.

The Snows settled in Toronto and, a bit later, Montreal. Their first child, Denyse, was born in 1925. Michael James Aleck arrived three years later in Toronto on December 10, 1928. In 1929 or 1930, the family moved to Montreal, where, in 1935, Bradley had a work-related accident in a tunnel that cost him his sight in one eye when it was crushed; the other eye was also seriously compromised when it was peppered with dust. During his recovery, Bradley decided to return to Toronto, where his family could look after him; Marie-Antoinette, Denyse, and Michael moved for a year to Chicoutimi.

Seven-year-old Michael first attended school in nearby Arvida — he recalled that earlier, in an ornery way, he had informed his parents he had no interest in attending school. On his first day he, without interference, walked out of class, went to the nearby highway, and attempted to hitchhike his way back to Chicoutimi, a distance of about thirteen kilometres. By chance, his uncle Marcel was driving by and picked him up, asking, "Bruder, what are you doing here?!" For many years after, his sister, Denyse, as well as his parents, grandparents, and uncles and aunts called Michael "brother." Years later, when a friend called the house, Denyse answered and bellowed: "Brother, you're wanted on the phone." When Michael picked up the phone, the friend asked, "Are you some kind of monk?"[1]

During that extraordinarily snowy winter in Chicoutimi, the children had a wonderful pet, a gift from Elzéar, a St. Bernard dog named Buck. The children spoke French to the dog. Though completely bilingual, when in Chicoutimi, Marie-Antoinette always spoke to her children in English. Michael's ability to speak French was hindered by the fact that the inhabitants of Chicoutimi, anxious to learn English, spoke to him only in English.

During one of the summers at Lac Clair, after their dog, Buck, died, Marcel arrived at the Lac Clair island cottage with a dog, which he gave to Denyse and Michael. Marcel explained that he had gone

FIGURE 7. Michael and Denyse Snow, 1939.

to the Montagnais reserve near Chicoutimi to buy some moccasins. He liked a dog he saw there enough to buy it, intending it as a gift for Denyse and Michael. The owner of the dog, who insisted that the animal was half fox, asked only for a bottle of beer in exchange for Miro. The children and mother brought Miro back to Winnipeg and then Toronto, where he lived with them for about three years.

Even before their year there, the two children and their mother spent several summers at Lac Clair. Denyse remembered herself as an ordinary young girl who played with dolls. Michael, she recalled, played with his Meccano set, but he spent large amounts of time daydreaming and drawing.[2] He has a precise memory of the island cottage: it "cover[ed] most of the island. It was like being on a boat that does not move. There was the land, the sand and the rocks."

He cherished the cottage on the island, but another environment was equally significant to him — the magnificent house Elzéar and the architect Alfred Lamontagne designed and built on Racine Street in Chicoutimi.

> The third floor of the house had two large rooms available for play. One of these rooms had a window

FIGURE 8. Michael Snow, "Aeroplane Ace," 1938.

with a frame so large that it was possible for me to sit
there. I spent hours just watching the activities of Ra-
cine Street from above. The port of Chicoutimi was
also visible. It was not at all boring for me to spend
hours there.[3]

The artist's sister has a vivid recollection of her brother, at the cot-
tage, in a trancelike state, looking out at Lac Clair.[4] He created comic
strips — one concerned "Aeroplane Ace," an air force pilot. Another
was called "The War of the Planets."

In retrospect, Michael feels that Chicoutimi and Lac Clair provided him with the impetus to become an artist. At the ages of seven and eight, he was subconsciously on his way to becoming a maker of images. "During this sad period," he reflected, "there were extremely positive events in Chicoutimi that were crucially important for my developing into an artist."[5]

For him, that creativity is in large part derived from his grandfather's strong sense of taste and the comforting environment that he provided at a critical stage in his grandson's existence. Michael's mother reflected: "We were really alone there — my father owned the lake, and our cottage was on a very tiny island and filled it. You felt you were living on a boat. I think the quiet and the solitude had an effect on Michael's art."[6]

If there was a transformative moment in which the future Michael Snow — the experimental artist — can be glimpsed, it was at Chicoutimi. The eight-year-old, on the grass, asked his sister to take a picture of him reclining from the feet end. He was fascinated by the resulting distortion. He wanted to see what it would look like.[7]

CHAPTER TWO:
CONVERSION

After the year in Chicoutimi, the Snow family reunited in Winnipeg; then, the following year, they moved to Belsize Drive in Toronto. About three years later, they moved yet again, this time to a large, comfortable Queen Anne–style fourteen-room house in Toronto's Rosedale area, at 10 Roxborough Drive. From September 1937 until June 1942, Michael attended Hodgson Middle School on Davisville Avenue. In the autumn of 1942, he was enrolled at Upper Canada College's Preparatory School and was promoted to the Upper School in September 1943. His sister attended Loretto Academy in Toronto. From the ages of fifteen through seventeen, Snow spent part of each summer at Camp Calumet on Boshkung Lake in Haliburton, Ontario. The surviving records show he actively participated in every activity there, including sports.

Both Bradley and Marie-Antoinette were affectionate parents who wanted the best for their children. They also made it clear to Denyse and Michael that they had high expectations of them. As well as insisting that their children work hard mastering their academic courses in school, they also encouraged them to develop their artistic talents. In particular, Marie-Antoinette tried to foster a love of music in her children. In addition to the piano, she played the violin. Michael resisted her wishes that he study piano, but later he had his "conversion" to jazz and started to teach himself to play. He had no formal lessons.

FIGURE 9. Marie-Antoinette with violin, 1917.

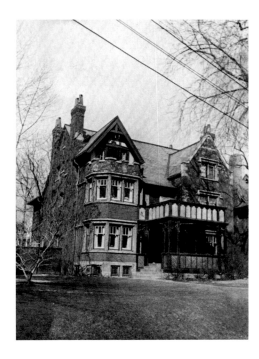

FIGURE 10.
10 Roxborough Drive,
Toronto.

Ironically, when his mother attempted to lead Michael to study piano (before his awakening), she had acquired a mimeographed booklet — *An Introduction to Basic Harmony* — issued by one of the possible teachers of "popular" piano. He refused her urgings to study it. Some months later, though, Michael remembered this booklet, retrieved it from the piano bench, and began studying it. When, one day, Marie-Antoinette arrived home unexpectedly and heard Michael playing jazz tunes in the basement, she was pleasantly surprised.

This "conversion" occurred when the young man began listening to New Orleans and Chicago jazz from the 1920s.

> As a kid, I was never interested in anything at all — I just wandered around in a daze of zeroes. That changed one day when I came across an album of Duke Ellington, *Victors* [RCA Victor Recordings]. It flipped me. It had 'Black and Tan Fantasy,' [Stompy Jones] all 1930s stuff. It was very, very beautiful. Then

> I heard a few more things … it might have been Jelly
> Roll Morton … or Jimmy Yancey … and I knew right
> away that was what I wanted to do, and I started to
> play the piano. It was the first thing I found that I
> really cared about.[1]

Marie-Antoinette was delighted by her son's playing, although she remained baffled by improvisation.

Snow's father, Bradley, was also a cultivated person — he had studied Greek in school. In 1943, when he lost the sight in his second eye, he fought back against the darkness. He sometimes made his way by streetcar or by subway to downtown Toronto. He once appeared with his white cane at one of Michael's exhibitions at the Isaacs Gallery. He learned to read Braille. Although completely blind, Bradley did some consulting work. Michael or Denyse would read him details on a blueprint, and their father would make notes in Braille. He also found a way to support his family by playing the stock market, where he was an astute investor, and one who was consistently successful. The year before he died, he was writing, in Braille, a novel based on Greek mythology.

Naturally reserved, Bradley retreated further after he lost his sight completely. He did not complain, however; he was a determined stoic. Bradley's quietness contrasted significantly with the outgoing ways of Marie-Antoinette. As a teenager, Michael observed, the cultural and personal differences between his parents widened. Denyse, as a teenager, recalled that her parents rarely spoke at the table — not even chitchat — and that the unspoken tension between them was palpable. Michael reluctantly agrees: "Father was absent, in a way."[2]

Dinnertime conversation was often replaced by radio programs, such as American comedy shows like the *Jack Benny Program*, but during the war the family listened to the BBC broadcasts from London. Eventually, in about 1955, the Snows separated. Marie-Antoinette remained in the Roxborough Drive house, and Bradley bought and

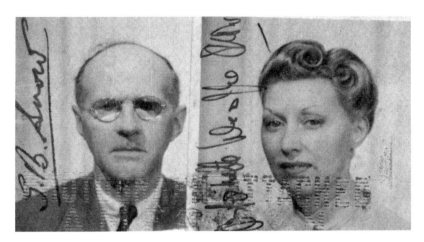

FIGURE 11. Gerald Bradley and Marie-Antoinette Snow, 1942.

moved to a small house, caring for himself despite his disability. He later died from a heart attack while shovelling snow in front of his new home.

Michael Snow once concisely observed: "I think the most important things in my life … my father went blind when I was fifteen, and … my mother is a very fine pianist."[3] That comment shows the obvious great love Snow felt for both parents and his appreciation for what they had bestowed upon him.

CHAPTER THREE:
JAZZ BAND

The teenage Michael Snow witnessed his father's descent into darkness. He began to imagine what it would be like to lose one's sight, and, as result, he saw the world in an enhanced way. He became more aware of what one could see, of the beauty of what one could behold. His mother's extraordinary talent to play the piano, Michael began to realize, had been bequeathed to him, although his gift manifested itself in a different way than did hers. In some of his subsequent work, Snow would explore the relationship between sight and sound, and, in the process, he became both an artist and a musician.

At Upper Canada College (UCC), Snow was not keen on his studies; his interest in music — particularly jazz — became his focus. The Snows sent their son to UCC, perhaps thinking that the compulsory athletic program would be good for him. Instead, at 3:30 in the afternoons, when he was supposed to be in the gym or on the field, Michael retrieved the bike he kept stashed in nearby bushes and headed for the Promenade Music Centre on Bloor Street, where he sat in a booth listening to Louis Armstrong, Duke Ellington, and Jelly Roll Morton.

When they could manage it, Snow and another student, Ken Dean — a trumpet player — would sneak into the piano practice rooms at UCC to make music. For several summers, Snow, Dean, Roy Glandfield (trombone), and Don Priestman (clarinet) went to Chicago. There, he said, "we sat in where we could and heard a lot."

It was during one of those trips that Snow smoked marijuana for the first time. The members of the band drank a good bit. They also tended to have discussions well into the night. "Once," Snow recalled, "[Don Priestman and I] walked together to Rosedale — it took ages — arguing all the way about the function of the clarinet.… The sun was coming up and we sat on my front porch arguing about this stuff. My father came out to get the paper and there we were, saying 'You can't play thirds to the trumpet like that.' My father said, 'Oh my God.'"[1] Through his fellow band members, he received a cultural education far beyond what he received at UCC: on their recommendation he read Joyce's *Ulysses*, Dos Passos's *USA*, Flaubert, Stendhal, and Dostoyevsky.

Like many adolescents, Snow felt unfocused, not quite sure what he was going to do with his life. He also was trying to "cope" with the full implications of his father's blindness. For him, music became a solace, an escape from everyday reality. As a child, Michael had spent many hours sketching. At the age of ten, he created a cartoon character he called "Aeroplane Ace." At UCC, he drew surreptitiously.

In 1940, his drawing of ice skaters obtained honourable mention at the Canadian National Exhibition. He flirted with painting when he combined a slow-growing attraction to visual art with his consuming interest in jazz.

In the October 13, 1947, issue of *LIFE* magazine, the nineteen-year-old came upon two articles on Picasso: an anonymous piece with colour illustrations entitled "PICASSO: The brilliant Spaniard is this era's most important painter. But is he a truly great artist?" and "Portrait of an Artist" by Charles C. Wertenbaker. The Wertenbaker article is headed by a black-and-white photograph labelled "Pablo Picasso Poses with His Latest Work, Paintings of Strange Creatures." This work, a triptych in oil and charcoal on three asbestos boards, is entitled *Satyr, Faun and Centaur with Trident* (1946). The satyr is playing a flute-like instrument. The *LIFE* article awakened Snow's interest in cubism and led him to paint *Jazz Band* (1947), a work containing portraits based on Dean, Glandfield, and Priestman. Like Stuart Davis and Piet Mondrian, jazz spoke to his art and inspired it.

Torn between his passion for jazz and his love of art, Snow remained indecisive about his future. In June 1948, he let fate make the

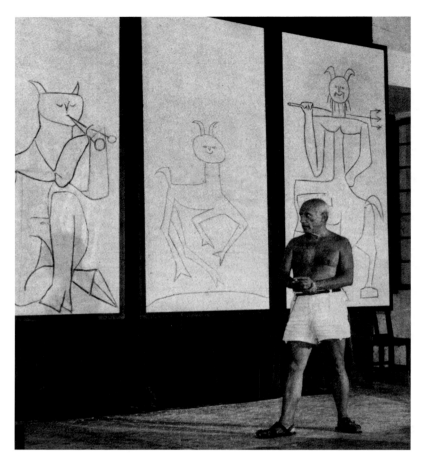

FIGURE 12. Picasso article in October 13, 1947, *LIFE* magazine.

decision for him. Despite poor grades, he graduated and was awarded his school's art prize. Based on that success, he decided to attend the Ontario College of Art (OCA; now OCAD University) rather than pursue a career as a musician. "I took a compromise course called 'design,' because I didn't know whether I was going to turn out to be a commercial artist or what." Then he began painting, although he remained in his chosen course: "I had this idea that when you go out you had to have an occupation of some kind. Not a career, but a business."[2]

At first, his rebelliousness remained strong, as his lecture notes reveal. He doodled instead of paying attention. He made a caricature of

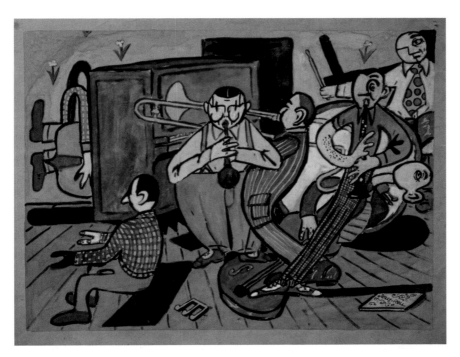

FIGURE 13. Michael Snow, *Jazz Band*, 1947.

one teacher while asking himself, "What is beauty?"[3] What might have been a haphazard decision turned out to be a wonderful turning point in the twenty-year-old's life. For one thing, the design unit at OCA was very much a bastion of Bauhaus School principles and placed a great deal of emphasis on form, a concern that would dominate the young man's later career. Even more important was the presence of John Martin (1904–65), the etcher and textile designer who was the head of the design division. Paintings did not have to be submitted in the design program, but when Snow showed some he had done to Martin, he "provided provocative feedback."

Sensing Snow's potential, Martin took him under his wing. "He suggested reproductions that I ought to see and books that I ought to read. Among the books he mentioned were the [various volumes in the] Documents of Modern Art series, a collection of various artists' writings: Mondrian, Kandinsky, etc."[4] Martin was particularly interested

in contemporary English artists — Graham Sutherland, John Piper, Stanley Spencer, Ben Nicholson. Snow studied their work and gravitated to the cool, cerebral abstracts of Nicholson.

A year or so later, the young artist discarded his fascination with Nicholson in favour of Paul Klee. The highly stylized work of the Swiss artist became the dominant influence on Snow's early work. He was attracted to its purity of form, its careful regulation of colour values, and its playful approach to surface values. Interestingly, along with the visual connection to Klee that Snow felt at that time, there was another bond — one that Snow was unaware of at the time. Klee was a violinist, an admirer of Bach and Mozart, and he had attempted to translate musical form into visual form.[5] At an unconscious level, perhaps, Snow the musician was responding to Klee the musician.

In his attempts to find pictorial equivalents to music, Klee was following in the footsteps of Wassily Kandinsky (in *Concerning the Spiritual in Art*). Specifically, "Klee sought the actual basis for the analogy in the most inner being of music — its rhythm — which in his opinion not only marks the movement of time but also in art."[6] For him, each colour had an intrinsic sound.

Blue Panel (Wall Panel V) shows how Snow responded to Klee in its careful regulation of colour values and its playful approach to the surface of a canvas. *Blue Panel* may remind a viewer of Klee, but, on closer inspection, the colour scheme, which is dominated by strong blues together with flecked whites and creams, is not one favoured by the European artist. Moreover, the use of various blocks — configured in several variations — does not conform to Klee's ordinary way of working. He almost always constructs series of blocks rather than series of variously shaped groups of blocks.

Responding to an advertisement in *Canadian Art* magazine, Snow submitted a design for its cover. His design was accepted and appeared in the Summer 1951 issue. As Snow was then merely a student in the OCA design course, this was a significant accomplishment.

When Snow was in his final year at OCA (1951–52), Martin encouraged him to submit work to the Canadian Society of Artists' eighty-first annual exhibition. The CSA had never before accepted student work; however, two pieces — *Wall Panel II* and *Polyphony* — were

FIGURE 14. Michael Snow, *Blue Panel (Wall Panel V)*, 1952.

accepted by committee. Snow's "sharp colour sense" was noted in a review of the show.[7] Early in 1952, another work was included in the twenty-seventh annual Exhibition of Canadian Society of Painters in Water Colour.

Shortly after his graduation from OCA, Snow and a classmate, Bob Hackborn, a drummer who later became a set designer at CBC, were commissioned to design a mobile (now destroyed) to hang above the staircase of Wymilwood, the new student union at Victoria College in the University of Toronto.

While still at OCA, Snow had formed a romantic relationship with another student there, Georgine Ferguson. She had been born in Winnipeg but grew up in Montreal. In order to put some distance between her and her parents, she decided to study in Toronto, where she trained in commercial art. At times during the summers of 1952 and 1953, she shared Michael's bedroom at Roxborough Drive. Bradley and Marie-Antoinette had no objections to this arrangement. During her stay, the young woman noticed that Michael's parents lived

FIGURE 15.
Georgine Ferguson, 1953.

FIGURE 16. Michael Snow, *Georgine*, 1954.

completely separate lives. Another strong memory was of herself and Michael in Marie-Antoinette's bedroom, one on each side of her, as she read Proust to them.[8]

Georgine and Michael's love for each other was all-encompassing. Each was the centre of the other's universe. Although their ardour may have been fierce and unrelenting, it was also a romance on which their relatively young ages ultimately put a damper.

Michael had found makeshift work doing paste-ups and other entry-level chores at a commercial art firm that made catalogues. In retrospect, he recalls: "It was horrible, and I was horrible."[9] He was living at home and saving up to travel to Europe.

He knew that he had to find ways of extending his knowledge of art, and he realized that he had to leave Canada to make that happen. That urge conflicted with his love for Georgine. He came to the conclusion that their connection to each other would survive despite the long absence a stay in Europe would entail.

CHAPTER FOUR:
A MAN DRAWING LINES

One way to survive in Europe was to find work in a jazz band. Snow had already acquired a lot of experience professionally. From 1948 to 1952, he played occasional jazz gigs: for instance, he was a guest artist for the Queen City Jazz Band on May 5, July 17, and July 21, 1948; and June 30, 1950; and was a member of his former classmate Ken Dean's Hot Seven on August 13, October 22, and December 2, 1948; and June 18, August 24, and October 19, 1949. On July 9, 1949, the

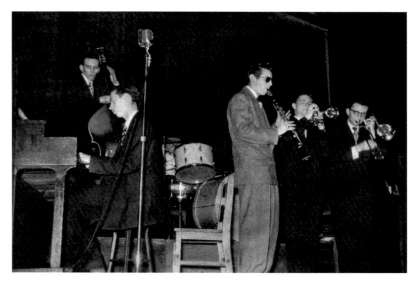

FIGURE 17. Ken Dean's jazz band in concert at a high school in Toronto, probably 1948. Michael is playing piano.

Globe and Mail reported that Snow and Dean were interested only in Dixieland: "no bop or any other so-called progressive style will sway them from that objective." According to the article, "they were still growing musically, and willing to grow."

Robert Fulford, a friend of the clarinettist in Ken Dean's band, recalls this period:

> [I was] a junior impresario — doing promotion stuff, renting the halls, selling tickets, trying not to lose money [for the band, which] played on the Island several times in those days, and the Island seemed like one big party. Mike was not a hell-raiser, but he was funny and sexy — very attractive to women and very attracted to women. He was totally lacking in braggadocio on the one hand or modesty on the other … [playing the piano] seemed natural to him.[1]

Bob Hackborn remembers that time vividly, too: "We played frat houses, and hooker hotels in the tenderloin district. I remember we were both playing at the Warwick Hotel, and these two hookers, Micki and Vicki, took a liking to us. They knew we were students, but we actually arranged a meeting with them, and Mike and I were anticipating all kinds of lascivious delights. And the night of our date — that was the night the cops picked them up. We were heartbroken."[2]

In leaving Canada for Europe, Snow had mixed feelings — he was very attached to Georgine. Nevertheless, his spirits were high. He knew he had to undertake this particular rite of passage: he desperately wanted to expand his knowledge of the world. He needed to complete his education. "I was very indecisive then. I did work that was pretty decisive, I suppose, but I kept on vacillating, trying to decide what I should do."[3] Travelling, he felt, would clear his head and allow him to move forward. His decision to travel might have been assisted by a fire at his parents' home that destroyed five of his canvases. Since those pieces were gone, he could begin from scratch. He had saved up three hundred dollars for the trip.

In April 1953, Michael, Bob Hackborn, and Georgine travelled to New York City. As Georgine said goodbye to her boyfriend, she was distraught. Deeply in love with Michael, she feared that this separation might become a permanent one.

Snow took his trumpet — an instrument he was not then adept at — whereas Bob took a complete set of drums. The two left for Le Havre aboard the SS *United States*. As soon as they arrived in France, the pair took a train to Paris. They hoped to find employment playing jazz and thus pay their travelling expenses. That summer they obtained work at three Club Mediterranée (known as Club Med today) camping resorts at Golfo di Barrati on the coast of Tuscany, on the island of Elba, and at Becici-Budva on the coast of Montenegro in Yugoslavia. Bob Hackborn fondly remembers the night they were "coming down from Trieste on a boat, and we suddenly arrived at this small coastal village. It was night and beautiful and it looked like a Van Gogh painting, and there was this little club at the end of the wharf, and we heard jazz coming from it."[4] Michael's memory was of being enthralled by hearing the sounds of jazz and the music becoming louder as they approached shore. The two hurried off the boat and headed in the

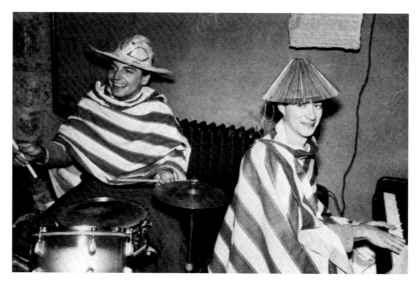

FIGURE 18. Bob Hackborn (left) and Michael Snow at a costume night in the bar of the Hotel Grand Coeur, Méribel Les Allues, February 1954.

direction of the music, which was emanating from a small bar where a band was playing New Orleans jazz.

In September and October, Snow worked with David Lancashire at a jazz club (La Rose Noire) in Brussels. Michael later told his friend that he was in a constant state of depression, but that observation startled Lancashire. "Everything was for laughs then. And for music. We had an apartment above [the club], and we'd sit up and talk all night and talk all day. He was serious about art — Cézanne was very important to him — but I can't remember any gloom."[5]

Hackborn has similar memories. He recalls only two arguments: "one was about colour. We were trudging down this dusty back road to the Club Med, and the sun was setting, and I said it was such a beautiful orange colour, and Mike said no, it was yellow, and we argued about it, and he really got quite angry."[6]

A month after the band's run in Brussels ended, Snow, as prearranged, met Bob in Milan. The two travelled through Germany, Switzerland, the south of France, and Spain, and ended up in December in Malaga, on the Mediterranean coast of Spain. They remained there until the end of January, then made a short trip to Tangiers, headed to Paris, and finally to the French Alps, where they obtained work as a piano and drums duo.

In the French Alps, at the ski resort in Méribel Les Allues, Snow had a precarious sexual adventure. One night, Hackborn remembered, he "commandeered" another man's girlfriend, and later that night "the guy got drunk and burst open the door of our room and stood there swaying and yelling at us." This is not the complete story, as Snow recalls. The person who hired Hackborn and Snow was a French novelist who had won the Prix Goncourt. He had a wealthy girlfriend — she had her own airplane. Snow recalls:

> Somehow, the guy thought I was making out with her, which I wasn't, and he threatened me a couple of times. One night he got into a rage and said "I'm going to kill you," and he went and got a gun. Everyone was trying to talk him out of it — you know, *Don't*

shoot the piano player. Hackborn and I ran away and
there was a chase. The guy had this big dog, and we
were scuffling and running and falling in the snow.
We made it through the night and a couple of hours
after breakfast the police came and arrested him, but
not because of what had happened. It turned out that
he was an impostor, a criminal with a record, and off
his rocker.[7]

Only years later did Hackborn reveal to Snow that he had slept with
the lady the night before the incident with the impostor.

After less than a month in the Alps, and another month in Paris,
the two moved to London at the end of April. Six weeks later, after
receiving an upsetting letter from Georgine, Snow headed home. She
had informed him that she had committed herself to someone else
and was engaged to be married. When he arrived back in Toronto,
Snow, surprisingly, did not attempt to change her mind, and Georgine
remembered that he and she had become distant from each other.

Despite a hectic time travelling and playing, Snow produced a size-
able amount of work during his time in Europe, especially in Malaga.
Two important oils, *Colin Curd About to Play* and *Man with a Line*
were done there.

Partially indebted to Klee, this painting of Colin Curd (his
real name) is based, Snow reflected, "on a wonderful character and
musician I met in Paris — as usual it is not just one subject but a
multiplicity of meanings, the largest one discussing the position of
all artists (flautists, magicians, painters or poets) and the audience.
As you can see, I consider both ends *un poco loco* [a little crazy]."[8]
Later, he provided further details: "I had met an interesting young
classical musician from England, a flautist. We had memorable con-
versations about what it was to be an artist, and in particular about
who the audience for our work might be and what our relation to
them should be."[9]

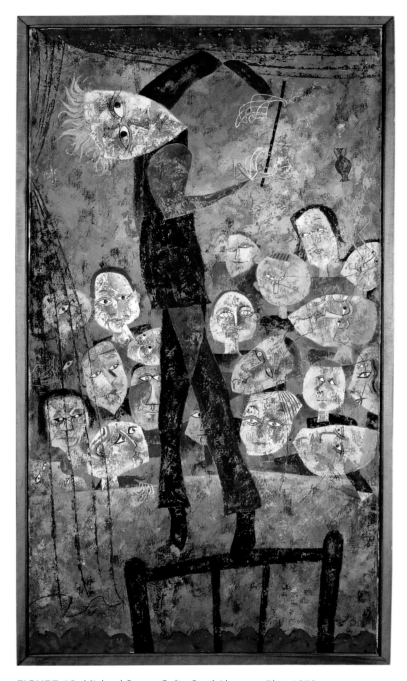

FIGURE 19. Michael Snow, *Colin Curd About to Play*, 1953.

FIGURE 20. Michael Snow, *A Man with a Line*, 1953.

A Man with a Line was made on a canvas on which an early work may have been scraped away. The critic John Grande points out "the simple effect of the continuous line," admiring how "with a typical Snowian sense of *double entendre*, *Line* becomes both a metaphor for the process, his own reflection of the process, and the actual subject as well: which, as the title suggests, depicts a man examining a line that extends between the thumb and forefinger of each of his hands."[10]

The man may be examining the line, but he is also a series of lines. The man is Klee-like, but he is placed against a mottled, almost marble-looking background. In this work, Snow compares his subject (drawn with a series of lines mainly in red) to the stolidity of the background. As a result, two levels of representation are placed against each other.

If Snow became an artist by serendipity, his previously haphazard energy came into sharp focus by 1953. His devotion to exploring what

it means to be an artist took over and, in a sense, *became* his life. For Snow, the artist is someone who ventures into new territory on a constant basis, always willing to embrace evolving conceptions. In 1953, that process was underway.

CHAPTER FIVE:
INTIMATIONS

The Toronto art scene to which Snow returned in 1954 is often described as moribund. This is not completely true. As much as in any large American city in the fifties — except New York and Los Angeles — there was a kind of bedrock conservatism in Toronto, more so than in Montreal. However, both these Canadian metropolises had already been the homes of some major innovations in contemporary art. In Montreal, Paul-Émile Borduas, Jean-Paul Riopelle, Yves Gaucher, and Claude Tousignant were advanced modernist artists.

In Toronto in 1953, eleven abstract painters from Ontario — Jack Bush, Oscar Cahén, Hortense Gordon, Tom Hodgson, Alexandra Luke, Jock Macdonald, Ray Mead, Kazuo Nakamura, William Ronald, Harold Town, and Walter Yarwood — formed Painters Eleven and held their first exhibition at the Roberts Gallery in 1954. In the mid-fifties, William Ronald moved to New York City, where his work was taken up by Samuel M. Kootz, a leading dealer.

American abstract expressionism may have influenced Ronald and the other members of Painters Eleven, but, in various ways, they had established a distinct, authentic modernism. Douglas Duncan (Picture Loan Society), a connoisseur of Canadian modern art, showed prime examples of it. Before 1950, he was the only dealer doing so in Toronto.

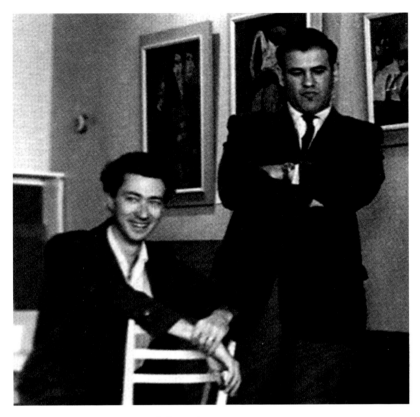

FIGURE 21. Michael Snow (left) and Av Isaacs.

While students at OCA, Snow, Graham Coughtry, and some other students had congregated at the tiny Greenwich Art Shop (ten feet by twenty feet) at 77 Hayter Street, where the proprietor, Winnipeg-born Av Isaacs, "did good framing cheap." He would also, as Michael recalled, "hang [our] work and try to sell it!"[1]

Isaacs moved from Winnipeg to Toronto when he was fifteen years old. He graduated with a degree in political science and economics from the University of Toronto in 1950, and then he and a friend opened a framing business. After a year, he bought his partner out.

"Greenwich," named after New York City's Greenwich Village, was the bohemian area near where OCA was located (on Gerrard Street West between Bay and Elizabeth Streets). There were small galleries, framing shops, and coffee houses — even a French restaurant. From

1946, the centre of the village was the after-hours jazz club, House of Hambourg, which began to attract devotees of avant-garde jazz, art, poetry, and drama.

Not far away, Spadina Avenue, as Peter Goddard observed, was the "stomping ground in the 1960s for one of the most mercurial, argumentative, hard-drinking, and seriously talented coteries of artists in Canadian art history — I mean Gordon Rayner, Graham Coughtry, Robert Markle, and the rest of the gang that had second- or third-floor studios up and down Spadina Avenue and along College Street, showed mostly at the Isaacs Gallery and drank at Grossman's Tavern."[2]

For a time, Av Isaacs shared living quarters with Coughtry. Six years later, on February 1, 1956, he officially opened the Greenwich Art Gallery at 736 Bay Street, near Gerrard Street West.[*] It was not very long after taking this momentous step, that he became discouraged: he was not selling very much, and the Roberts Gallery, which had sell-out exhibitions of mostly traditional artists, was extremely successful. Isaacs soldiered on, however, confident that he had a good instinctive eye.

Snow remembers: "Once Av felt convinced of the quality of intensity in someone's work — and of course this decision was 'intuitive' — he was surprisingly trusting and confident." That confidence eventually led to a new group of Toronto artists, whose work did not have a unifying stylistic or iconographic thread — they included Snow, Graham Coughtry, Gordon Rayner, Dennis Burton, William Ronald, and Robert Varvarande. In fact, there was not really a consistent look to an Isaacs artist, because the dealer was only on the lookout for the "quality of intensity."

As Snow fondly recalls, Isaacs was a very collaborative dealer: "We would agree on a date when an exhibition would be possible. I generally described what I was working on and planning to show. When it came time for the exhibit, he usually saw the work for the first time when it was delivered. I always planned what might go where, but hangings were always interesting, with the two of us deciding mutually what would look best."[3]

[*] However, the Greenwich Art Gallery was in operation from late 1955. It became the Isaacs Gallery in 1959. In 1961, the Isaacs Gallery moved to 832 Yonge Street.

FIGURE 22. Dennis Burton, *Egypt Asleep*, 1966.

If it can't be said that there was a common style found in the works of the members of the Isaacs stable, it can certainly be said that the gallery owner enabled a group of artists to produce a distinctive body of work independent of anything else in Canada. He literally gave space for new works to emerge in a wide variety of directions. Everything was a work-in-progress. Isaacs's taste evolved, too. As he recalled, his artists also evolved rapidly.[4] Most of those he took on had not reached the age of thirty.

Dennis Burton's career began with what could be called second-generation abstract expressionism, but by the mid-sixties his interest turned to making images of women inspired by "skin books" from

FIGURE 23. Graham Coughtry, *Two Figures XI*, 1963.

the States; this fetishistic work is influenced by the bright colours of some American pop art, especially that of Andy Warhol. Coughtry's work showed a plurality of influences: the dynamically moving, slashing tormented figures in Francis Bacon, the colour values of Pierre

Bonnard, and the photo studies of wrestling male figures in Eadweard Muybridge. Gordon Rayner's work is even more eclectic in its sourcing than Coughtry's.

If the work of each of these emerging artists was vastly different from each of the others shown by Isaacs, this observation is particularly true of Snow. The connection of Snow with these other young men was really improvised music, particularly when the Artists' Jazz Band was formed.

New directions in the arts emerged in the 1950s and throughout the 1960s. There was the celebrity status of the country folksinger Gordon Lightfoot, who performed in the coffee houses in Yorkville. Bob Dylan, in transition from acoustic to electric guitar, appeared at Massey Hall. The Art Gallery of Toronto became the Art Gallery of Ontario in 1966; this was accompanied by an interest in the acquisition of cutting-edge contemporary art.

The commercial gallery scene was rapidly expanding: Barry Kernerman opened the Gallery of Contemporary Art in 1956 (closed in 1959); Dorothy Cameron opened the Here and Now Gallery from 1959 and then the Dorothy Cameron Gallery from 1962; later, there was the Park Gallery, the Jerrold Morris International Gallery, the Mazelow Gallery, and Gallery Moos. But success could be fraught: Dorothy Cameron's Eros '63 exhibition was shuttered by the Morality Squad, and Cameron was subsequently found guilty of displaying obscene material.

Before this time, groups such as the Ontario Society of Artists, the Royal Canadian Academy of Arts, and the Canadian Society of Painters in Water Colour, through their juried shows, had controlled what was put on display. The Canadian Group of Painters — founded when the Group of Seven disbanded — had become fusty and had no connection with truly contemporary art. All of a sudden, in the mid-fifties, there were collectors anxious to see and buy innovative work: Ayala Zacks, Charles Band, the Bronfmans in Montreal. Robert Fulford, especially in his columns for *Mayfair* and the *Toronto Star*, eagerly proselytized

trail-blazing Canadian art. Young artists felt that the art world was coming into its own in an exciting new way. And there was a glimpse of hope that the public's perception of art was changing.

In the winters of 1954 and 1955, Snow entered work at the annual OSA exhibitions; the Canadian National Exhibition in 1955; and the 1st and 2nd Winnipeg Art Shows in 1955. However, his most important early venue was Hart House, where he had a two-man show with Graham Coughtry January 3–17, 1955. The checklist shows that *A Man with a Line, Woman with a Clarinet, Wall Panel I, Blue Panel (Wall Panel V),* and *Colin Curd About to Play* were among the twenty-two works displayed by Snow.[5] Coughtry, heavily influenced at the time by Francis Bacon and the photographer Eadweard Muybridge, showed nudes in which the figures seem to emerge from inside the surface of the canvas.

This exhibition turned out to be a *succès de scandale* rather than a *succès d'estime*. The only review was in the University of Toronto student newspaper, the *Varsity*, but Nathan Phillips, the mayor of Toronto, ordered three images of nudes to be removed because, according to what a newspaper reporter told his office, they were obscene. There was a photograph taken of Nathan Phillips, the newly elected mayor of Toronto, standing puzzled before a Snow painting. The mayor also objected to the title of one of Snow's paintings, and was quoted as stating that the title of one, though intended as a pun, was certainly objectionable — according to Coughtry, he was referring to *Woman with Cock in Her Hand* — which shows the woman holding a rooster.[6]

When Coughtry was asked why the show contained so many nudes, he flippantly responded: "[B]ecause every damn tree in the country has been painted."[7] Despite this contretemps, Snow was completely aware of what he was trying to accomplish: "All I want to do is present some kind of moving image using all the [elements] of painting — It must end up being an object which rewards, invites, provokes contemplation, awareness — 'A painting is a small experience in feeling and thinking, that is, living.'"[8]

The most successful early exhibition of Snow's work was at the opening show of the Greenwich Art Gallery, on February 1, 1956, which was devoted to works by Snow, Coughtry, William Ronald, Gerald Scott, and Robert Varvarande. In her review in the *Globe*, Lotta Dempsey was suitably impressed and approvingly quoted Isaacs: "While these five young painters represent diverse directions in painting, their work suggests, I believe, a common standard of artistic integrity, and it is my earnest intention to adopt this standard and grow with it as it grows, rather than trying to adjust to any mythical 'level of public taste.'"[9]

Varvarande's work was figurative, but in a misty, quasi-abstract manner; Scott's well-turned, mannered portraits were perhaps the most traditional pieces of art on display; Ronald's single work was an abstract in the manner for which he was already well known; Coughtry's contributions were figure drawings; Snow showed three collages, including *Man at a Desk, A Night*, and *The Mirror*. The reviewer for the *Varsity* was awestruck: "The best of Bohemia … turned out to acknowledge their own in an atmosphere which was full of smoke and the feeling that something was happening."[10]

Snow had taken a job at Graphic Associates — a firm producing animated films and some commercials — run by George Dunning, who had been so impressed by what he saw at the Coughtry-Snow exhibition early in 1955 that he telephoned Snow to offer him a job. He informed the young artist that he was interested in hiring "fine art" artists rather than commercial ones.

As Snow recalls, that was his first contact with film. There was some live filming, but the firm specialized in animation. To his amazement, he became director of that department — just before the place closed. Eight years older than Snow, Dunning had trained at OCA and then worked at the National Film Board. After Graphic closed, Dunning worked in London, England, and was the director and chief animator of the Beatles' film *Yellow Submarine* (1968).

At Graphic, Dunning told Snow that he could make his own short films and could even use the animation camera and cameraman as long it did not cost the company any money. "This is how," Snow recalled, "my first film, *A to Z* [an animation four minutes long and filmed in 16 mm] came about in 1956. It uses the kind of Klee-influenced drawing

that Dunning admired and was done as cut-out animation, in which one moves elements of the drawing in each frame." He continued:

> I was inspired at that time by studying the music and visual art that moved me the most and then imitating and modifying it. In art, the examples of Klee, Picasso, Matisse, Duchamp, and others were models to consider. But my fascination with film came about through my introduction to it as a particular process — learning what it was/is from the inside, as it were, adding frame to frame, twenty-four frames passing in one second on the screen.[11]

Graham Coughtry was also hired at Graphic to learn animation "from the teeth up." He and Snow were not above using their jobs to their personal advantage. Once, they telephoned the National Ballet, claimed to be from a film company making a documentary, and asked if they could visit to lay the groundwork. "So," Coughtry recalls, "we went down and met a lot of them and we ended up having these wonderful parties in Mike's basement, but the whole thing was just a pure scam. It was just a way to meet long-limbed, beautiful girls."[12]

Snow was never interested in traditional narrative cinema; movement entranced him. Moreover, the artists who fascinated him were not filmmakers; his interest in surface became transformed when he tried to understand how a series of drawings could be animated. Snow has described how he started by animating the "vases, flowers, tea cups floating." In *A to Z*, the chairs and tables are sexually active as they attempt to mate with each other.

Later, when Snow began to make films, he would exploit the sense of cinematic movement he had learned in *A to Z*.

FIGURE 24. Michael Snow, still from *A to Z*, 1956.

CHAPTER SIX:
GESTURES

At Graphic, Snow met Joyce Wieland, two years younger than he. She was from a lower social stratum than Michael. Emotionally, she and Michael were also vastly different. Although Michael may have been more vulnerable than he appeared, he was inwardly a confident person, probably because of the considerable approbation bestowed on him as a child by his parents. Joyce, who had never completely recovered from losing both her parents as a young child, had no such reservoir to draw upon.

The two fell in love — Joyce hopelessly so. In their relationship, there was an inequality between the person who loved too much and the person who was more detached. Some of Joyce's friends felt that she should have become involved with a more-fatherly person than the slim, handsome Michael.

Donna Montague felt "they just seemed a natural somehow. Joyce was shy and Michael encouraged her to believe in herself." Graham Coughtry maintained they were "made for each other."[1] And work at Graphic was fun. After hours, the three made a film — a spoof, based on the Salada Tea commercials they were making at Graphic. One segment was based on *Hamlet*. Coughtry "was Hamlet and Mike played the ghost and Joyce was Ophelia. [In an attempt to lift his son's depression, the ghost offered Hamlet a cup of tea.] For all of us there was a common thread I can only call Dada ... the humour, the craziness."[2] In another section of this joke film, Wieland plays a victim assaulted on Grenville Street who was comforted by a cuppa.

FIGURE 25. Michael Snow and Joyce Wieland, 1965.

Michael and Joyce were totally committed artists. Their work shares few stylistic similarities; however, before she met Michael, Joyce had a well-developed interest in film, and this fascination was a shared preoccupation. Each could talk to the other and receive honest feedback on all sorts of issues. There was a negative side of this relationship, though. They were both dedicated to their work and often fell back on each other when they reached an impasse. But while Joyce was jealous of his work, she knew that he did not feel the same about hers. Increasingly, she became despondent because her love for him was not reciprocated in a way accessible to her: "I learn a little more every day about love. Too bad I've learned this so late.... Never show a man what's in your real heart. Especially a conceited bastard like Mike."[3]

In autumn 1956, the two moved in together, taking an apartment over Clean-it-eria Cleaners at 312 College Street, just west of Spadina in Kensington Market. There was a studio for Michael on the third floor. That September they married at Toronto City Hall. After the ceremony, the newly married couple and their two witnesses went to the Walker House Hotel on Front Street (near the Royal York). There was a celebration party that evening on Roxborough Drive.

The couple did freelance animation jobs, and Michael played in various bands. He was zealous in overseeing their precarious finances,

and Joyce delighted in cooking, cleaning, and other domestic chores. In those days, she referred to herself as Joyce Snow.

On January 8, 1958, the couple withdrew $1,003.88 from their bank account, travelled to Florida, and, shortly thereafter, flew from Miami to Havana, which they explored for a few days. Most of their time was spent at La Boca, near Trinidad, an isolated hill town on the coast. They knew little about Castro's revolt against Batista, although the rebels were in hiding in the mountains near them. Their only experience of the hostilities occurred when they learned that a bomb had exploded in a theatre that they had walked past half an hour earlier.

Michael's most vivid recollection of his time in Cuba involved a parrot that he, Joyce, and some locals attempted to teach to speak. The bird was completely resistant to their efforts, despite the many long hours of practice. When he and Joyce headed back to Havana, Michael constructed a cage so that they could take the parrot with them. Almost the moment they arrived in their hotel room in that city, the bird, to the amazement of the couple, began to speak. Not only did he talk, but the animal repeated all the phrases and sentences he had been taught — and he did so in the variety of accents of his teachers. Michael wanted to take the talented bird back to Toronto, but because of the hurdles involved in trying to import the creature, he abandoned his efforts and found a new home for it in Cuba.

After this extended visit, the couple returned to Toronto and moved in to a new apartment on the ground floor of the Manhattan, an apartment building on the corner of Charles and Church. Soon after, Snow shared a studio with another artist, Robert Hedrick, above a furniture store on Yonge Street near Elm. In the foyer of their apartment was a suit of Japanese armour — bought at auction by Marie-Antoinette — and a stove, which she also gave them. The stove remained there unused, since Joyce was content with the old-fashioned one that came with the flat.

Upon returning to Toronto from Europe, Snow had played in Dixieland groups, and, after his stay in Cuba in 1958, he became the

pianist in Mike White's Imperial Jazz Band, which performed in the Basin Street nightclub of the Westover Hotel. Those gigs could lead to some interesting events. The penis of the bass player was especially large, and he would often play with it hanging out. At one party, he took his penis out and hit Michael on the head with it.[4]

Through White, Snow performed with many celebrated guest performers, such as George Lewis, Rex Stewart, Jimmy Rushing, Paul Barbarin, Edmond Hall, and Cootie Williams. At this time, Snow began, as he recalled, to be interested in "more 'modern' groups, in which I was influenced by Thelonious Monk, Charlie Parker, and Miles Davis." That transition had begun even when he was playing in White's band, when Snow became part of a risk-taking rhythm section consisting of Terry Forster, bass; Larry Dubin, drums; and himself. According to him, "that rhythm section was interested in modern jazz and we used to play in a fairly modern way with the Dixieland front line. It was interesting what happened: the Dixieland people hated it because we didn't play right, and the modern people didn't like it either, because the horns were old-fashioned to them … [it was a] typical kind of mix-up, but sometimes it was really extraordinary music."

According to Larry Dubin, he and Michael "played together for years in Dixieland bands. We used to play *free* in the rhythm section sometimes." Snow laments the outcome: "We were playing in the New Orleans format but with a Bop influence. I think it may have actually killed the band. People started to complain. They'd say, 'Stop fooling around, you guys.' They wanted the same old beat; it's part of the idiom. But Mike White liked what we were doing and he switched a little bit and started to play Ellington things, more modern material. And so this band started to lose its audience."[5]

Besides playing regularly with Mike White's band, Snow was sometimes the leader of the Michael Snow Quartet (Snow, Dubin, Forster, and Jones), which played at places like George's Spaghetti House. Their music was in the idiom of Monk, Davis, and Parker. For its appearance in Don Owen's National Film Board film *Toronto Jazz* (1963), the same group was called the Alf Jones Quartet. Much of the jazz playing was filmed at the House of Hambourg; the film also includes an interview with Snow in which he makes a distinction

between his art, in which he stops time, and his music, in which he shapes it.

Snow's transition to more modern jazz occurred at about the same time he began his large abstract paintings, in which he produced his own modified versions of abstract expressionism's use of the gesture. In these canvases, it can be argued, he both stopped time and shaped it. He sometimes uses the "gesture" and its accompanying "action" as seen, for instance, in Jackson Pollock, but from the outset, he modified and "tamed" it.

Although the "gesture" that dominated the work of Pollock, Willem de Kooning, and Franz Kline can be glimpsed in Snow's abstracts from 1959 to 1961, his preoccupation is more with surfaces and how colours interact with each other in the manner of Mark Rothko and Barnett Newman. Abstract expressionism is often discussed in terms of existential anguish, but Snow's interest remained focused on the formal qualities of these works.

In essence, there are two basic types of abstract expressionism. There are works that highlight "the gesture" and are sometimes referred to as "action paintings." The other variety is concerned with surface and colour values. Snow may occasionally make use of the gesture, but his preoccupation, as argued above, is often with surfaces and how colours interact with each other. In this way, he is closer to the second group. Moreover, Snow's originality resides in his blending of these two types of abstract expressionism, or in the manner of a jazz riff, departing from and then building upon them.

According to Snow: "About my abstract painting and sculpture of 1959–60, several different tendencies were involved, none of which were influenced by specific painters of the New York school. Rather, my works were concerned with the *principles* that certain New York painters were involved in making their paintings."

In *Secret Shout*, Snow deliberately "attempt[ed] to 'frame' or 'tame' gesture" in a way fundamentally different from artists such as de Kooning and Pollock.[6] Here, two black forms capture the eye immediately. The one on the right can be read as the downward shaft of a penis, the one on the left as a vagina that could be penetrated. The blue rocket-like form is both phallic and orgasmic.

FIGURE 26. Michael Snow, *Secret Shout*, 1960.

The two large black forms are gestural in the sense that they are carefully contained on the canvas, although the artist has emphasized their ragged edges. The small shapes at the edge of the canvas focus the action in the centre. The black shape on the right — and its accompanying small black rectangle — are placed into a grid, another way of framing or containment.

(When, as above, Snow employs the word "frame," he uses it in a variety of ways. For example, it can describe a physical frame surrounding a painting. However, the term must also be seen as metaphorical. An artist or photographer can decide what to leave in or leave out of a frame and thus "frames" what he depicts. Jacques Derrida used the term "parergon" to describe a process whereby what is in the frame and what is outside it are intimately related, and that it is necessary to take this relationship into account in assessing a work of art. In a similar way, a piece of sculpture has a frame because it is a construction in which the artist decided what to put into three-dimensional space. In referring to the gesture in abstract expressionism in his own abstracts, Snow was attempting to set limits on what kind of frame he could

impose on such compositions and thus establish his own individuality as an artist.)

Another major abstract, *The Drum Book*, combines finely tuned brush strokes in an arrangement of nine evenly painted rectangles. The cobalt blue is so saturated that it looks black against the yellow background. Fulford suggests that the result looks like the nine blocks are held in by a powerful magnetic field. According to the same critic,

FIGURE 27. Michael Snow, *The Drum Book*, 1960.

FIGURE 28. Isaacs Gallery, 1960: (left) *Blues in Place* (1959); (middle) *Self-Centered* (1960); (right) *Bracket I* (1960); and *Goodbye* (1959) is visible, on the other wall.

Snow, in the exhibition where this painting was first shown, was becoming "more and more intellectual. There is nothing here which could be called, by any stretch of the imagination, 'an action painting.' Indeed, the word 'non-objective' seems almost irrelevant here; there are no 'subjects,' but certainly the painter's stance is close to being an objective one." He adds that *The Drum Book* is "totally formal … a collection of nine rectangles and squares, arranged in a close-to-perfection dynamic tension."[7]

In 1960, at an out-of-town gig with Mike White's Imperial Jazz Band, Snow roomed with the drummer, Larry Dubin. As the artist recalls, "He practised a lot, often just with drumsticks on his knee or a

pillow. He had with him a book of drumming exercises. The layout of a page of illustrations in this book — nine rectangular photos — caught my attention. Back in my studio in Toronto I used this layout as the basis for *The Drum Book*."[8]

In the instance of *Blues in Place*, the name of this work also provides an excellent way of understanding it. The various areas of blue and black can be read as musical notes that form the pictorial equivalent of the blues, that mode of Afro-American jazz that uses a call-and-return pattern. Blue notes (or "worried notes"), usually thirds or fifths flattened in pitch, are an essential part of the sound. Snow was fully aware of this genre from his time in various bands and had a great deal of experience playing the blues in both its melancholic and raucous forms. Such music must be grounded "in place," since they contain notes and passages that diverge markedly from each other to allow improvisation to take place.

On the canvas, the five passages in blue contrast sharply in shape with each other but are held tenuously together by the grid lines that occupy the centre of the composition. Two passages in black contrast with those in blue. The forms at the top and bottom are not connected to this grid; a horizontal shape occupies a space between the middle of the canvas and the right side of it, in what Snow would call a constructed gesture, one that comes as close as he ever does to gestural painting in the tradition of de Kooning and Pollock. This painting can be read as an attempt by Snow to visualize a form of jazz.

The masterful *Lac Clair* is one of the most personal works in Snow's canon. The greens and blues that fill most of the canvas are painted with various levels of intensity and the resultant layers on the surface immerse the viewer in its world. The four pieces of adhesive tape place a border on the inner world of the painting; in fact, they frame it. The result is a contrast between the rich texture of the blues and greens and the prosaic adhesive tape. As in nature, a body of water is enclosed. Lac Clair, the site of the Lévesque family cottage, is where Snow as a child spent many happy moments.

When the painting was first exhibited, Paul Duval labelled it, somewhat dismissively, as "Snow's flat blue area of canvas … unbroken except for four short lengths of brown paper stuck to the corners."[9]

FIGURE 29. Michael Snow, *Lac Clair*, 1960.

Elizabeth Kilbourn, on the other hand, was very appreciative of what Snow was doing. "The two-dimensional quality of the canvas is explored by the simplicity of the medium and calls into play the space around it to complete the image.... By the very allusiveness of the painting, it accretes to itself a new constellation of images."[10]

Although their art shows limited points in common, Snow's career trajectory is similar to that of his near contemporary Jasper Johns, who in 1954–55, in *Flag* and *White Flag*, took contemporary art in a new direction. Like Snow, Johns was concerned with framing and surface. *Flag*, an encaustic, oil and collage on canvas, *seems* to be a reproduction of the American flag, but the heavily textured surface gives it an

eerie, otherworldly presence. The image may look like the American flag, but its surface causes the viewer to consider the nature of what is being represented. This point is made even more strongly in the huge three-panelled *White Flag*, encaustic and collage on canvas, in which the existence of the flag, drained of its traditional colours, gives it the appearance of the ghost of a flag and thus bestows upon it a much more otherworldly presence than *Flag*.

Like Snow, Johns, although he has remained mainly a painter, is relentless in moving his art in new directions. From 1958 to 1961, works such as *Numbers in Color* established him as an artist who not only questioned the use of the abstract expressionist gesture (he sometimes painted in short, delicate brush strokes), but also as someone who displayed a fascination with the synaesthesia that can be established in the use of numbers/letters. He later combined abstraction with objects (including photographs of his face) in the mid-sixties; and there are the cross-hatch and collage-based paintings from the 1980s. Snow's fascination with the surface of a canvas is readily evident in *Green in Green*.

The intersection in the work of Snow and Johns is best discerned in how they interrogate the nature of art and ask many questions about what constitutes a work of art. The other common dominator joining them is the way in which rigorous intellectualism is married to strong emotional commitment. Both foreground ontology, but they each insert a portion of their inner lives into their work. Each has a philosophical turn of mind generated by strong emotional forces.

Another aspect of Snow's work can be foregrounded. The intimate connection between Snow's music and his art is one that Robert Fulford recognized. For him, this artist is a "romantic painter.... Lately this emotionalism has been joined in a work by a special fluidity. Many of his paintings, even the still-lifes, are essays in motion; at times the canvases seem to be caught in the act of changing into something else."[11] In 1958, he observed, when reviewing the artist's second one-man show, that Snow's art was unique "mainly by the fact that so much *happens* in it. His pictures are never still; they move ... in sharp, jerky, irregular

FIGURE 30. Michael Snow, *Green in Green*, 1960.

rhythms. Yet there is never a hasty feeling about them … he manages to assert a style all his own, and this is surely a statement that can be said about only a few abstract painters."[12] Elizabeth Kilbourn voiced a similar opinion: "Like experimental jazz, Michael Snow's work is 'cool.' The classical underpinnings are never denied; the formal structure is firm and sure but [it is] stripped down to the absolute essentials."[13]

For Snow, visual art and music occupied his daily existence. From 1958 to 1962, he had an established routine: he slept in the morning, worked on his art in his studio during the afternoon, and played with Mike White's band in the evening.

From the beginning of his career as an artist, one aspect shines through. Snow is and remains an extremely cerebral artist. Fellow artist Dennis Burton was flabbergasted when his friend confided in him "that he gets images in his mind, creates an image and thinks about it — and while thinking about it, eliminates everything that is not important, ending up with the simplest possible statement he could make."[14] This type of image-making typifies the artist's entire career: in addition to looking with his eyes, he creates intellectually. The push in this direction may have been assisted by his knowledge that his father had lost his eyesight.

CHAPTER SEVEN:
DRAWN OUT

Snow's first solo exhibition at the Greenwich Art Gallery in October and November 1956 included the sculptures *Three Chairs*, *The Table*, and *Metamorphosis — Chair*. Also on display were four nudes à la mode of de Kooning and the monumental, lushly beautiful *Seated Nude (Red Head)*. On that occasion, Robert Fulford claimed that the artist "has a huge capacity to absorb human shapes and reproduce them in significant and moving form. This may indeed be the most impressive of his several talents."[1] Pearl McCarthy, in the *Globe and Mail*, was not taken with what she saw: "Too clever by half and without cohesion."[2]

The two critics were probably responding, in very different ways, to the female figures (two *Reclining Figures*, *Enchanted Woman*, *Seated Nude*, and *Unseated Figure*) done in photo dyes on paper collage on board. (John Martin had introduced this technique to his pupil.)

Photo dyes were intended for use in tinting or colouring black-and-white photos. They were available with the various coloured pigments on a paper backing and were used exactly as one would use watercolours. Inspired by de Kooning and Conrad Marca-Relli, Snow cut out the forms rather than drawing them on canvas. The resulting images may bear more than a passing resemblance to Arshile Gorky's work, such as *Water of the Flowery Mill* (1944), but in technique they look very much like the figurative-abstracts of de Kooning, such as *Gotham News*, or Marca-Relli's *Odalisque*.

FIGURE 31. Michael Snow, *Metamorphosis — Chair*, 1955.

FIGURE 32. Michael Snow, *Colour Booth*, 1959.

FIGURE 33. Michael Snow, *Seated Nude (Red Head)*, 1955.

FIGURE 34. Michael Snow, *Seated Nude*, 1955.

"They [*Metamorphosis, Three Chairs*, and *The Table*]," Robert Fulford, a jazz aficionado, argued, "fit neatly and consistently into the style Snow has lately maintained, a style that is almost never static and implies motion, some sort of motion, in almost every [way, one of these] sculpture[s] contain a special sort of excitement, a kind of refined joy. [*Metamorphosis*] shows a chair that is warped and twisted

69

but still very much a chair. It appears to be in the process of changing into something else — a girl, say, or a bathtub."[3]

Two years later, at Snow's second one-man show, the centre of attention was nine large abstracts; similar canvases were front and centre at the third and fourth solo shows in 1960 and 1961, although some "foldages" were on display at the latter. Snow's abstracts from 1959 to 1961, as discussed in chapter six, are influenced by abstract expressionism and post-painterly abstraction, but he creates very individual responses to those two movements.

Snow's mother always attended her son's openings. A thin, gaunt, and blind Bradley came once to one of the shows at the Isaacs. He came by himself, with his white cane, and walked up to inspect the surface of one of the canvases. Michael told him how touched he was that he had made it to the exhibition. Bradley turned to his son, "That's a nice colour, Brother. Jesus Christ! Fuck!" That moment has always stuck with Snow: the memory of the blind man finding a way to tell his son he admired his work.

At the Isaacs's *Sculptures by Painters* show held October to November 1961, the artist showed *Quits*, *Shunt*, *Window* and *A Day* — the latter is a free-standing ladder-like construction, but the spaces between the various rungs create frames; both *Quits* and *Shunt* inhabit two spaces — like canvases, they inhabit the walls against which they rest, but they also live on the floor.

Window is meant to be viewed from both sides; in this way, it calls attention to its framing while at the same time inviting the viewer to ponder the various elements contained on the ledge of the frame, hanging within the frame, stretching across the frame, and resting on top of the frame. *Window* may be a sculpture, but it also invites being looked at as if it were a double-sided two-dimensional image.

Quits and *Shunt* can be read, in their various ways, as responses to Clement Greenberg's insistence in "Modernist Painting" that every

FIGURE 35. Marie-Antoinette and Michael Snow at opening of exhibition at
the Isaacs Gallery.

form must find an intrinsic way of inhabiting its physical existence.
(The American critic's pronouncements on this score had been articu-
lated in 1961 and were well known to anyone with an interest in con-
temporary art.) A painting had to be concerned with surface values —
its confinement to two dimensions had to be pronounced and had to
privilege surface rather than depicting three-dimensional space. Snow
had already shown such a commitment in his abstract paintings. In the
same way, he realized, sculpture had to do the same. Snow's aesthetics
were congruent with Greenberg's on the relationship between works of
art and two-dimensional and three-dimensional space.

The sculptor Donald Judd was struggling with the same prob-
lem in his work at the same time, although Snow was not then aware
of Judd's work. The American artist created simple, minimalist

FIGURE 36. Michael Snow, *Quits*, 1960.

forms to depict the three-dimensional reality of sculpture. In order to avoid the representational tradition, he wanted his pieces to exist in their own environments, and he fashioned them from geometric forms produced from industrialized, machine-made materials that

FIGURE 37. Michael Snow, *Shunt*, 1960.

removed evidence of the artist's touch. Such sculptures are anti-Romantic in that they remove evidence of the existence of their creators and move away from the kinds of representation that had dominated sculpture.

Later, Snow came to admire Judd's work, but the similarities between the two remain limited to the fact that both were trying, in different ways, to construct sculptural objects that allude simply and directly to their physical existences in space.

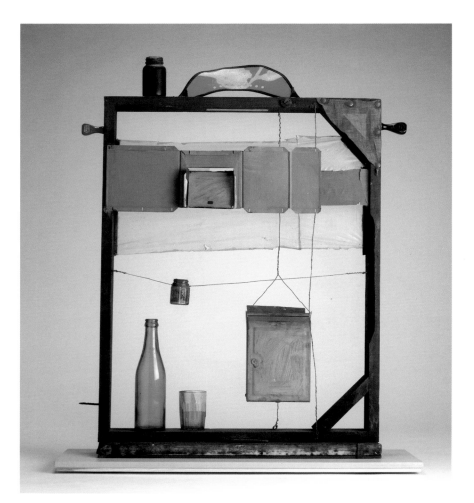

FIGURE 38. Michael Snow, *Window*, 1960.

Using similar ideas but with different results, Snow created in *Quits* and *Shunt* sculptures that join the wall to the floor (or the floor to the wall). In another similar subject, *A Day*, the framed spaces in the "ladder" invite comparison to traditional two-dimensional picture areas, while at the very same time this construction is the abstract three-dimensional form of a ladder.

Snow also found a way to make *sculpture-like* works in his foldages. From 1936 to 1954, Matisse made a wide assortment of cut-outs, or as he put it, "carvings into colour." The results are textured because some

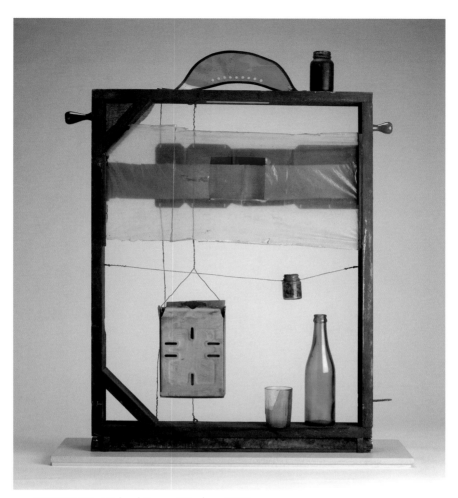

FIGURE 39. Michael Snow, *Window*, 1960.

pieces of paper are glued on top of others. In 1960, the Hungarian-born French artist Simon Hantaï began making his own *pliage* (folding). Although there is some connection between the work of those artists and Snow's foldages, in truth, his work bears little resemblance to theirs.

In the eyes of Robert Fulford, the foldages were an important breakthrough for the artist:

> The form is a sort of painting-and-sculpture com-
> bination — painting, because it is framed and because

FIGURE 40. Michael Snow, *Blue Monk*, 1960.

paint is used; paper, because the paper juts out from the basic surface. The most important aspect of all this is that it introduces into Snow's work an element of romantic fantasy that has rarely appeared before. In a sense, it throws together and synthesizes all those elements — intellectual, comic, sensual — which have been important in Snow's painting and drawing up to now.... [In these works] Snow is reclaiming and asserting the values of adult play in art.[4]

Snow moved easily between figurative and abstract work, between painting and sculptures/foldages. Done at the very outset of his career, for example, *Colin Curd* and *Blue Panel* are masterful opposites. Then there are the figurative nudes constructed with photo dyes on paper collage on board. These were followed by the sculptures of tables that seem to exist in a state between the inanimate and the animate. Some of the paintings of tables and chairs from 1957 are

FIGURE 41. Michael Snow, *Table Life*, 1954.

FIGURE 42. Michael Snow, *Drawn Out*, 1959.

FIGURE 43. Michael Snow, *Drawn Out*, 1959.

representational (*Table and Chairs No. 1*); others have more abstract existences (*Table Life*).

Drawn Out (1959) is a series of portraits done at the same time as the abstracts *Notes from the Underground* and *Blues in Place*. Inspired by a newspaper photograph of James Grierson, a convicted murderer, Snow made twenty-one charcoal drawings of his subject, depicting him using a variety of approaches: representational, cubist, cartoon-like, and so on. There is an additional drawing of the victim. The title is, of course, a pun: one photograph has been drawn out to twenty-one drawings.

Snow later recalled that he went through periods of "try this, try that,"[5] and his successes came in a wide variety of ways. The sculptures *Quits* and *A Day* are ladder-like constructions, whereas *Shunt* is more abstract. The foldages *Blue Monk* and *Blews* are abstract, whereas the foldage *White Trash* is slightly more representational.

Years later, reflecting on Snow, Fulford remembered he found the artist "stimulating but also frustrating: he wanted attention, but he didn't want to be entirely understood. He knew that critics were essential in some way, but he didn't trust our assumptions that we could tell the public what was going on. 'I'm interested in doing something that can't be explained.'" Fulford also correctly placed the abstract paintings in perspective: "The habit of most artists, as abstract painting grew popular, was to show together some fifteen or twenty paintings on the same theme. [Contrary] to this, Snow was capable of producing a dozen paintings that reflected a dozen different ideas."[6]

Often overlooked in assessing Snow's early career is his brief flirtation with Marcel Duchamp and Dada. In the spring of 1961, Joyce and Michael, along with the Dada scholar Michel Sanouillet, travelled to London, Ontario, to participate, at the invitation of the event's instigator, Greg Curnoe, in Canada's first "Happening," held on the second floor of the London Public Library and Art Museum, an event that left the venue in shambles. This Dada-inspired show was followed by the Dada exhibition that ran at the Isaacs Gallery from December 20, 1961, to January 9, 1962.

FIGURE 44. Michael Snow, *Blews*, 1960.

This show, organized by the artist Richard Gorman, included work by Curnoe, Burton, Gorman, Wieland, Arthur Coughtry (the photographer brother of Graham), Rayner, and Snow, who contributed nine pieces: *Newspaper, Window* (apparently the only piece by Snow surviving from this exhibition), *Cézanne, Moe Lester Scholarship, Walking Woman, Fifty Dollars* (this piece of currency was for sale at seventy-eight dollars), *Thelonius Monk at the Blackhawk, Bag-Walking Woman,* and *Central One Hour Cleaners*. In retrospect, Snow feels that the only major work of his that can be linked directly to Duchamp or neo-Dadaism is *Window*, where the pieces in and surrounding the frame are found objects.

The spirit of creative energy and freedom of Duchamp and Dada may have fascinated Snow, but he did not, like Curnoe, create work directly from such influences. In a very general way, however, his art,

FIGURE 45. Neo-Dada show. 1961. Av Isaacs is seated in the centre with a flight attendant standing next to him. On the floor are, from left to right, Greg Curnoe, Joyce Wieland, and Michael Snow. Standing, left to right, are Dennis Burton, Richard Gorman, and Arthur Coughtry.

like Duchamp's, was in the service of the mind, as opposed to the purely "retinal" art, intended only to please the eye, which the French artist castigated. What Duchamp inspired in Snow was a commitment to exploring the intellectual underpinnings of art and to questioning accepted notions of what constituted a work of art.

Of central importance to the neo-Dada exhibition in Snow's career were the first showings of two now-lost *Walking Woman* (hereafter WW) figures: *Walking Woman* and *Bag-Walking Woman*.

CHAPTER EIGHT:
A LOT OF NEAR MRS.

The WW figures emerge from various parts of the artist's practice. He wished to move forward from the "surface" abstracts painted between 1959 and 1961; he also wanted to return to the figurative tradition. For him, abstract expressionism had become a blind alley. One day he constructed a cut-out of a figure jumping out a window and the space that left set an idea glimmering. He began to puzzle out ways of painting within this contour. He puts the process this way: "Depending on how you look at it, a shape can sometimes appear to be going deeper into the painting, like a hole, or it can appear to be coming out of the canvas. I was noticing these things in my abstracts and I got the idea to experiment with works that were just figures."[1]

From 1953 to 1958, representations of the female nude form constituted a significant part of Snow's output. The artist's amorous sensibility can be glimpsed in a text he wrote in 1958, "Something You Might Miss," which begins, "There's this place in women or some women I guess…. Imagine a woman (any woman or possibly one you know) with no skirt on (I hope I can make this clear) at the very top of the legs *between* each leg the start of the body."[2]

Seated Nude (Red Head) from 1955 is both sensual and sensuous. There is a luxuriant feeling to this canvas that was first exhibited, shortly after it was completed, at the CNE in August–September 1955; the artist then submitted it to The Winnipeg Show at the Winnipeg Art Gallery that November. Much more sumptuous in its use of colour

than either *Reclining Figure* or *Seated Figure*, it is also more representational than those other two works and much less de Kooning–like. Dennis Reid describes the work:

> the woman seems over life-size "as she swells up to almost fill the canvas, her opalescent body the sheen of mother-of-pearl, her wiry red hair vibrating in contrast to the green upholstered chair. Then the force of that presence begins to take over. That it is a physical presence is underlined by the lack of facial features, by the lack, in fact, of all but the most rudimentary articulations of the details of the body. The blend of pulsating pinks, blues, peaches, greens, yellows and whites that appear to hover like a local atmosphere off the surface of the body seems to absorb our gaze."[3]

Thinking back to the figure collages he had made in 1955 that were inspired by Conrad Marca-Relli and de Kooning, he realized that the WW is "the daughter of these early collages as it was cut out of cardboard using the same type of 'mat' or 'Exacto' knife as the collages and 'drawing' the same kind of forms."[4]

In 1961, Snow created the collage *January Jubilee Ladies*. It was then, as he recalls, he realized that he could cut out a complete figure-shape that did not have any background. This realization about the form of the WW may have also come to him in part when he was working on *Seated Nude (Red Head)* in 1955.

The WW is, like *Red Head*, both representational and abstract. There is a clear distinction in this oil between the nude and the background from which she emerges, and the original WW figure is cut out from cardboard.

Snow has a vivid recollection about the origins of *January Jubilee Ladies*: "In 1961, I reconsidered [some earlier collages] … and in a [reminiscent] mood made *January Jubilee Ladies*, a somewhat Matissean collage in which I used paper I found in my studio, a former storage space for a retail store. The title was written on one of those pieces of paper."[5]

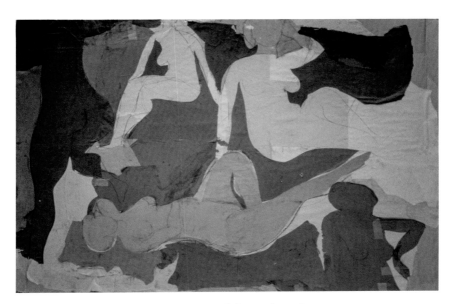

FIGURE 46. Michael Snow, *January Jubilee Ladies*, 1961.

This huge collage contains a wide variety of colours — red, blue, white, various ochres. It does not resemble Matisse's cut-outs as much as it recalls, as Dennis Reid suggests, Picasso's *Demoiselles d'Avignon*.[6] The sensuousness of the floating female forms and the deliberate crudity in the use of collage bestow upon this monumental work sexuality reminiscent of the Spanish artist's celebrated rendition of the five prostitutes. There is the strong possibility that Snow was alluding directly to Picasso's masterpiece, since Snow's gouache-collage contains five female figures and the spatial arrangement of the women in each painting is similar.

This is the background to the WW. Snow made some cardboard-cut figures (one was of a jumping woman). Then, one day, he drew a figure of a walking woman on a 152 x 228 cm cardboard rectangle and then cut the figure out with a mat knife. He realized that "both the positive figure and its negative shape were repeatable, that one could draw or paint around the shapes to make 'a copy.'"[7] At first the "reproductions" were of the 152-centimetre-tall positive figure and its negative outline.[*] Then came variations in different sizes and formats.

[*] A bit earlier, Snow had made a series of images of the same face in *Drawn Out*.

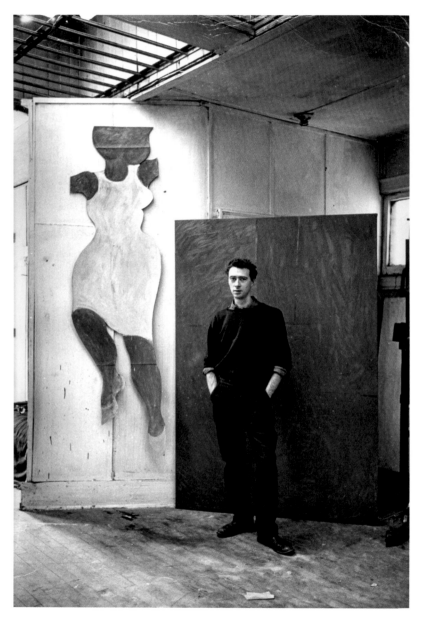

FIGURE 47. Michael Snow with a jumping figure cut-out and *Green in Green*, 1962.

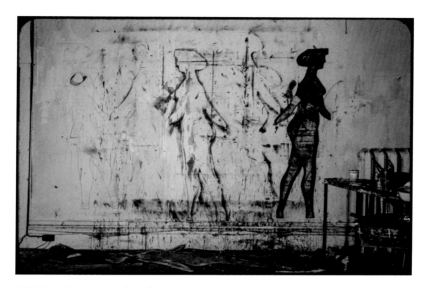

FIGURE 48. Original *Walking Woman* cut-out on Michael Snow's studio wall, 1961.

In most of these works, the WW figure is framed: the top of her head is sliced off, her feet are not represented, and parts of her arms are not visible. These sharp edges stylize the WW and remind the viewer that she may participate in the representational tradition but that she is — and remains — an artifact upon which various surfaces can be imposed. She may well reference Marcel Duchamp's *Nude Descending the Stair No. 2* (1912), which is a depiction of a woman walking.

In discussing a WW figure, Snow always references it as an "it," "because the Walking Woman is a cut-out, not a woman. It may be the representation of a female form, but it's not a woman." He is also quite clear why the hands, feet, and top of her head have been lopped off: "It seems more a doll when all the parts are there. The cropping indicates that it's come out of a rectangle. I like that it shows that the cut-out has a relationship to painting and drawing; that it's been extracted from a two-dimensional object and placed in a three-dimensional world."[8]

(During a visit to Snow's studio, Don Franks, the host/narrator of *Toronto Jazz*, grabbed a *Walking Woman* cut-out, turned her on her side, and then, strutting, made her into a guitar. The artist, startled by this gesture, laughed good-naturedly at Franks's improvisation.)

This movement between dimensions is something that Snow explored in the photographs that he took of WW. At the time, Snow was not aware of any other artist such as himself making photo work. *Four to Five* came about, as the artist recalled, from "placing a black silhouette Walking Woman, a two-dimensional representation, in the three-dimensional world in order to make black-and-white recordings of its placement in various locations [at bus stops and in the subway in Toronto] in relation to other people and objects in view."[9] He was putting a two-dimensional form into the three-dimensional world and then returning the object into a two-dimensional photograph. In this way, the WW leaves the confines of a gallery and wanders into the real world. A bit later, she would star in a film.

Years later, in 1994, Snow recalled the inner buzz generated by his new creation:

> In [its] background is this looming achievement of the history of painting, and I wanted to add to it. In a way, artists have designed characters or types — there's a Renoir, a Modigliani.... I wanted to continue that. I wanted to make a subject for my work, and then make my subject known to people. I wanted it to be part of the scene, anywhere people walked. It was Duchamp in reverse — not found works, but lost works. It was pretty radical.... It occurred to me to make a figure that was just a figure.[10]

His mind, he recalled, was jumping.

Snow's last show before leaving for New York late in 1962 was at the Isaacs, and ran from March 15 to April 3. It was devoted to thirty WW in various formats. In beholding this powerful assemblage, Fulford wrote an extremely sympathetic review that showed he had a clear understanding of where Snow was going:

> Snow's paintings have rarely shown recognizable objects or persons, but for this series he has created a

FIGURE 49. Michael Snow, *Four to Five*, 1962.

central image that is both arresting and puzzling. His silhouetted woman is vulgar, like a cardboard figure standing outside a burlesque house, or a character in an old-fashioned comic strip. She exists in two dimensions only; there is not even a hint that she might have substance.

This is a clue to the artist's intentions. He apparently wanted, for these pictures and assorted curiosities, an image that would remove his work from total abstraction and yet not interfere with the picture making which is his real purpose.... The result of this unusual activity could be called abstract-painting-which-is-not-abstract painting. It has the impersonality, the objectivity, of the abstract picture; but on the other hand, there is the figure, large as life.[11]

In an essay written two years after the appearance of the first WW, Snow reflected on what he was trying to achieve. He linked this series to his abstracts from 1959 to 1961: "Process as subject in Pollock, De Kooning." He also made explicit how process dominated his thoughts.

In fact, one of the best ways to understand the WW figure is to follow Snow's lead when, on reflecting on the WW's various manifestations, he insisted that he did not believe in representation. But then, he realized, a viewer looks at a WW and thinks: "It's a woman!" However, the vehicle or "material" (cut-out, canvas, sculpture) in which the figure is confined may well be a "representation in its own right." We must, therefore, he insists, "believe that it is. My 'subject' is the same in the '59 and '60 abstract paintings and sculpture, but now it is acted."[12] Despite his best efforts to avoid traditional representation, Snow is conceding that the various WW can be appreciated as figurative pieces of art.

The "acting" should allow a viewer to appreciate how the stylized figure is a perfect vehicle for all kinds of formalist inventions. The various WW were also inspired in large part by the infinite variety of improvisations that can be created by the twelve-bar blues, one of the most prominent chord progressions in jazz.

Venus Simultaneous (1962) — oil and Lucite on canvas, cardboard, and plywood — contains seven WW and is perhaps the work that most clearly brings together the various sides of Michael Snow the artist before he left for New York City. One WW cut-out is positioned in front of the irregularly shaped canvas — like some early Snow sculptures, she inhabits the wall but her feet reach down toward the floor (the yellow passage at the very bottom of this piece provides her with light and space but also adds an abstract touch); a WW outlined in black against black shadows her; the top of the head of one WW juts out of the canvas; the figure on the left occupies positive and negative space; the outline of another juts out to the right; the blue WW on the right part of the canvas is complimented by the black-outlined blue on the left; the strong but carefully controlled blue and black brush strokes applied to all the figures and on the canvas are reminiscent of how Snow painted his abstracts from 1959 to 1961. This cut-out, sculpture, and oil piece displays much of what the artist had accomplished at an early age.

FIGURE 50. Michael Snow, *Venus Simultaneous*, 1962.

This major early work clearly shows that form takes precedence over meaning *because the form of a work of art is its meaning*. In this sense, form is eternal; meaning becomes variable. Here, there are manifold meanings because there is an abundance of forms. In commenting on the complexity of the *Snowgirl* that "absorbed" him, Fulford pointed out that its ambiguities summed up Michael Snow: "[T]he use of shallow, varying space; the play of light and shadow; and the nervous, restless activity of his art, exemplified in this case by a painting which seems to be on the point of turning into sculpture." But, he also maintained, Snow was determined to be a difficult artist: "He never stands still long enough to be acceptable. Whenever you believe you know all he has to say, he quickly changes the conversation. He is that kind of painter; the best kind."[13]

For Fulford, Snow was an intellectually restless man. Someone, who like the *Walking Woman*, was always in motion. The same critic dubbed him *the* Toronto Artist. In 1962, Snow was exactly that. However, although he had accomplished a great deal, he remained uncertain what the future held for him. He was absorbed by the WW and its wide

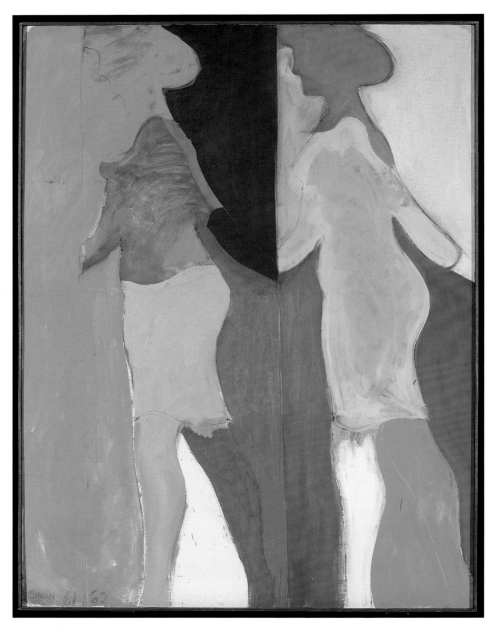

FIGURE 51. Michael Snow, *61-62*, 1961–62.

FIGURE 52. William Ronald, *Ancient Sky*, 1955.

variety of forms, but — despite any impression he gave to the contrary — he was not completely sure of himself. He considered moving to New York City, although he was well aware that the finest achievements of abstract expressionism and post-painterly abstraction were in the past. He knew that minimalism was on the rise there and that pop art had from the late fifties been the new Manhattan-based "ism."

He wanted to become a better artist, and he wondered if living in New York City would help him achieve that goal. William Ronald had enjoyed tremendous success when he moved there and was taken on in 1957 by the prestigious Kootz Gallery. Snow would have known that although Ronald's rise had been meteoric, his sales had plummeted by 1962.

Snow felt that all his fellow artists in Toronto — with the exception of Rayner and Wieland — were simply, from a safe distance, observing what was happening in New York and then making weak imitations. He came to the conclusion that the environment in which he existed was provincial. If he wanted to make strong art on a large scale, he needed the kind of excitement New York could provide. Inspired by Marcel

Duchamp's dictum — "Make the contribution you think you can make" — he decided that to do the finest work of which he was capable he had to move.

Joyce and Michael had visited Manhattan many times since their marriage — mainly to hear jazz and attend shows at museums and galleries. She did not wish to move to New York, but, realizing that Michael was seeing other women in Toronto, she did not wish to let him loose apart from her. "It scared me to go," she said, "because I was comfortable [in Toronto], and I wondered what would happen to us there. I was excited but scared." Michael told her that he was certain "he would get really good there if he went there. He just felt that's where he should be."[14] And so in the autumn of 1962, the couple moved to the States.

CHAPTER NINE:
SURVEYING

In 1962 Snow closed the book on his early career. In 1970, eight years after leaving Toronto for New York and one year after he had returned to Toronto, forty-two-year-old Snow was given a retrospective at the Art Gallery of Ontario: *Michael Snow/A Survey*. Many examples of his work up to 1962 were obviously featured in the exhibition and in the catalogue that the artist designed. WW figures created from 1963 to 1967 were included, as were stills from his film *Wavelength* (1967) and sculptures from 1967 to 1969.

The catalogue, however, is dominated by pages that are (or look like) family album photographs, nineteen show images of Chicoutimi, Bradley Snow, Marie-Antoinette Lévesque, Denyse Snow, Elzéar Lévesque, various ancestors, and the bridges Bradley constructed in Chicoutimi. Even more curious is the fact that the front cover shows the Lac Clair cottage — inside the catalogue are five more exterior photographs of the same building. (All the photographs of the cottage were taken by Snow, and he intended them to act as chapter headings.) The water surrounding the island on the front cover is matched on the back cover by the view of the photograph of water — taken by Snow in New York — that ends *Wavelength*.

Inside the catalogue are three pages displaying the sculpture *Blind* (1967); immediately following is a full-page photograph of a text in Braille. The last image in the catalogue — a photograph taken on

property owned by Roberto Roig, then Marie-Antoinette's partner — shows a deserted swimming pool that has been overtaken by weeds. Above the pool is a metal staircase, one half of which is missing.

In constructing and ordering the catalogue, Snow, in a very Proustian manner, is reminiscing on things past. In one opening, the Lac Clair cottage sits beside *Blind*, as if the artist is referring to his mixed heritage. On the final page of the catalogue, there is a photograph of a bridge that leads nowhere, a wrecked swimming pool, and a weed-infested landscape — time conquers all things. The artist, however, has internalized the past and in time-present makes it live again. He has travelled from the childhood innocence of Lac Clair to the experience encapsulated in the catalogue's final illustration.

The photographs of the cottage on the island have a romantic tinge to them and recall Courbet and Turner's treatments of the fabled castle on the water in Chillon near Montreux, Switzerland. The Lac Clair cottage dominates the catalogue because there Michael Snow came into being as an artist.

Becoming an artist is sometimes not an option — it is a choice made by inner forces. When Michael Snow discovered he was destined to become an artist, a change in character ensued. No longer wondering what he wanted to do with his life, he knew that art was his life. When that insight came to him, he searched for reasons why this particular destiny had been bestowed upon him, and he realized that, to a large extent, his gifts had been given to him by his parents and his ancestors.

FIGURE 53. Michael Snow, spread from *Michael Snow/A Survey*, 1970.

FIGURE 54. Michael Snow, last page of *Michael Snow/A Survey*, 1970.

PART TWO
1962–1970

CHAPTER TEN:
COOL CITY

From first-hand experience, Snow knew that New York City was a much more frenetic place than Toronto. By 1962 Manhattan had conquered the art world through abstract expressionism and, in many ways, had triumphed over Paris as the centre of contemporary art. Although the abstract expressionism and post-painterly abstraction no longer had the status they once enjoyed, many abstract artists remained there. The new idioms were pop art and minimalism. This was not of concern to Snow because he was simply looking for a different urban milieu, one that would energize him. He had no set agenda regarding how he wished to develop as an artist.

Apart from its place as the centre of visual arts, Manhattan held other attractions for Michael. He was especially drawn to the city since it was the centre of experimentation in various idioms of jazz, and that part of the city's cultural life had been the real draw when he and Wieland had visited there in the early sixties.

Not only did Manhattan have a vital arts scene, the city was a place of political euphoria — the election of John F. Kennedy in 1960 had provided a boost to it. Many of the city's residents thought of themselves as liberals, and a sense of new beginning after the dreary Eisenhower years infiltrated the metropolis. In every possible way, New York was exciting, especially in comparison to sedate, Anglo-Saxon Toronto.

Of course, New York had an almost unparalleled number of public museums and galleries that featured works of contemporary art. In addition to the Museum of Modern Art and the Whitney, there was

the sensational and controversial Frank Lloyd Wright version of the Guggenheim Museum: "that spiraling drumroll of a museum, with its surprising mix of buoyancy and weightiness had an immediate iconographic power … you could feel the power in" that building.[1] Then there were the private galleries — lots of them in comparison to Toronto. Snow could see a lot of modern art, and he could visit the premises of the dealers to find a suitable one for himself.

In the 1950s, a new Manhattan had even emerged in architecture. Many of the buildings that had been constructed using the precepts of beaux-arts neoclassicism or touches of art deco had been replaced in the midtown thoroughfares by sleek, stark, glass-fronted and air-conditioned skyscrapers. This was New York modern, the place where anything could — and often did — happen.

Then there was the music scene. Until about 1955, bebop had reigned supreme in jazz. And then varieties of "cool jazz" emerged and proliferated. Earlier jazz had employed harmonic progressions and chords whereas the new jazz used "modes" as a way of focusing on melody. As a result, this new music allowed a new sense of space and freedom to emerge. Snow, as can be seen in *Toronto Jazz*, was well aware of what was happening in the jazz world and responded positively to this new sound, but the centre of that world was Manhattan.

Before leaving for the States, Snow decided he would not seek part-time work as a musician. Still, the new sense of experimentation in the jazz world beckoned him, almost as if he knew it would contribute to the type of artist he wanted to become. One friend, David Lancashire, lamented this decision: "You should have heard him in the forties and fifties. He was extraordinary. There's no question in my mind that Mike would have been one of the world's great piano players. But I think he deliberately sacrificed that for painting."[2]

Overall, Snow sought an environment that would challenge him, force him to transform himself into the best possible artist. He wanted to put himself to the test, imagining his new surroundings would give him the opportunity to pit himself against other highly talented, ambitious, and risk-taking individuals. He was open to change, anxious to forge his destiny in a way that had evaded him in Canada.

Settling into New York City was not an easy task. The going rates for rents were staggeringly high, especially for two Torontonians who were not working at other jobs. At first, Michael and Joyce stayed with Betty and Graeme Ferguson at their large Upper West Side flat at 924 West End Avenue near 105th Street. Four years earlier, the Fergusons had moved there from Toronto when Graeme found work as a free-lance filmmaker.

The stay with the Fergusons was not only convenient and financially beneficial, it was also one that affected them emotionally as a couple. Both Michael and Joyce were entranced by the Fergusons' son, Munro, who, according to family lore, was the reincarnation of the Dalai Lama. Snow played word games with Munro. Inspired in part because of her devotion to Munro, Joyce, in December 1962, had herself retested for tubal insufflation — a process that was supposed to determine if her Fallopian tubes were blocked.

The Manhattan to which Snow and Wieland moved had changed a great deal since the legendary, brawling encounters of Pollock and de Kooning at the Cedar Tavern. Snow, who was not a heavy drinker, occasionally visited the new in-spot, Max's Kansas City at 213 Park Avenue South, where Andy Warhol and his entourage controlled the back room. Donald Judd, Larry Rivers, and Philip Glass could often be seen there.

Snow and Wieland tried to take advantage of all that New York City could offer. They attended performances by the John Coltrane Quartet, became devotees of the dance performances of the minimalist artist Robert Morris and his wife Simone Forti, and attended openings of galleries such as Leo Castelli's.

By the spring of 1963, the couple had rented a loft for fifty-five dollars a month at 191 Greenwich Street in Lower Manhattan. Such occupancies were banned — the landlords were acting illegally in renting such properties and the tenants were also breaking the law by occupying properties in extremely substandard conditions. In every way, the living accommodations were spartan — there was no heating and no plumbing. The couple reconnected the existing plumbing, which allowed them to install a sink, toilet, and shower; they also tapped in to electricity lines. The walls were bare brick; there were large windows

at both ends of the long living space; the stove was an ancient coal one. The furniture consisted of castaways found on the street.

Despite the apartment's terrible conditions, it had not been easy to get. In order to convince the landlord that she and her husband were hip, Joyce claimed that Michael played the piano like John Coltrane played tenor saxophone. Of course, there was no piano in the apartment. However, various WW inhabited the loft: Michael constructed a coffee table in her shape, stencilled her on the white enamel cupboard door next to the stove; she was imprinted on the wallpaper, drapes, and kitchen table. Michael's studio was on another floor; one end of the loft was Joyce's.

The neighbourhood was sketchy. The couple were a bit taken aback when a burning mattress was thrown out a window onto the street. However, they soon settled in. They discovered a lucky sign about the place: a small sign outside the building indicated that Steve Swallow, the jazz bassist and composer, apparently lived there on the first floor (he had left by the time Michael and Joyce occupied the apartment above). As a result, Michael named his studio "Swallow Studio," and used that as a mailing address until there was concern the electric company would investigate the space thoroughly to discover why none of its invoices had been paid.

Settling into New York was not too difficult emotionally for Michael, although he was later completely taken aback by Kennedy's assassination: that "death obviously floored me," he told Av. "It is if all the air had been taken away. It's hard to describe how he created the environment in which we were living. The whole situation is fantastic. I've never experienced anything like the last few days."[3]

Michael and Joyce became friends with their next-door neighbours, Paul and Jo Haines, with whom they listened to jazz recordings and smoked pot. Joyce became sufficiently close to Jo to tell her that she desperately wanted a child but had experienced great difficulty in becoming pregnant.

After one or two years on Greenwich Street, the couple moved into a twenty-four metre, third floor loft at 123 Chambers Street, an industrial area just west of city hall. The space they took over was filled with ships' gear, perhaps the leftovers from a chandler's shop marketing

such items. Similar to their previous abode, their new residence had no plumbing, gas, or electricity. Friends wired the loft and tapped gas lines to make the place inhabitable. Makeshift plumbing was reconnected by two men doing this work in order to eke out a living: the sculptor Richard Serra and the composer Philip Glass.

There was a living area at one end of the flat. Since this new space was illegal, a peephole was installed so that they could scan who was at the door. The couple carried their garbage several streets over so that no such telltale evidence revealed their presence. Years before, Willem and Elaine de Kooning had taken similar steps to evade detection.

One evening, the lights in the loft began to sputter. Afraid that he and Joyce had finally been caught using electricity illegally, Michael looked out the window and saw no sign of any kind of law enforcement officer. He walked out to the street and saw lights spluttering everywhere. Then total darkness. This was the Big Blackout of 1965.

To keep financially afloat, Michael worked from time to time for a low-rate firm of movers managed by Serra; the other labourers included Glass, the musician Steve Reich, and the artist Chuck Close. Michael had largely abandoned playing in a band when he arrived in Manhattan but took the odd gig. He stopped completely after a New Year's Eve party where the audience hated the musicians and the musicians disliked each other.[4]

Living across the street was Roswell Rudd, a trombonist, who played the new "free" music, although his background was in Dixieland. "Roswell was broke and wanted to sell his piano. I bought it for 50 bucks and moved it into my loft." Michael then allowed the trombonist and his group to play at his place. There were many sessions there (with, among others, Paul Bley, Archie Shepp, and the Jazz Composers Orchestra), although Michael did not play with them because he was unfamiliar with their kind of music. "I would only try to play after a session was over."[5]

CHAPTER ELEVEN:
EYE AND EAR CONTROL

In addition to pursuing their own artistic practices and soaking up a great deal of jazz, Joyce and Michael shared a strong interest in film. Wieland's taste was much more eclectic than her husband's: he tended to be interested in film as process whereas she enjoyed traditional narrative film, albeit those with experimental edges such as Resnais's *Last Year at Marienbad*. In 1953, she had made her first film, *A Salt in the Park*, in which she performed a Lillian Gish–type role.

While considering their move to Manhattan, the couple had stayed with Bob Cowan, a filmmaker and friend who was heavily involved in the independent film movement. The Toronto-born Cowan, two years younger than Snow, had attended UCC and OCA; William Ronald had convinced Cowan to move to Manhattan, where he studied painting with Hans Hoffman. Gradually, Cowan shifted his attention to the new experimental filmmaking in his adopted city.

Once Snow and Wieland were settled in the city, Cowan introduced them to George and Mike Kuchar, teenage twin brothers who were both experimental filmmakers; Cowan had been in a Kuchar film. Later, Michael and Joyce met Ken and Florence Jacobs, who often screened films at their apartment. When the Jacobs moved to Chambers Street, the couples became good friends.

Their mutual preoccupation with film — and their new circle of friends who were similarly committed — led the couple in the

direction of the underground films being made and discussed in New York City. Soon afterward, they were drawn into the orbit of Jonas Mekas, the Lithuanian-American correctly dubbed the "godfather of American avant-garde cinema." In 1949, he had immigrated to the United States, purchased a Bolex 16 mm camera, and begun to record key moments in his life. He came upon avant-garde cinema at Amos Vogel's Cinema 16 and then began curating such films at Gallery East and the Film Forum. In 1954, he founded the periodical *Film Culture* and four years later began writing his "Movie Journal" for the *Village Voice*. When Michael and Joyce arrived in New York, he had just become one of the founders of Film-Makers' Cooperative. Charming, knowledgeable, and feisty, Mekas was *the* experimental film go-to person in Manhattan in 1962.

The type of cinema that fascinated Mekas can be said to originate with the Russian Dziga Vertov's *Man with a Movie Camera* (1929), a film about perception. Vertov labelled his technique as accessing his "cine eye." Through his viewfinder, he saw space and perspective and movement in a revolutionary way.

In his columns for the *Village Voice*, Mekas attempted to make a link between commercial films experimental in nature (as seen, for example, in the work of Resnais, Godard, and Antonioni) and the films of the American avant-garde. This was no easy task because American audiences wanted to go to the "movies" — and most film critics chose to review only those works that corresponded to mainstream tastes. Mekas thought that viewers and critics should cast their nets wider. What about, he asked, films that could be compared on equal terms to serious works of literature?

> I don't think a responsible movie critic can go by people's definition of cinema. That's why I go back to the underground. I know that the majority of you cannot see this cinema; but that is exactly the point: It is my duty to bring this cinema to your attention. I will bark about it until our theatres start showing this cinema.[1]

At this time, the dominant strand in advanced cinema was of a Romantic tinge that can be glimpsed in the work of Stan Brakhage, one of the premier American experimental filmmakers. He worked in a self-expressive manner:

> The lyrical film postulates the film-maker behind the camera as the first-person protagonist of the film. The images of the film are what he sees, filmed in such a way that we never forget his presence and we know how he is reacting to his vision. In the lyrical form there is no longer a hero; instead the screen is filled with movement, and that movement, both of the camera and the editing, reverberates with the idea of a person looking.[2]

For Snow,

> Brakhage was very influential in a kind of clarifying way, because I wanted to not do what he was doing…. Of his work, I thought, he's a great filmmaker, [but], in some ways, too personal and expressionist. I thought that the machine-ness of the camera ought to be stressed, not negated. What he did was very diaristic, personal — and I think it's great, what he did, and that was a very avant-garde thing to realize that films don't have to be made by a crew with a 35 mm. camera. Stan wasn't the only person who did that, but that's what experimental film was founded on — that one person could do it. And Stan was definitely the leader. [3]

Previously, much of Snow's attention as an artist had been on "surfaces." Now, he became fascinated with film as a form of artistic exploration in which the thin moving surfaces of celluloid allowed him to explore the idea of duration, of how things both exist and non-exist in time. Since he was focusing on surface in the various WW figures, it is

appropriate that she appears in *New York Eye and Ear Control (NYEEC)* (1964); here the WW figure becomes a leading lady. Earlier, in a similar vein, she had been the centre of the photo series, *Four to Five*.*

In part, the inspiration for *NYEEC* came from Marcel Duchamp. "Rather than choosing and taking a 'ready-made' from the 'world' and putting it in an art context, I made a 'sign' from within the art context and put it in the world."[4] When Joyce and Michael visited Marcel and his wife, Teeny, in their Manhattan apartment, the Frenchman agreed to appear briefly in *NYEEC*.

In addition to showing the WW in a number of locations, Michael, in *NYEEC,* placed the figure in a series of environments in which she does a variety of things: sometimes, she is a ghostlike *genius loci*; in other situations, she is perceived as an outsider by the humans who encounter her. Of course, she is a flat, thin quasi-sculptural cut-out — a two-dimensional being in a three-dimensional world. As such, she is a sort of alien creature. That is part of the point — the worlds of art and of ordinary human life are separate spheres of existence. On the surface of the cinema screen, however, two- and three-dimensional forms can become equals.

Another central component of the film is the soundtrack. Snow sought out the controversial Albert Ayler, recently returned from Europe, to record it. At first glance, this is a strange choice, since Ayler's discordant, strident, cacophonous sound is constructed from whole timbre rather than harmony and melody. However, that is precisely why he was chosen.

The challenging soundtrack adds an essential layer of meaning because it emphasizes the uneasy tension between art and life that is at the heart of the film. Snow recalls, "One of the elements in the story is the length of a very strong, very vocal, very spontaneous, almost wholly 'emotional' music."[5] The result was exactly what the artist hoped to achieve: "I wanted [the music] to co-exist with the images of the black-and-white silhouette *Walking Woman*, shot from mostly fixed camera positions in many different locations. 'She' was static, though depicted as walking: a stand-in for real women who, in a sequence in the film,

* There are two other early WW films: *Little Walk* (1964) and *Short Shave* (1965) made after *NYEEC*.

FIGURES 55 AND 56. Michael Snow, two stills from *New York Eye and Ear Control*, 1964.

were imaged through and behind the negative cut-outs of the walking figure. In this 'movie,' most of the motion is in the music." Since the film was edited with no reference to the music, the result is an improvisation. The film's first audience was appalled — many walked out.

As is usually the case with Snow, he is careful in his use of words. "Control" refers to his conscious decision to place sight and sound *against* each other. He put it this way, he was simultaneously juxtaposing "two different animals."[6]

Michael and Joyce's closest friend in their film world was Hollis Frampton. The couple were never introduced to the photographer, but they came across him at several film events. At this point, Frampton was a still photographer, not a filmmaker.

Frampton's quirky view of the world can be seen in some passages of autobiography.

> I was born in Ohio, United States, on March 11, 1936, towards the end of the Machine Age. Educated … in Ohio and Massachusetts. The process resulted in satisfaction for no one. Studied (sat around on the lawn at St. Elizabeth's) with Ezra Pound, 1957–58…. Moved to New York in March 1958, lived and worked there more than a decade…. Began to make still photographs at the end of 1958. Nothing much came of it. First fumblings with cinema began in the fall of 1962; the first films I will publicly admit to making came in early 1966. Worked, for years, as a film laboratory technician….
>
> In the case of painting, I believe that one reason I stayed with still photography as long as I did was an attempt, fairly successful I think, to rid myself of the succubus of painting. Painting has for a long time been sitting on the back of everyone's neck like it crept into territories outside its own proper domain.

> I have seen, in the last year or so, films which I have
> come to realize are built largely around what I take to
> be painterly concerns and I feel that those films are
> very foreign to my feeling and my purpose. As for
> sculpture, I think a lot of my early convictions about
> sculpture, in a concrete sense, have affected my hand-
> ling of film as a physical material.[7]

Snow never saw painting as a succubus, but he was attempting to find in film and photography an alternative way of painting. Unlike Frampton, he never saw film's painterly qualities as a hindrance to his creativity. Although Snow and Frampton had very different takes on aesthetic issues, their conversations were animated by such philosophically based ideas.

Snow's involvement with Frampton extended to reading the voice-over for his friend's thirty-eight-minute film *nostalgia* (1971), which shows a series of black-and-white photographs being burned on a hot plate. Snow's voice on the soundtrack comments on each photograph *before* it appears on screen; when a description of an image is read, it has already been burnt and the viewer is looking at another image about to be consigned to the flames. Later in his career, Snow would explore the phenomenon of burning and similar conjunctions of past and present.

The underground film movement in Manhattan with which Snow had cast his lot was rife with controversies. Mekas was jailed for showing material deemed obscene. Andy Warhol made films with virtually no montage and replaced it with duration. Not only did such films provoke negative responses amongst the general public, visual artists generally looked contemptuously at experimental filmmaking, too. Snow, since he was both an artist and a filmmaker, was an anomaly, as he recalled: "[T]here was at that time, and still is, a separation of communities between those involved in the painting and sculpture world in whatever capacity — artist, dealer, critic, collector — and those

FIGURE 57. Michael Snow in the loft at 123 Chambers Street, New York, probably September 1965.

involved in experimental film. [The audiences for film] were looked down [on as] grungy and inbred."[8]

As Philip Glass recalls, there were exceptions to this rule: "a community of people living and working very much together ... we were actively sharing the stages of our work together ... we were the audiences." [9] These were the kind of people for whom *NYEEC* was made.

CHAPTER TWELVE:
MORE SNOWGIRLS

Between 1961 and 1967, Snow created WW figures in a wide variety of genres. However, there are some important differences between the Toronto and New York ones. The latter respond directly to the kind of art then popular in Manhattan. Although they cannot be labelled pop or minimalist, some of the new figures teasingly appropriate elements of those genres. In other words, they show a knowledge of what was trendsetting without being seduced by it. In so doing, Snow employed the shape and surface of the WW figures to provide a critical commentary of the work being created in his new environment.

When Michael and Joyce arrived in New York City, Andy Warhol, the doyen of pop art, had reached his apotheosis with the emergence of the Factory. In popular culture, high art had been overtaken by a charming and powerful art form often based on commercial advertisements. Elements of pop art can perhaps be glimpsed in the bright colouring of *Display* (1963), *Hawaii* (1964), *Cry-Beam* (1963) and *Morningside Heights* (1965).

Snow's work in these instances might justly *remind* the viewer of the very cerebral Roy Lichtenstein, but their source only resides in the colours used by Lichtenstein and *not* the ads or comic books that inspired Lichtenstein. Marjorie Harris put it this way:

FIGURE 58. Michael Snow, *Cry-Beam*, 1965.

FIGURE 59. Michael Snow, *Morningside Heights*, 1965.

> [M]uch of Snow's work is an ironic comment on Pop
> Art: whereas the Pop Artist brings commonplace ob-
> jects into the realm of art by making them larger than
> life … or recreating popular objects, Snow is making
> his Walking Woman into a popular or common ob-
> ject … she is lifeless and wooden, yet humanistic and
> full of new forms and meanings. By using this image,
> pushing and coaxing her into new positions, now not
> only gives greater meaning to his Walking Woman,
> but to the familiar things she touches.[1]

Harry Malcolmson observed that although Snow was the "think-
ing man's artist" and his work had an ivory-tower feel to it, it never-
theless had "market place manifestations. Last summer, the Coca-Cola
[C]ompany ran a series of stylized, cut-out figures bearing an uncanny
resemblance to Snow's Walking Woman figure."[2] Snow had no idea
how this had happened.

On the relationship between the WW and pop art, Snow has made
it very clear: his figures were manufactured objects that he placed in
the everyday world. "I was working against the flow of pop art. I was
doing the opposite. I wasn't using pop culture as the starting point for
my work like they [Warhol, Lichtenstein] were."[3]

In a different vein, the simple dramatic shapes of *Gone* (1963),
Interior (1963), and *Seen* (1965) have some elements in common with
the work of the minimalist sculptor Donald Judd. At the time these works
were created, Judd and Snow exchanged pieces. Snow obtained *Untitled*
(1964), a brass and wood boxlike structure with red enamel paint.

Ultimately, "[w]hatever else she may be, the WW is also an *it* — a
formal emblem used to organize on a two-dimensional plane," John
Bentley Mays pointed out. Although Snow has always insisted on its
origins as de Kooning-like, the WW are a series of "obsessive images"
that embrace formalism, popular culture, and the Western tradition in
the depiction of women.[4]

The New York WW figures obviously continue a project begun in
Toronto. Very much in the manner of an artist like Monet who painted

FIGURE 60. Michael Snow, *Gallery*, 1965.

the same subjects (haystacks, lily ponds) over and over, Snow searched relentlessly to make meaningful variations on the same basic subject. In the WW series, there is always figuration in the use of the basic shape, but this limitation triggered the artist's imagination to create new variants.

Gallery (1965) — oil and enamel on canvas, Masonite, and wood — is a direct commentary on the New York art world. Here, the WW

figure — a painted sculpture wearing a red dress — strides before a mystical-looking late Rothko. The imitation Rothko canvas and the lady inhabit separate worlds. She, in a philistine-like way, hurries by the Rothko; the canvas is of no interest to her. The difference between the WW and the canvas is emphasized by the clash between her dress and the blue canvas.

There are variations within variations, as can be seen in *Mixed Feelings* (1965) in which the WW figure appears in fifteen different outfits. The title might hint at an indecisiveness on the part of the figure: What will be the best dress to wear today?

One of the pleasures in looking at the over two hundred WWs is to see the artist's ability to make each figure compelling and unique. As a group, they provide the viewer the pleasure of seeing how a single artist can make eye-catching variants on the same shape and surface.

There are also the WW "Lost Works." These came into being when the artist used rubber stamps of various sizes of the original outline. These were also constructed in other media. "This," he recalls, "led to the making of many 'illegal' public works, where placement was precisely an important factor."[5] He made three small paintings: one was glued onto a subway advertisement, another left in a subway car, and the third taped to the entrance of the Cooper Union subway stop. Lost Works were mailed, placed in various drawers in the Manhattan apartment of the Canadian-born broadcast journalist Peter Jennings, and inserted as bookmarks into books at the Eighth Street Bookshop. A few days after that insertion, a friend phoned him: "I just bought one of your things!"

For Snow and Wieland, surviving in New York continued to be arduous. In order to make ends meet, Snow relied on Av Isaacs, who regularly sent him money in payment for works he had sold — or, quite often, in anticipation of being able to sell them. The artist playfully called these payments welfare cheques or his "bread and butter." Isaacs obviously had a large inventory of unsold works in his storage space, and in 1964 he gave Snow another one-man exhibition (although he regularly

FIGURE 61. Michael Snow, *Mixed Feelings*, 1965.

included him in group shows). In Manhattan, Snow was anxious to find a dealer to supplement Isaacs — in that undertaking he was fully backed by Av, who obviously hoped that such exposure would make Snow a more marketable artist in both the States and, of course, Canada.

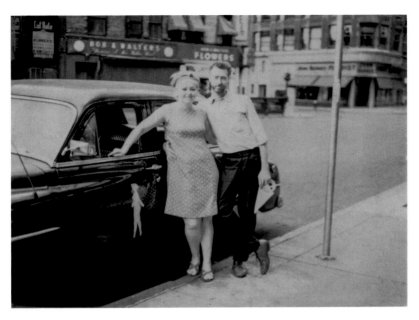

FIGURE 62. Joyce Wieland and Michael Snow with Graeme Ferguson's car, 1963.

In 1955 the Montreal-born Elinor (Ellie) Poindexter took over a defunct gallery and gave it her surname. An avid collector of both abstract and figurative artists, she showed the work of artists such as Richard Diebenkorn, Al Held, and Jules Olitski. She had a good eye for talent but once told Robert Rauschenberg that she could not act for him because shipping his work back and forth was too expensive. Taken by Snow's work, she gave him one-man exhibitions in 1964 and 1965.

In October 1963, Isaacs expressed some trepidation about the Poindexter Gallery. "Is she really that great … are her artists that great?" Av was a bit exasperated because Ellie had implored Snow to ask Av if news of the Isaacs exhibition scheduled after hers could be squelched; however, Snow asked Av to tell others about his breakthrough in New York. The Canadian dealer was not pleased. He told the artist: "I am not the Canada Council; I cannot afford to promote another commercial gallery. I would have imagined that you are showing at the Poindexter to advance your reputation in the States and your sales."[6] He added that Mrs. Poindexter was rich whereas he was not.

Snow became "cheesed off" in June 1964 when Isaacs, on a visit to New York, pitched Graham Coughtry to Mrs. Poindexter, complaining that he did so without "mentioning it to me."[7] Isaacs shot back: "I approached the galleries that I thought would be receptive to [his] work…. I was not riding on your coat-tails." Although Snow had told Isaacs he had serious reservations about the direction Coughtry's work had taken at this time, the dealer refused to take sides. "I am aware of your feelings about Graham's paintings, and accept your feelings as a fact of your beliefs. To accuse me of subterfuge is completely unfair and unnecessary."[8]

The relationship between Michael and Av was such that Snow could express feelings of frustration or scorn openly. In March 1964, the Art Gallery of Toronto purchased *Venus Simultaneous*. In response to this good news, Snow told his dealer that he thought that the decision had a "charity element" to it. They had, in fact, purchased a work that Snow in his "ego moments … consider[ed] to be a master-piece … I think you'll agree that it felt as if they had finally decided that 'oh well, we just have to have something.'"[9] (Two years earlier, the gallery had purchased its first Snow, another WW work: *Rolled Woman I*.)

The WW's and Snow's first New York show in late January 1964 and the Isaacs Gallery's second WW exhibition in April 1964 shared only six works. Toronto had twenty-one pieces, New York, twenty-seven. The exhibits in Manhattan were mainly from 1963 with a few from 1962. The Isaacs had one work from 1962 but the works were mainly from 1963, although it had eight from 1964, including *Grey Panels*.

In the *New York Times*, Stuart Preston envisioned the work he saw as pop art meets the prototypical American girl: she had become "a heroine of Pop art's Coke culture."[10] In *Art News*, Natalie Edgar offered a very dismissive reading: Snow "reduces and then freezes subject-matter into the form of a 152-centimetre silhouetted female figure, which he then treats in a number of styles." She flippantly concluded: "It's like having a paper doll all your own."[11] Emily Genauer, in the *New York Herald Tribune*, also trivialized the exhibition: "All together, the constant presence of the woman [WW] creates an environment like that of a too-small apartment shared with an obsessive wife."[12] In

his sensitive evaluation, Donald Judd paid close attention to the formalist qualities he beheld, especially *Olympia* — the title alluding to Manet's celebrated painting of 1863.

> Depicting a single thing in different ways is potentially interesting. Snow makes his subject, and in addition, one pose, the constant part of his work; the style and techniques vary widely. This is something of a point-to-line relationship, and it [is] the reverse of the old idea of a permanent style depicting everything. But Snow's variations aren't developed enough yet.... I like the three-dimensional pieces best. The profile isn't so obvious, in fact almost justifies itself.[13]

Judd's discomfort with any kind of representation can be discerned here, but he was obviously moved by what he saw at the Poindexter. The Museum of Modern Art purchased one of the WW on show in New York.

On view only at the Isaacs was a work from 1963: the enormous *Clothed Woman (In Memory of My Father)*, which the artist has described as "a sequence of seven selective fillings-in of shapes made by a dress outline. Using a spectrum-related series of colors, all the possible shape combinations are 'colored.'"[14] Of all the WWs, this oil and Lucite on

FIGURE 63. Michael Snow, *Clothed Woman (In Memory of My Father)*, 1963.

canvas displays the most perfect integration of figurative and abstract representation. Each of the colours is rendered in carefully modulated, varied brush strokes and the resulting colour values call attention to their surfaces; each of the shapes is so varied that they tease the viewer to try to put them together.

In both Toronto and New York, the WW — despite the fact that each WW is markedly different — were seen as responses to pop art. Snow gave credence to these views in "A Lot of Near Mrs.," when he said, "I like work of Johns, Oldenburg, Dine, partly because apparently they came to similar conclusions arising out of the accomplishments of the great senior New York painters." Put another way, Snow was recognizing the fact that pop art was a reaction to abstract expressionism. However, he draws a sharp distinction between pop art and his own practice: "I don't see what those signs and those things are selling. Some of my ideas turn out to be similar. An unexplainable coincidence which is not leading me to work directly from that material [as in pop art] tho I often see signs, displays, etc. which are very interesting."[15]

Perhaps the best distinction between pop art and the elements of that movement in Snow was made by Elizabeth Kilbourn in 1964: "Unlike pop artists who take the products of other factories, soup labels, Liz Taylor ads, comic books, beds, toasters, and use them as art and bring them into the gallery, Snow audaciously manufactures walking women and puts them in the everyday world."[16] There are connections between the WW and pop art, but the line between them is strictly drawn.

In looking at the work on display in Toronto in 1964, Fulford noticed the difference between the Toronto and New York WW:

> Snow took the Snowgirl to New York with him …
> and began using her in a new series of paintings. But
> now she is used in a far less abrasive and "difficult"
> way — or so it seemed to me. Many of the new paint-
> ings in the new show are brilliantly original … what is
> new is that some of them are also charming and a few
> are genuinely elegant. My guess is that Snow, having

moved away from his reputation, has been able to lift himself beyond it. In a city where few art lovers know him and few expect anything of him, he has been able to let his own personality spread across his art in a way that wasn't possible in Canada.

Moving to New York City had liberated Snow from a previously "intransigent … edgy kind of art, given to bumpy rhythms and abrasive, almost unacceptable color contrasts." In Canada, the artist had "apparently always found it necessary to bridle his talent in one important way. He tended to shun 'fine painting,' warm and obvious bursts of color, and charming effects. I think the reason was at least partly his reputation, and the pressure it put upon him."[17]

The WW in the December 1965 exhibition at the Poindexter and in April 1966 at the slightly larger Isaacs show included *Five-Girl Panels*. In *Art News*, Jill Johnson found this piece "striking."[18] Amy Goldin in *Arts Magazine* was not impressed, although she remarked accurately (probably in reference to the same painting) that Snow was engaged by the "laws of perception" but that, for her, "his enthusiasm does not seem highly contagious."[19]

The Toronto journalist Harry Malcolmson reviewed both shows. In his first notice, he paid close attention to *Five-Girl Panels*: "Each canvas reproduces a distorted Walking Woman as if we are seeing her image in a Fun House mirror.... Where the image is short and squashed, Snow uses a stubby canvas shape. Where the image is long and lean, the canvas is correspondingly tall and narrow." For this critic, this work was "the best representation of the problems he has been exploring." He makes another crucial point: Snow's "work provokes a viewer's eyes, then his mind."[20]

Back in Toronto, the same critic observed: "Every piece is telling and authoritative. After several years of working with the Walking Woman, Snow knows exactly what he wants to do in each new variation, and he does it."[21] In an appreciative notice in the *Globe and Mail*, Kay Kritzwiser repeated what the artist had told her: "I want to make seeing more palpable. I want to say something with static things — to

fix something which has stopped within the flux of what's going on." Quite soon, his attention would move from "static" to "moving."[22]

The bubble gum–coloured *Hawaii* was shown only at the Isaacs, but *Mixed Feelings, Seen, Sleeve,* and *Cry-Beam* were shown in both shows. All of the WW shown in 1965 and 1966 embrace another remarkable change. *Hawaii*'s colours resemble pop art and the same observations can be made about *Cry-Beam, Seen, Sleeve,* and *Morningside Heights*, but, in addition, these four pieces have significant sculptural qualities.

The difference in the rendering of the face in the middle panel (on canvas) of *Cry-Beam* and the two jutting-out painted boards offers not only a contrast in textures but also something between representational and abstract modes. In *Seen*, the long panel (viewed from the front) looks mainly like a minimalist work but seen from the left-handed side the figure is much more visible.

The two parts of both *Morningside Heights* and *Sleeve* use window-like structures as in *Window*, but they take that fascination in a different direction. One part of *Morningside Heights* is a sculpture — a long rectangular floor box painted blue — that has a pink plastic window. On the wall near the sculpture is a trapezoid-shaped painting on canvas of a WW head. The painting is brightly coloured; if one looks through the window the colours become only pink and blue. Snow has observed that this is the first work in which he included the spectator's participation in his work.[23]

Sleeve provides a free-standing, two-sided wall in which there is a rectangle viewing space of red plastic. The view through this window is of various WW: a 152-centimetre painted cut-out; a torso modelled in oil paint; three photographs; a small, heavy-impasto horizontally placed but not on the wall; at the top is a yellow foldage. This assemblage becomes a deep red when looked through the window.

The use of window-like structures to change colour might have been the artist's attempt to talk about the effects of LSD on perception — the same observation could be extended to *Five-Girl Panels*. More importantly, these two works are preludes to the artist's later, more

direct works, which emphasize perception and how changes in perception alter the way in which a work of art is viewed.

The WW has not escaped its share of negative criticism. In 1979, Amy Taubin castigated the entire concept:

> Most critics have dealt with "Walking Woman" in terms of how she is represented rather than *what* she represents. But she is a very particular representation of a woman, fascinating and repellent at the same time. In psychoanalytical terms, the "Walking Woman" is the classic female figure of plenitude and lack, the repository and symbol of male castration anxiety. This anxiety is expressed and simultaneously alleviated and reinforced by the obsessive viewing or exploring of the female body. The resulting behaviour may be predominately either voyeuristic or sadistic. The deprivations of the "Walking Woman" — her lack of hands, feet and crown — symbolize and reinforce the image of the woman as castrated, but this framing of her body also emphasizes the curving plentitude of her sexual characteristics: breasts, buttocks and legs.

The WW, Taubin also observes, "doesn't have two feet to stand on, let alone walk. Her 'walking' is dependent on the assistance of her maker."[24]

For Snow, the issue of objectifying women in his celebrated series is a non-starter. For him, *how* the figure is represented is central — not *what* the figure represents. There is, however, a very fine line between *how* and *what*. The clothed or nude female figure is a commonplace subject in the history of Western art, but that may originate in large part because objectifying women has long been part and parcel of Western society.

Perhaps the most balanced critical evaluation of the WW came from John Bentley Mays, who dismissed the idea that these works were made in the wake of de Kooning's nudes.

If a modern precedent is wanted for the WW, the strong working women of Fernand Léger will do very well. Like Léger, Snow in this series seems genuinely to like and enjoy women, with none of the intense sexual anxiety we find in Picasso and de Kooning. Again, like Léger, Snow appears to be happy with women like the WW, who know what they are, know where they are going, and are on the move. Snow is one of the few male artists of the twentieth century who have created a gently humorous, convincing, complex sexual icon of woman on her feet, moving in freedom, in her own way.[25]

The artist himself has always insisted that the WW must be seen in formalist terms, especially in the way in which they are framed:

Every image that we ever look at has been cropped. I think you can say that without question. If I show you a photograph, it's been cropped. It has to be because of the way a camera's viewfinder frames what's to be photographed — it cuts out whatever it can't fit in. In the case of a photo, cropping means that the image has been fit into the shape of a rectangle. In the example of the Walking Woman, the cropping indicates that the Woman has been taken from a rectangle, that gives it a defined relationship to painting or drawing. I find that the interpretation that she's been amputated to be funny, but it shows how people don't really look at how they look.[26]

Ultimately, the WW portray women in action — in the process of walking rather than simply standing. As such, the figure inhabits and explores a wide variety of existences. Ultimately, she is active rather than passive. In that sense, she is not objectified.

CHAPTER THIRTEEN:
WAVELENGTHS

During his early stay in Manhattan, despite the remarkable freedom he found in his new WW works, Snow could be prickly. For example, he was deeply bothered by his encounter with Marcel Duchamp, who had invited him and Wieland to his walk-up apartment on 11th Street near Fifth Avenue. Beforehand, Snow was "nervous, apprehensive." On the walls of Duchamp's flat were works by, among others, Matisse, Ernst, and Tanguy, but Snow was reminded that the Frenchman, who had given up art for chess, made money by brokering the sales of works by his confreres. "My mind sneered," Snow recalled. Duchamp "basked in our adoration," and as a result Snow "became supercritical of everything he said." The young man also felt he'd "gone in there on my knees and it hurt." Although Snow asked Duchamp if he would appear in *NYEEC*, he loathed what he considered Duchamp's condescending behaviour.

Once they had left, Wieland asked her husband what had gone wrong: "I gradually realized with deep dismay how far I had sunk under an Oedipal lump.... I don't believe I wanted to marry Teeny [Duchamp's wife], but I sure had wanted to kill my Dada." His ego was "so frail at that particular time that [he] was unable to encounter a superior with [sufficient] respect and curiosity."[1] Michael was able to maintain the facade of the superior young man, but that was in many ways a role he was play-acting.

A week later, feeling "like apologizing" to Duchamp, Snow phoned and "asked if [they] could meet again and shoot the little

scene: Joyce and Marcel walking across the street, seen through a mask of the Walking Woman outline. Unfortunately, I couldn't use this shot in the film."[2]

In some ways, Snow's career at this time bears comparison with his contemporary, the American artist Alfred Leslie, who began in an abstract expressionist mode and then ventured into film with Robert Frank to make *Pull My Daisy* (1959), the Kerouac-inspired underground film. In Manhattan, Snow also discovered, there was great fluidity in what constituted being an artist, but such knowledge can, at first, be unsettling to someone still in the process of formation. Nevertheless, he was determined to make a new film.

Once again, he wanted to make a film in a completely different mode from Brakhage. He was also trying to evade another kind of cinema. As Elizabeth Legge explains, "Snow's zoom could be seen to allude to the very long duration of some of Andy Warhol's films, such as the eight-hour shot of the Empire State Building in *Empire* (1964); but, in contrast, *Wavelength* is a constructed — not a 'documentary realist' — recording, and the time of *Wavelength* represents real time as well as taking place within it, as day turns to night twice during its 45 minutes."[3]

However, Snow did see several links between *Empire* and *NYEEC*, especially in their shared fascination with time, and he was pleased when Warhol told him he thought *NYEEC* wonderful.[4] Snow and Warhol also share a penchant for using photographs in serial arrangements, but Warhol tends to repeat the *same* image multiple times (e.g., *Lavender Disaster* [1963]) whereas Snow is more complex in arranging *similar* photographs (*Authorization, Venetian Blind*) in a manner that follows from his practice as a filmmaker.

Undeterred by the hostile reception of *NYEEC*, Snow, after one year of studying and "muttering," made *Wavelength* in one week in December 1966. He wanted, he recalled, "to make a summation of my nervous system, religious inklings, and aesthetic ideas. I was thinking of, planning for a time [a] monument in which beauty and sadness

would be celebrated, thinking of trying to make a definitive statement of pure Film space and time, a balancing of 'illusion' and 'fact,' all about seeing."[5] The resulting forty-five-minute film is a continuous zoom from its widest field to its smallest and final field. It was shot with a fixed camera from one end of an twenty-four-metre loft.

In *Wavelength,* the space of the loft — Snow's studio at 300 Canal Street — slowly disappears and the film ends with a single photograph of a wave. The film deliberately eschews traditional narrative action, although it does so teasingly. During the course of it, four moments of narrative are briefly inserted. In the first, two delivery men deliver a bookcase to a woman (Joyce Wieland), who instructs the men where to place this piece of furniture and they all leave. Later, the same woman returns with a female friend; they drink and listen to "Strawberry Fields Forever" on the radio. After they leave, the sound of breaking glass is heard. At this point, a man (Hollis Frampton) enters and collapses on the floor. Later, a woman in a fur coat appears and makes a phone call, speaking, with a strange calm, about the dead man in her apartment whom she has never seen before.

There is the hint of a murder or some other nefarious deed, but this plot thread is not developed. The film, in deliberately avoiding narrative coherence, provides its own take on the kind of film *Wavelength* does not seek to be. The year before, Antonioni's *Blow-Up* had caused a storm in advanced film circles. In that film, the photographer protagonist may or may not have inadvertently taken snapshots of a murder. The blow-ups do not provide evidence to prove either scenario convincingly. The Italian director was using narrative film to talk about the difficulty in obtaining any kind of stable truth. Snow is interested in similar ideas but goes about it in a completely different way.

The *real* plot development in *Wavelength* is between the slow, steady zoom and the coloured gels and their accompanying noises that momentarily distract the viewer from the inexorable move toward the window and, then, the photograph. As one reviewer put it, the "cool kick … was seeing so many new actors — light and space, walls,

soaring windows, and an amazing number of color-shadow variations that live and die in the windowpanes — made into major esthetic components of movie experience."[6] For Hollis Frampton, this film in particular "modified our perception of past film.... This is an astonishing situation. It is like knowing the name and address of the man who carved the Sphinx."[7]

There are many possible readings of *Wavelength*. One is that the film is about loss and accompanying dislocation. Since the room obviously disappears as the zoom proceeds, the viewer is left with less than when the film began. As that process takes place, there is an uncanny sense of displacement, but that sense of dislocation, it can be argued, is ultimately augmented by the photograph of the wave that ends the film. The water can signify that what the viewer sees at the film's completion is part of the natural world and that the world of art merges into the world of nature.

Another interpretation might claim that the film re-enacts sexual intercourse in that the slowly moving zoom represents the phallus heading into a tight small space that denotes the vagina. If this is so, the camera's actions can be said to be a manifestation of the male gaze objectifying women.

However, as Adelina Vlas has observed, as the camera's trajectory goes forward, "we find two images of the Walking Woman at different scales, echoed by two photographs of a nude woman just above and to the left. Overlapping slightly, these two parts of female silhouettes — one photographic, the other painterly — are the focus of the zoom for most of the film. But as the film approaches its end, it becomes clear that the actual focus of the camera is another image pinned below this double representation — a photograph of waves on the surface of a body of water." It can be argued that in the final portion of the film, when the zoom moves to the photographs of the wave, any gendering in the film is literally washed away. As Vlas also observes, the shift from the WW to the water image "parallels Snow's transition from painter to photographer to filmmaker."[8]

The film's final movements can be read as Snow's valediction to the WW phase of his career and a suggestion that he will now pursue photography. Regina Cornwell has suggested that this shift reflects in part a

FIGURES 64 AND 65. Michael Snow, two stills from *Wavelength*, 1967.

rejection of hierarchal forms in favour of "relationships [of] continuity and repetition rather than contrast and interplay." The WW figures are contrasting repetitions that "interplay" with each other. In the future, the emphasis will remain with repetition, but dissimilar objects will be examined in photographs sequential in nature.

Snow has claimed that *Wavelength* resembles more a Vermeer than a Cézanne. Like in the interiors carefully rendered by the Dutch artist, the inner drama in Snow's film takes place in a quiet, sedate domestic space; like the French artist, space is always being reconfigured as the zoom moves forward.

As Regina Cornwell has also pointed out, the work of Stan Brakhage bears comparison to that of the abstract expressionists because both are dominated by a "romantic subjectivity." As such, his films "become repositories of his inspired and mythopoetic vision in abstruse and recondite images."[9] Snow does not venture in this direction. In fact, it can be argued, in *Wavelength* he avoids the "gesture." In so doing, according to the film historian P. Adams Sitney, Snow created a new kind of experimental film that Sitney labels "Structural."

In a letter to Mekas and Sitney, Snow claimed that what his film "attempts to be is a 'balancing' of different orders, classes of events and protagonists.... The film events are not hierarchal but are chosen from a kind of scale of mobility that runs from pure light events, the various perceptions of the room, to the images of moving human beings."[10] Put another way, Brakhage is a romantic whereas Snow is a classicist who attempts to investigate and balance reality.

CHAPTER FOURTEEN:
NEW SURFACES

By 1967 Snow had in large part obtained what he had wanted to achieve in New York City. There, he exchanged his experiments on WW figures for a new preoccupation: film. At first, this seems a considerable shift in direction. That is really not so. In Toronto, Snow, in a large number of oils, had constructed his own takes on abstract expressionism and post-painterly abstraction; his early sculptures employed some minimalist approaches. In a way, he had exhausted such avenues *before* he settled in New York City. The WW figures gave him the opportunity to constantly challenge his imagination to create exciting new variations. The connection between the WW figures and films resides at a very basic level: the *Walking Woman* looks as if she is in motion, but she is stationary.

Films allowed Snow to add actual movement to his work. It permitted him to explore a new kind of surface texture. *Standard Time* (1967) is a good example of this new turning. It has the feel of "a home movie … shot somewhat spontaneously" in Snow's loft at Chambers Street. This film includes some completely circular pans, in which the camera moves at different tempi; some pans are left to right, others are right to left; there are also up and down tilts. Parallel to the movements of the camera are sounds from a radio moving in and out of different stations and increasing and decreasing in volume. Snow's description of the film is short but to the point: "This is my home, wife, camera,

FIGURE 66. Michael Snow, still from *Back and Forth*, 1969.

radio, [pet] turtle movie. Circular and arc saccades and glances. Spatial, parallel sound." In form, *Standard Time* is the deliberate opposite of *Wavelength*, and, provocatively, does not live up to its title.

Back and Forth (1969), set in a classroom, concentrates on motion rather than *Wavelength's* light. As one critic observed, in this film Snow is able "to completely suffuse form with content, while not relinquishing the traditional elements of characterization and acting."[1] The camera pans the same distance from side to side at medium speed, slows down and then goes extremely fast. Events take place in the classroom, including a mock fight. In his own commentary on the film, Snow points out that it is concerned with perception, attempts to capture a new kind of spectator-image relationship and is "sculptural because the depicted light is to be outside, around the solid (wall) which becomes transcended/spiritualized by motion-time." In comparison, *Wavelength* is more "transcended by light-time."[2]

In *Artforum*, Manny Farber claimed that the beauty of this film resided in its hardness. "Snow has mobilized a mirthless, lonely subject,

FIGURE 67. Michael Snow, still from *One Second in Montreal*, 1969.

a classroom, into an expressive weapon…. As the back-forth image speeds up to a hair-raising psychotic clip, light appears to filter off the sides of a horizontal cube of greenish whiteness. All literary connections in a film image have been junked and … sculpted-in-motion space — has been made the jump-off point of a film design that doesn't rely on any behaviour-sensory patterns of the spectator."[3]

One Second in Montreal (1969) is a black-and-white silent film with no motion. It consists of holds on thirty photographs taken in the winter of some parks in Montreal. Each photo is first shown for an exact number of frames; then the durations become longer and longer; after the longest durations, the holds get shorter and shorter until the final image is one frame in length. The photographs were badly printed offset lithographs sent to Snow years before as part of an invitation to submit ideas for a competition. The artist recalls, "I did not enter the competition, but I was moved by the rather barren, artless photos and kept them."[4] For Snow, the photographs had a nostalgic aura — he had lived in Montreal for five years as a child.

In some ways, Snow's early films — all extremely formalist — invite the viewer to gaze at them as if they are stationary works of art, such as sculptures. In eschewing traditional narrative film and employing "structural" techniques, they demand a level of attention not usually paid to cinematic works. Instead, they insist that the viewer exercise patience in order to see how films are created, how motion functions. Snow's films are ultimately about what we can see if we look carefully. In addition, he confronts the viewer. *Have you really looked? Did you really see what is placed in front of you?*

What these four films have in common is a determination on the part of their creator to form a new aesthetic independent of both traditional cinematic form and Brakhage's lyrical brand of cinema. These films do not tell stories in any traditional way and, moreover, they do not emphasize the interiority of their creator. Rather, they demonstrate aspects of looking that have been overlooked in earlier cinema. P. Adams Sitney provides an excellent description of this new kind of cinema which he calls structural: this is a "cinema in which the shape of the whole film is predetermined and simplified, and it is that shape which is the primal impression of the film. The structural film insists on its shape, and what content it has is minimal and subsidiary to the outline."[5]

In the work of a lyrical filmmaker such as Brakhage, the sensibility of the creator is foregrounded; in the work of a structural filmmaker such as Snow, that mediating presence is absent. Snow uses cinema to create a new ontology; for him, it must have a distinct existence separate from all other arts. In fact, it must rid itself of any vestiges of painting at the very same time it paints in a new way using movement, shadows, and sound. For him, traditional narrative cinema is compromised because it too readily integrates elements from other genres.

As Snow was well aware, experimental cinema engages viewers in a new way. Instead of waiting for a narrative to unveil, the audience must turn its attention to the meaning of the images appearing and flickering on the screen and respond actively to them. These demands force viewers to become engaged with what the surface and forms on the screen mean independent of traditional storytelling. Meaning

resides on the surface — and the usually rectangular shape of cinema is a form of framing.

Film, as it liberated Snow's imagination even further, provided him a segue into photography, a form he had explored in *Four to Five;* later that project was transformed into *NYEEC. Atlantic* (1967) comes directly out of the experience of making *Wavelength.* The final photo in that film was taken at New York's South Ferry Terminal, and *Atlantic* is composed of a grid of thirty similar photographs taken at the same place and arranged on tapered tin boxes. On the bottom of each of the thirty framings is a black-and-white photograph displaying the surface of the water in motion. Each of these photographs resembles a frame in a film reel. Moreover, the work stands 244 centimetres high, 170 wide, and 38 deep and thus has an arresting sculptural presence.

As the spectator walks alongside this construction, some of the images vanish, obscured by the sides of the boxes. If the spectator

FIGURE 68. Michael Snow, *Atlantic*, 1967.

stands back, a multitude of different views — all shimmering — can be glimpsed. Technically, *Atlantic* may be a sculpture composed of photographs, but the result is in large part cinematic because of the sense of movement elicited.

The last performance of the WW figures was at the Ontario Pavilion at Expo 67 in Montreal. Each of the eleven figures (slightly larger than life size) was made of brushed stainless steel placed over plywood cords. Some were single cut-out WWs, but several were three-dimensional "solids." The central piece (*Big Wall Figure*) was a free-standing, four-sided wall piece with a pie-like sculptural form removed from the corner of the rectangle. It also had a "passage made (in effect) by passing the *Walking Woman* shape across the face of the 'wall.'" Snow assigned each figure a particular location around, near, and within the pavilion. In essence, he created an environment or installation in which the stationary walking women allowed spectators to walk around them. The small community of WWs also acted as hosts to the pavilion in

FIGURE 69. Michael Snow, *Expo Walking Woman (Big Wall Figure)*, 1967.

that they welcomed members of the public to stroll around and in them. For Snow, this large project came at the perfect time "because my attentions were increasingly moving elsewhere."[6]

Leaving the WW behind allowed Snow to return to sculpture in a new way since the works in this medium from 1967 are "related to aspects of the camera. These are all pure objects concerned with their means of construction, but also are concerned with the work as a Director of Attention."[7] Put another way, Snow's work as a filmmaker and photographer released a new impetus in his work as a sculptor because those two media had made him even more aware of the inter-actions possible between surface and movement. The titles of some of the works call attention to how they are "Directors of Attention": one sculpture is about confusion, bewilderment, and, ultimately, blindness; another is about non-blindness.

Snow has offered several analogies to describe *Blind*: "it's like a three-dimensional cross-hatched drawing; it's an object that monu-mentalizes fading in and fading out; and in another film-related resemblance, it's like a zoom."[8] In many ways, *Blind* can be related to *Wavelength*. In each, there is a profound sense of loss.

This piece consists of four porous partitions framed in steel and clad in aluminium mesh. There are four different gauges for the panels, which are mounted parallel to each other and form a cube on three sides. The viewer can look at this 244 x 244 x 244 cm cage-like form from the outside and, in so doing, realize it has the appearance of a place of confinement, a prison. In fact, as a viewer from the outside looks at persons already wandering into this piece, they look fuzzy and ghost-like — very much removed from everyday reality. When the viewer enters this structure and then walks between the panels, the "depth of field" of the resulting maze is entangling and causes confusion. *Where am I and where am I going?* is the usual response. In a sense, the work's construction causes one to go blind. What looked discernible from the outside becomes much more mysterious when its interior is experi-enced. The title also obviously relates to Gerald Bradley Snow and, in this sense, captures the sense of isolation and loneliness he experienced.

When *Blind* and three other sculptures were shown at the Poindexter in February 1968, John Perrault in the *Village Voice* realized

FIGURE 70. Michael Snow, *Blind*, 1968.

that "they were instruments of perception that focus the environment and make it visible. They are 'frames' that intensify visual experience. They are efficiently made but brutal in appearance. They were not made to be looked at, but to be 'looked through.' An art work is not necessarily an object to see; it may also be an object that creates a way of seeing."[9] Hilton Kramer in the *New York Times* was castigating: for him this was sculpture raised "to the level of brutalized absurdity.... They manage to suggest the atmosphere of a chic concentration camp, but that is about all the imagination discernible in them. Ugh!"[10]

Sight (1967), like the earlier *Window*, is a two-sided sculpture. One side can be seen from the outside; the other is a black plastic surface with incised white lines, cut mainly in a grid pattern, although there are some diagonals. A portion of the plane section has been cut away to allow a hole through which a spectator can look at anything in his range of view; the other surface, in contrast, is armour plated — a

FIGURE 71. Michael Snow, *Abitibi*, 1969.

viewer can see only inside the gallery. The contrast between unlimited and limited viewing is the trick here.

In the imposing *Abitibi* (1969) — named after the area in western Quebec known for logging — what should be the frame has taken over (usurped) the area traditionally reserved for an image, and at the edge of what would have been the frame, cement oozes out. The cement replaces the oils that would have been used on a canvas. The cement is repulsive in colour and texture, although the highly varnished wood panel

143

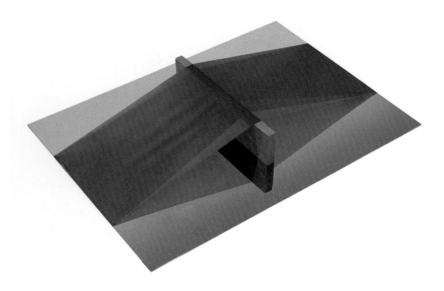

FIGURE 72. Michael Snow, *Membrane*, 1969.

is attractive. Here, in a complete reversal of viewer expectations, Snow uses sculpture to make a commentary on another genre: oil painting.

Other works move in a very different direction. *432101234* (1969) and *Membrane* (1969) are experiments in minimalist art. The first employs C-clamps to compress two metal bars across a 6.3 centimetre-thick rectangle of sponge rubber and onto a rectangular plane of chrome-plated metal. The title refers to the transition that takes place on the surface of the mirror from one space to another. The name *Membrane* refers to the rubber material stretched across the wood. These two works are companion pieces in that in the former, the sponge rises up and sheds its reflection on the mirror-like chromed steel; in the latter, the rubber stretches downward to cast its reflection on the chromed steel. In both pieces, the pliant, stretched sponge and the rubber are contrasted to the hardness of the steel.

By 1970, Snow had established the paradigm that he would follow for the remainder of his career. First, he would always be guided by his

FIGURE 73. Michael Snow at Isaacs Gallery with *Half-Slip* on the wall, 1964.

instincts as to what to investigate. In New York, his conviction that an artist need not focus on a single genre was strengthened. Of course, he had already learned much on this score in Toronto. Manhattan reinforced that conviction. Second, following from this resolve, he would never be confined to one or two genres — in fact, he would often seamlessly blend several together. Third, in his artistic practice, Snow would concentrate even more than before on the role of perception.

The last is key in understanding Snow's work. He would create works that frequently question their own authenticities as aesthetic entities; his creations often do not look like traditional pieces of art in whatever genre or genres they exist, and that is exactly the point. From the outset, someone looking at pieces of Snow's work has to let go of previously held convictions — and pay attention to its formalist qualities.

CHAPTER FIFTEEN:
CANADIANS IN MANHATTAN

Joyce's time in Manhattan strengthened her works, especially those in oils, some of which employ fully saturated pop-like colours. As well as continuing to paint, she also started working in quilted cloth and making mixed-media constructions. The couple always worked separately, but they discussed each other's accomplishments on a daily basis. Joyce and Michael often, during long walks, talked about what they were trying to accomplish. "It was important to us that we were working on our own thing," Michael recalls. "I think it was pretty unique ... that we were both pretty good and we were both working on different stuff."[1]

Her time in New York enlivened Joyce's interest in making films. In 1958 she had made the four-minute *Tea in the Garden*, and the following year, with Michael, the twenty-minute *A Salt in the Park*. Before the couple left Toronto, it could be claimed that they were equally intrigued with the possibility of making films. While in New York, Wieland completed four films: *Larry's Recent Behaviour*, *Patriotism: Part I*, *Patriotism: Part II*, and *Water Sark*. By 1967, Michael had received considerable acclaim for his work in cinema; she had obtained almost none.

In Joyce's view, she was the victim of the male establishment. She and her husband shared many friends who were directly involved in the independent film movement, but these connections were of no use in helping her work get attention. Michael was — and remained — deeply loyal to his wife when she suffered such slights. That sense of loyalty did not, however, extend to sexual fidelity.

FIGURE 74. Joyce Wieland, *Sinking Liner*, 1963.

Michael's infidelities aggravated Joyce, although she usually held her tongue. Michael remained the centre of her existence: he was, she claimed, "the only person who can help me."[2] Although Michael thought he was being discreet in various assignations, his wife knew full well what he was up to. It was difficult for her to confront him on the thorny issue of faithfulness, however. Before leaving Toronto, she had an affair with George Gingras, with whom she and Michael had worked at Graphic Associates. When Joyce and Michael were living on Charles Street, she — lonely on the nights Michael was playing at various gigs — would walk over two or three times a week to nearby Isabella Street, where Gingras lived.[3] As well as the issue of sexual fidelity, there was also the issue of children. According to Joyce, Michael wanted children. Although she, too, wished to have a family, she was unable to conceive; this became an issue, one over which the two quarrelled.

Michael's womanizing was a significant part of his existence, as he once told an interviewer. "I've been extremely active sexually. I've been involved in a lot of happiness and pleasure that way, but I've also caused a lot of trouble. But the positive aspect of the fact that I've had many relationships with many women is that we've been very

FIGURE 75.
Joyce Wieland,
The Camera's Eyes,
1966.

happy together. And I now think it's more normal than I sometimes thought when I was struggling with it. I was extremely horny, and if I was attracted to someone I would simply try to go to bed with them. It wasn't always necessarily meeting someone [for] one night, though that certainly happened, and it was wonderful. For both of us. For all of us sometimes!"[4]

For Joyce, however, her husband's sexual behaviour remained deeply unsettling. Moreover, living in New York City remained a disquieting experience. There was the time when, as she was unlocking the door to the building where she and Michael lived, a man grabbed her. She yelled, and Michael came to her assistance. Traumatized — a chunk of her hair had been pulled out — she burned the clothes she had been wearing, including a pair of new shoes. She also took to her bed for a week. Another time a thief broke into the Chambers Street loft and took some sound equipment.

There were other important aspects to the couple's life in Manhattan. As Michael recalled: "I've taken pretty much all the drugs that were possible. And I'm happy about that. It was beneficial, and it was educational. Grass is a really interesting creative aid — it was very good for

my imagination in every way. I never used to paint when I was high ... though dope and music are ancient companions, and it always does affect playing spontaneous music beneficially. I've always enjoyed grass, and I've taken acid and peyote and all those other things for ideas, for thinking ... for a while it was an important part of [my] thinking. It's philosophic and religious as well as aesthetic — it concentrates your attention in certain ways, and I've always found it life-enhancing."[5]

The sixties were a time of significant political turmoil and it affected the couple's lives. Michael and Joyce would have known of Valerie Solanas's shooting of Andy Warhol in June 3, 1968, and would also have been aware of the escalating opposition to the Vietnam War and the resulting fragmentation that shattered American society. Michael and Joyce even took part in demonstrations against the war.

There were happy events. In 1968, Joyce planned and hosted a cocktail party for Prime Minister Pierre Trudeau at the Columbia Pictures building: sixty Canadians living in Manhattan showed up (Trudeau did not, but he sent a filmed greeting). On November 8, 1969, she and Michael hosted a party for the prime minister — at which he did appear — at their loft. Canadian food was served and there was a free jazz group. That evening Michael stuck with Trudeau, whose knowledge of Manhattan impressed him. At one point, he introduced Milford Graves to the prime minister, praising him as a world-class drummer. Without skipping a beat, Trudeau asked: "What about Max Roach?"[6]

The couple travelled frequently to Toronto, usually at Christmas. Isaacs now represented Joyce, and of course Michael wanted to be in regular contact with Av. On their Christmas 1964 trip home, they had an accident near Alexandria Bay, New York, when their car skidded off the highway and hit a post. The car was a writeoff, and presents were strewn all over the road. Joyce was unhurt, but Michael was unconscious and had to be taken to a nearby hospital, where he remained for four days.

Travelling between New York and Toronto may have been hazardous at times, but it was life in New York that was becoming more of a problem for Joyce. She wanted to quit New York City well before Michael did. He was reluctant to leave the place where, he knew, he

had fulfilled his ambition to better himself in his artistic practice. In any event, from 1970 to 1972, Michael and Joyce, as he recalled, "were half there [New York City] and here [Toronto]" and their interest in the Canadian art scene increased. Also, for them, "Toronto [now] seemed to be fresh and young. There's something about New York that has a worn, pushed down kind of quality."[7] The couple also became acutely aware that the United States "wasn't our country and maybe we should do something in our country."[8] Les Levine, a Canadian-born artist who had settled in New York City, felt that there was another reason for the decision to return home: "It was virtually impossible for them to sell any work or do anything here, and if they had stayed any longer it would have started to become a real liability to them."[9]

The Toronto art scene had expanded in the nine years that Michael and Joyce lived in New York City: there was the rise of Harold Town, a renewed interest in Jack Bush, and the emergence of young painters like David Bolduc and Paul Fournier. Snow's reputation had risen during his time in New York, but he was no longer "THE Toronto Artist."

PART THREE
1970–1979

CHAPTER SIXTEEN:
THE PRESENCE OF THE PAST

Eighteen months before Snow returned to Canada, the Art Gallery of Ontario had decided to inaugurate "over the coming years a series of exhibitions of Canadian artists in mid-career. It is particularly fitting that the first of these should be dedicated to Michael Snow, an artist whose multi-sided genius has illuminated for so long, and never more brilliantly than at present, the vanguard of contemporary painting, sculpture, film and music."[1] In a sense, this exhibition, as retrospectives do, would celebrate the artist's accomplishments — in Snow's case, it signalled his many accomplishments up to the age of forty-two and provided a portent for the future.

In many ways, it made sense for the couple to return to Canada in 1972 in the wake of the retrospective. Snow was an established artist, certainly not someone who really needed to remain in New York. In June 1970, he represented Canada in the Venice Biennale; about the same time, *Aluminum and Lead* was chosen by the Government of Japan to represent Canada at Expo 70 in Osaka. From 1964 to 1976, he had sixteen one-man shows in New York City and Minneapolis; he had represented Canada at three Edinburgh International Festivals (*Canada 101* in 1968, and the 1969 and 1975 film festivals).

The list of the items in the retrospective and their sequential placement go from a cartoon drawing called "Aeroplane Ace" (1938) to the early panels (1951–52), to the Klee-inspired pieces (1953), to

Man with a Line and *Ocul* (both 1954), to the chairs/table works and female nudes (1955 to 1957), to the large abstracts (1959–60), to *Shunt* and *Quits* (1959), to various WW (1967), to *Blind* and *Scope* (1967), and to photographs, including *Authorization* (1969). The films from 1956 to 1969 were also shown.

The most curious entry is the last — No. 150: the exhibition catalogue designed by Snow. This is not a traditional catalogue. It is that event's printed record; however, it deserves its place as an entry in the catalogue because it is a complex work of art in its own right.

In essence, the catalogue is a daring reinvention of this type of publication. There are some traditional parts. Four essays — "Apropos Michael Snow" by Robert Fulford, "Origins and Recent Work" by Dennis Young, "Right Reader" by Richard Foreman, and "Michael Snow's Cinema" by P. Adams Sitney — provide evaluations of the artist's work. There is a four-page list of the works; Snow provides a one-page family history (that contains a number of errors) and also a guide to the photographs that occupy pages thirty-five through sixty-six of the catalogue.

Perhaps the first glimpse of the unorthodox in the catalogue can be seen in the five photographs of the Lac Clair cottage that act as chapter divides, although the rationale for the placement of them as such is difficult to decipher. The first work illustrated in the interior of the book is *Lac Clair* (1960) and then, in this order, "Aeroplane Ace" (1938), *Scope* (1967), *432101234* (1969), *Membrane* (1969), *Sight* (1967), *First to Last* (1967), *Aluminium and Lead* (1968), *Portrait* (1967), *Press* (1969), *Authorization* (1969), and *Atlantic* (1966). After a chapter divide follow thirty-four pages of photographs of, among others, Snow's ancestors, his father and mother, Denyse and Michael as children, jazz events, pictures of Michael and Joyce, Michael with Steve Reich, Richard Serra, Bruce Nauman, and the WW in various places and installations (including Expo 67).

Without a chapter divide follow *Four to Five* (1962), *Venus Simultaneous* (1962), and other WW; then there is a chapter divide after which is a still from *Wavelength* (1967); after Sitney's essay (which occupies six pages) is a still from *Back and Forth,* followed by a mixture of photographs: the first private showing of *Wavelength,* a still

from *One Second in Montreal,* and photographs from 1937 of Michael, Denyse and Buck in Chicoutimi. After another chapter divide, three pages are allotted to *Blind* (1967) and then to a page of Braille. The list of exhibits is then inserted and is followed by *First to Last* (1967), *Ocul* (1954), and a photograph of Snow behind the wheel of a car.

The final chapter divide shows *Paperape* (1960), *White Trash* (1960), *Red Square* (1960), a portrait photo of Snow by Michel Lambeth, *Secret Shout, Blues in Place, Shunt, Quits, Colour Booth, The Drum Book,* a detail from *8 x 10, Blue Panel* (1952), *A Man with a Line* (1954), *Window* (1962), the WW *Olympia* (1963), *Aqua Table,* (1957), a photograph of three persons at a seashore, *Woman with a Clarinet* (1954), *January Jubilee Ladies* (1960), *Seated Nude* (1955), *Reclining Figure* (1955), a photograph of a rumpled bedsheet, and a photograph of a note on adhesive tape pasted over an out-of-focus view of the loft from *Wavelength.* There are two more photographs: One is of the artist at eight (mentioned above): "I'd heard that if you took a photo in this position the feet would appear gigantic. So I asked my sister Denyse to take this of me (1936). I also did a pastel version."[2] The last photograph is of a deserted, overgrown landscape with an unusable swimming pool.

The photographs in *A Survey* seem to provide a straightforward view of the past, but this is not necessarily so. Photo albums are evidence of the so-called truth, but whose truth do they show? In looking at such an assemblage, every spectator will construct a different story of what they mean. So such snapshots enforce the past and yet distort. They recall the past in a myriad of ways and, therefore, enforce and yet distort memory.

His catalogue nevertheless provides vital clues to Michael Snow and his art. Like him, this catalogue is a combination of the orthodox and the unorthodox. In order to respond to this book in the way the editor/designer intended, the reader has to actively engage with it. Why this form? For one thing, the use of family and other photographs (not in the exhibition) invites the reader to think about who the artist is, especially his ancestry. The items from the show in the first part of the catalogue demonstrate what Michael Snow has accomplished since 1967. Then a selection of WW from 1962 to 1967 follow. *Blind* is then

illustrated. Then *First to Last* and *Ocul* are juxtaposed — like *Blind*, they are about sight. The final assemblage ranges from 1955 to 1960.

In his introductory statement for the catalogue, William J. Withrow, the director of the AGO, provided an excellent evaluation of that publication: "Michael Snow himself designed and supervised the book's production, as both a contribution to and a comment on, his life and work to date. In its almost cinematic progressions, pivotal moments, and thematic changes, the book becomes a lucid exposition of the way his mind works."[3] Just as he calls attention to his roots in the family photographs, the artist invites the reader of the catalogue to look at the works in a vastly different way from the actual exhibition, which moved forward chronologically. The catalogue zigzags backward and forward and, in the process, constructs a gigantic jigsaw puzzle, which can be pieced together in various ways.

What the catalogue insists upon is that the artist is a product of his environment. There may be intrinsic, hard-to-unravel inner reasons why a person becomes an artist, but such a person can also manipulate and shape his vocation. In the case of Snow, the past is always present in his work, and the intermingling of recent works, older ones, and family ones in *A Survey* suggests that Snow felt that his family and his Canadian ancestry were dominant in his formation; in surveying his life experience and his accomplishments, those two factors shaped his understanding of who he became as man and artist.

In reviewing the exhibition, the American critic Gene Youngblood claimed: "[T]he installation is best viewed as a purposive and teleo-logic system which progresses [through many movements] and thus becomes a microcosm of modern art in our time. It is not, however, a model of that art, for [one of the] insights afforded by this exhibition is that Snow has worked predominantly outside the mainstream in his career, primarily in advance of the trends." In discussing Snow's work after the WW, Youngblood emphasizes accurately that the artist had become "very much involved with process as manifested in objecthood and seems to be striving toward ever more precise statements regarding natural and man-made objects as records of their own process." Overall, he saw Snow as attempting to resolve the modernist debate initiated by Cézanne between object and concept.[4] In *Canadian Forum*, the artist

Ross Mendes wondered if the "emphasis on ideas didn't draw attention to the artist. Like an intellectual arrow saying 'Look at me. Look at me.' Instead of, 'Look at this.'"[5] For Snow, the distinction was meaningless because his art is a reflection of himself.

In addition to paying close attention to the artist's accomplishments, *A Survey* provided ample evidence of two directions Snow was taking. In particular, he had begun to expand his repertoire into photography and into works that explore the Canadian Wilderness.

CHAPTER SEVENTEEN:
THE PAINTERLY PHOTOGRAPH

From the time of the invention of photography, the notion that it can be considered a fine art has been a subject of fierce debate. How, for example, can a photograph of a landscape bear any just comparison to a painting of the same subject? In painting, the sensibility of the artist selects what to depict — that person can make a naturalistic representation or the result can be rendered in any number of stylistic manners. On the other hand, the photograph, an illuminated image seen through a lens, is a representation created by a series of chemical reactions. Paintings, the argument goes, are the works of humans; photographs are the products of machines.

In this controversy, it is often forgotten that the sensibility of the photographer decides what to include in a frame, how to light the subject, and how to manipulate the negative. So, it can be said that the image in a photograph is a product of human creativity. On the other hand, the artifact — the photograph itself, its surface — is usually seen as being of no interest. The resulting images often look so integrated into the paper stocks on which they are printed that there appears to be no separation between image and paper. In other words, they lack the texture that oil paint can have on a canvas or the penetration of colours that can be discerned in many watercolours. On such terms, painting is privileged as a real art; photography is not.

The favouring of one form over another has many ramifications. The photograph, it can be asserted, in its recording of an object, captures

the essence of that object in a way that painting never can. If the object depicted (its ontology) is the central concern of a work of art, the edge can then be awarded to photography over painting. In this regard, Snow feels that the "miraculous freezing or catching an instant of an action is a factor in the history of photography" — obviously it is one in his own practice as a photographer.[1] More particularly, in his photo works he remains fascinated by the "stasis of the stopped-time photographic image."[2] Despite his interest in photography, Snow was clear that he did not want to undertake "art photography." To avoid doing so, he made "available to the spectator the amazing transformations the subject undergoes to become the photograph."[3] His work in this genre is underscored by this conviction: "[P]eople generally look through photographs to the subject with the kind of primitive faith that they are being shown the subject. I'm involved in a certain kind of skepticism that is just pointing out that the photo is a shadow of some subject."[4]

Photography has often been scorned because some feel that it does not contain the kind of aura possible in painting. Walter Benjamin defined "aura" thus: "A strange weave of space and time: the unique appearance or semblance of distance, no matter how close it may be."[5] It could be argued that the artist's presence — his aura — can be detected in a painting much more readily than in any photograph. In order to have an aura, a piece of art has to be separated (be distant) from its original incarnation although it must be closely connected to it. According to this line of argument, photographs are not sufficiently separated from what they depict.

Snow rejected these assumptions. Well aware of the differences between painting and photography, he chose photography for its ability to render "stasis" and "stopped-time" — new ways of exploring change. This was not a renunciation of painting as much as it was an attempt to explore objects in a way that painting could not, for him, any longer accomplish. In this agenda, immediacy is paramount. In the late 1960s, he felt that photography was the best form for exploring the self-referencing work of art in the very moment in which it is created. In his photographic works, Snow and other photographers of his generation rejected the standards by which photography had been elevated to the status of a fine art.

—————

The promotion of photography in the United States as a fine art was pioneered by Alfred Stieglitz and further developed later by Edward Weston and Ansel Adams, two of the founders of Group f/64, the group that advocated the use of great depth of field in the rendition of landscape and the nude. All three rejected the notion of "pictorialism," in which photography competed, often to its disadvantage, with painting. Diane Arbus was among the American photographers who took fine art photography in a new direction in her depictions of the marginalized, whom she often showed as grotesque. In so doing, she combined the surreal with strong formalist values. Garry Winogrand was a street photographer who used his strong powers of observation to produce many memorable images.

Snow has never been interested in making fine art photography. Like his contemporaries Ed Ruscha, Douglas Huebler, Mel Bochner, and William Anastasi, he has employed photography as a means of recording process and as a method of uncovering new ways of thinking about art. For him, photography is about the unveiling of what the mirror eye of the camera can reveal as opposed to what the eye of a painter can accomplish.

This distinction can be made another way. Painting is often seen in iconic terms: in recreating people, objects, and places, it, in a variety of ways, reproduces their aura, their essence. In contradistinction, photography is often considered indexical: it is so closely related to what it reproduces that it contains "traces" rather than "essences." This point is used by those who argue that painting is a fine art whereas photography is a mechanical one.

The dichotomy between painting and photography is, for Snow, a false one. Central to his practice is his quest to uncover painterly qualities in photography — in particular to discover how the thin surface of a photograph can be made painterly.

His exploration of photography opened up a whole new direction in Snow's work because it allowed him to explore how, at the moment of its taking, the photograph becomes a shadow of reality that can be transformed into art.

Once an analog photograph is taken, the subject is metamorphosed through a chemical bath into its representation on usually thin

paper. In this process, the photographed subject loses its primary identity when its negative is printed. Its new, secondary identity, it can be argued, does not have the separation that can be obtained in the fine arts. Photography is felt by some to be too close to what is represented — and thus not able to contain an aura.

In his practice, Snow deliberately bypassed this issue. As Amy Taubin has argued, "In Benjamin's terms, Snow is using photography, not in the service of 'the decay of the aura', but paradoxically, to affirm its presence. He refuses to use photography to 'bring things closer spatially' ... [His] photographs are records of, situated within and conditioning, each work; they record their own history. As history, they are reinforcements of the aura."[6]

In November 1972, when the Center for Inter-American Relations in Manhattan hosted an exhibition of fifteen works and fifteen films by Snow, Peter Schjeldahl in the *New York Times* labelled the artist as someone deeply committed to ideas resulting in "the kind of Conceptualism [that] aims ... to eliminate chanciness and obscurity from the work of art, leaving a content of clear and structured 'information.'" For this critic, this show "reflects modern experience.... This space-age art has still got a long way to go before it can rival the transcendent power of those other, ancient 'media,' painting and sculpture."[7] Well aware of this, Snow would more and more attempt to invest photography with painterliness.

Some early experiments with Polaroids led to *Authorization* (1969) in which the camera was placed on a tripod. On the centre of a framed mirror, Snow made a rectangle — the size of four Polaroid prints. "The image that the first Polaroid took," he recalls, "was of the camera, a bit of the tripod and about half my head."[8] He took that shot and glued it to the left-hand corner of the rectangle. Then he took the second shot and so on until the entire rectangle was filled. In the fourth photograph, the head of the artist is visible. Then Snow took a final photograph — the size of a single Polaroid — that he attached to the upper left-hand corner. Here, his obliteration is complete.

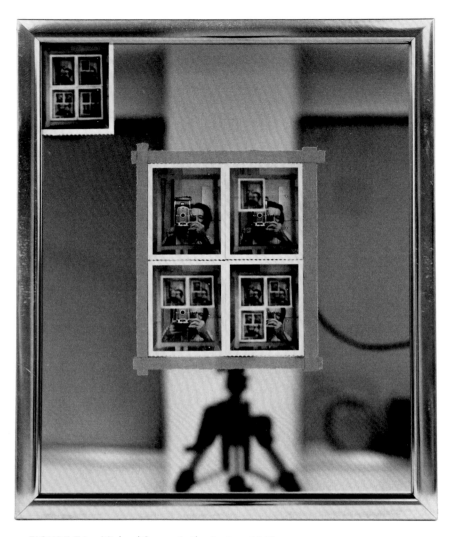

FIGURE 76. Michael Snow, *Authorization*, 1969.

The process by which the complete image came into being is fully revealed to the spectator. In some ways, it seems a reasonably easy image to "read" or interpret. This is far from the case, however. The title of this photograph suggests that the artist (the author) has authorized this image of himself. However, the central picture mirror area completely obliterates the maker, although he can be seen in four of the original Polaroids and in three of the smaller ones. The person likely to

catch a much fuller glimpse of herself or himself is the spectator whose reflection appears when walking by the framed mirror-photograph.

Several intriguing questions are posed by this piece. Does the artist here obliterate his own image in a kind of "death of the author" trope? Is this picture a piece of autobiography or a self-portrait? Does it belong to the realm of the real or the fictional?

This photograph should not be taken as a piece of autobiography. It is a work in which the artist uses the genre of self-portraiture not to reveal himself; it could be said that the artist is hiding himself — disappearing from view before the viewer's eyes. This image is a statement about the nature of art, not about the life history of the artist. Michael Snow is suggesting that there is no such thing as a stable truth. There can be attempts at telling the truth, but such possibilities are evasive and, eventually, unsatisfactory.

Authorization is a turning point in the artist's career. Heretofore, he had played with the notion of the instability of truth and the disparity between the real and the imagined. In this photograph, he tackles this issue straight on, and such investigations are at the heart of the work he does in the next decade. More directly and emphatically, he made pieces of art that document their creation and thus self-reference their existences.

That process is evident in two works from 1970 that were not in the retrospective. *Venetian Blind* (1970) is a sequence of twenty-four Ektacolor photographs in which the face of the artist — eyes closed — in the foreground prevents the viewer from seeing the various parts of the legendary city of Venice in the background. Again, these are portraits — this time with the appearance of snapshots — but, crucially, the creator does not disappear from view. In fact, he acts as an agent for obscuring the "tourist" views behind him. In some ways, the process here is the opposite of what is seen in *Authorization*. In looking at *Venetian Blind*, the viewer can experience frustration at being deprived of the "Venetian" at the expense of the "Blind" of the artist. These photographs can be considered one of the first instances of a now common form of photography — the selfie.

Sink employs a carousel projector with eighty slides and a colour photograph. The slides are projected every fifteen seconds alongside

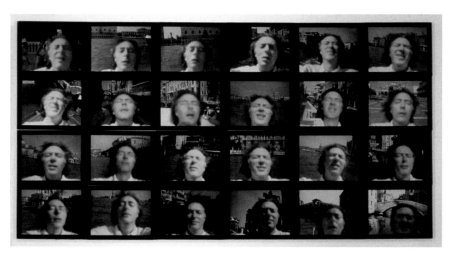

FIGURE 77. Michael Snow, *Venetian Blind*, 1970.

the photograph — slides and photograph (a print of one slide lit by white, "normal" light) are 62.9 x 64 cm. The artist recalls: "The sink had become such a mess through my negligence, the result of painting-related stains. There are also coffee cups and paint-stained brushes sitting on it." The slides, through the use of coloured gels and various illuminations, change the appearance of the sink — sometimes it looks more disgusting than it does in the photograph but in other combinations, the sink "becomes quite lyrical; sometimes there is a transcendent Rothoesque beauty."[9] The English art critic John Russell was taken with a piece he felt should not have been successful: "Snow gives an architecture-in-time to what should be monotonous but is paradoxically an immensely varied experience."[10]

The sink can be seen as a metonymy for the artist who, in the first place, created the mess and then recorded his handiwork in various manifestations. It could also be said that this work is, in part, an attempt to rescue the sink from its state of depravity. Again, this process can be read as a form of self-portraiture, not autobiography. The artist contains within himself the power to redeem what he has created imperfectly and transform it. "Despite my sloppiness," Snow observes, "the sink struck me as a beautiful elegy for painting, and I decided to do a 'painting in light' of it."[11]

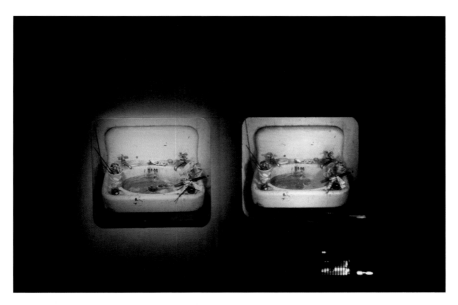

FIGURE 78. Michael Snow, *Sink*, 1970.

In *Authorization, Venetian Blind,* and *Sink,* the artist creates alternatives to painting, in that the traditional use of the texture of brush strokes on the surface of a canvas is deployed in a markedly different manner. In this regard, the artist has provided important clues to understanding this process: "I am trying to continue the soloist aspect of painting without painting. I have added the camera and its products to the traditional tools of the painter/sculptor." For Snow, such works are "objects of contemplation which I hope will continue to add to their dialogue with the viewer."[12]

In these works, the artist is an actor "in … events-that-become-objects," events that, through the mirror that is a camera, "are transformed to become photographs."[13] Just as earlier paintings in the Western representational tradition flattened the three-dimensional world into two, photography by its very nature does the same. It creates a "mirror" of the world. In that sense, photography in Michael Snow's practice becomes a continuation of the painterly tradition.

Press (1969), *Authorization* (1969), *Venetian Blind* (1970), and *Field* (1973–74) show the influence of cinematic practice in that each is a series of related photographs in which the concept of duration is approached

in various ways. *Field* displays in fourteen gelatin silver prints the results of pressing objects (including an egg, a cigarette, and a pair of women's gloves) together between sheets of Plexiglas. Plexiglas, polyester resin, metal clamps, and a wooden base are added to provide evidence of how the photographs were made. In two images, Michael Snow — his face obscured by the camera (in a manner reminiscent of *Authorization*) — reminds the spectator of the persona behind the creation.

Ladders became another preoccupation in several photographic works. In these instances, Snow blends his interests in cinema and sculpture. In bringing these three genres together here, he focuses

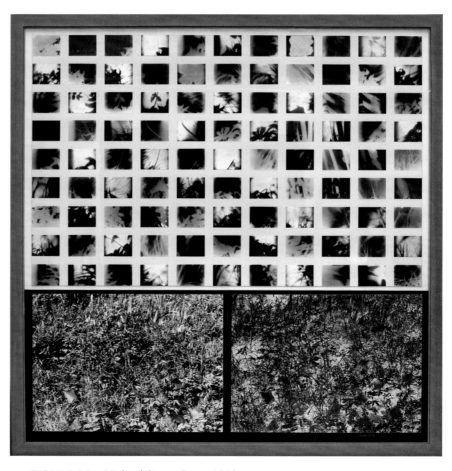

FIGURE 79. Michael Snow, *Press*, 1969.

on the nature of light. Like *Quits* and *Shunt*, *Of a Ladder* (ten selenium-toned gelatin silver prints, fronted and backed with Lexan) is positioned on both the wall and the floor. Although the work can be described as sculptural, it also resembles a series of film stills. This installation shows the distortion that occurs when light creates a shadow on the wall. The two prints on the floor show the bottom of the ladder. The other images were created, Snow recalls, by illuminating "the ladder a bit more brightly at the top. With the camera and tripod always in the same placement, I then photographed one 'frame' of the ladder after another."[14] The result is that the eight photographs on the wall are placed in small intervals so that the wall itself becomes a ladder. The conceit is that a series of photographs of a ladder becomes a ladder.

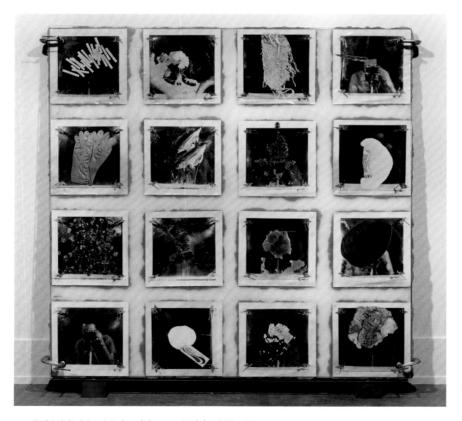

FIGURE 80. Michael Snow, *Field*, 1973–74.

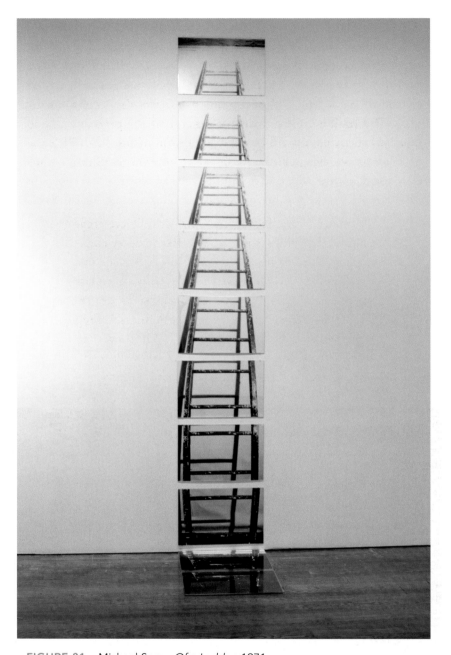

FIGURE 81. Michael Snow, *Of a Ladder*, 1971.

The book *Cover to Cover* (1975) presents a sequential series of photographs that have an even stronger cinematic quality to them in that they follow a protagonist (Michael Snow) through a day. Each page records the front (recto) and the back (verso) of the action being recorded by two photographers. At one point, the reader is forced to turn the book upside down in order to follow the "action" of the story. The book becomes cinematic because, if the pages are turned rapidly, it becomes a flip book (an early form of film) in which the protagonist is seen moving rapidly from location to location. One reviewer commented:

> The book is graphically exciting with all the trappings of flips, flops, split and multiple imagery alignments.... It often reads like a cinematic film strip, one frame spilling into the next. Forcing the eye to collate the action of spins, zooms, and pans which are recreated by page alignments and possible shuffling of the entire book. [This book can be] read cover to cover — posterior to anterior/anterior to posterior, self-creating passages of the protagonist's journey.

FIGURE 82. Michael Snow, spread from *Cover to Cover*, 1975.

FIGURE 83. Michael Snow, still from *Two Sides to Every Story*, 1974.

This book narrative is very similar to the film *Two Sides to Every Story* (1974) done at about the same time. In book and movie, each side of an image has a counterpart, and the reader or viewer is presented with double-sidedness. In the film, both sides were filmed continuously in a studio from directly opposite points of view. At one point a woman paints a green disk on the transparent screen and passes it through to the other side. Gradually the spectator, as Jean Arnaud points out, "identifies the real screen in front of him, and which he sees in the two films, as well as the room in which he finds himself and where the film takes place." In the end, the viewer wonders "if the woman didn't tear the actual screen projection."[15] Book and film attempt to give sculptural presence to the two dimensional as in *Of a Ladder* and, in so doing, establish new ways of experiencing books and cinema.

CHAPTER EIGHTEEN:
THE CANADIAN WILDERNESS

Upon returning to Canada, in November 1971, Michael and Joyce purchased a house at 137 Summerhill Avenue in Toronto for thirty thousand dollars; their new home was across the street from Canadian Pacific Railway tracks and was situated on the corner of two streets at the end of five houses surrounded by trees and bushes.

Earlier, in 1970, a year before settling back in Toronto, the couple taught at the Nova Scotia School of Art and Design. There, Joyce became preoccupied with purchasing a summer home. Nothing came of this plan, but then, when they were in Newfoundland that autumn, Joyce persuaded her husband to drive down a rustic rural road that eventually turned into rocky terrain. Since it was not possible to turn around, they continued onwards. Their car got stuck, and they were forced to walk out to get help. The land, they noticed, was stunningly beautiful.

The couple finally reached a fishing village where they were able to hire someone to rescue their car. On the journey back to their car, Joyce asked the driver if any land in that area was for sale. As it turned out, this man and his brother had some. Snow's recall of the turn of events is sketchy: "I think we must have stayed there a day. I seem to remember sleeping in some cabin."[1] The couple decided to lease two acres on a cape on the southwest coast on the Gulf of St. Lawrence; in the summer of 1971 they purchased them.

Snow laid out stakes for a nine-metre-square log cabin. Local workers cut and put up the logs; he did everything else — windows, interior, and furniture. There was no running water or electricity and the cabin was eight kilometres from the nearest village.

The return to his native land — especially the purchase of property in Newfoundland — initiated a new, more direct concern with Canadian subject matter in the artist's work. As discussed above, this commitment is first of all evident in the complex intertwining of photographs — especially of Chicoutimi — with reproductions of Snow's avant-garde works in *A Survey*.

This preoccupation surfaces in his second major film, *La Région Centrale* (1971), shot one hundred miles to the north of Sept-Îles in Quebec, which meditates on the nature of time; the velocity of the camera here introduces an entirely different transformation of space from *Wavelength*.

Snow had used rooms in three of the films preceding this one. In each instance, he hoped that viewers would not feel confined to a specific realistic place but would, instead, feel like they were inhabiting an area of metaphysical space. Since he wanted to do much more with panning, landscape became the genre of choice in *La Région Centrale*, which would take place in an "open" space not confined to the rectangle shape of rooms. In essence, he was now looking for the "unbounded." Soon he realized that there was no kind of film camera that would do what he wanted. Eventually, he met Pierre Abbeloos, a camera modifier at the National Film Board in Montreal, who built the "camera activating machine."

One early reviewer provided an accurate description of what this 190-minute film accomplishes: "In the first frames, the camera disengages itself slowly from the ground in a circular movement. Progressively, the space fragments, vision inverts in every sense, light everywhere dissolves appearance. We become insensible accomplices to a sort of cosmic movement."[2]

The viewer experiences the wilderness — one of the prevalent tropes in Canadian art — in a completely new way. Rather than looking at ground level, the camera swoops in all kinds of directions over primitive terrain. Members of the audience are forced to see landscape

in a revolutionary manner and, in the process, reflect on their place in it. Without the semblance of a traditional view, it is possible to experience — and imagine — land in a new way. The camera's view of the wilderness is mediated by Xs that divide the film and by sightings of the shadow of the camera.

Annette Michelson has pointed out that Snow's intent in making this film can be linked to Kant, particularly this passage from the German philosopher: "Since through the senses we know what is outside us only insofar as it stands in relation to ourselves, it is not surprising that we find in the relation of those intersecting planes to our body the first ground from which to derive the concept of regions in space." She also connects this film to the landing on the moon of Apollo 11 in July 1969: "Snow's film conveys most powerfully the euphoria of the weightless state; but in a sense that is more intimate and powerful still, it extends and intensifies the traditional concept of vision as the sense through which we know and master the universe."[3]

Almost fifty years later, in the summer of 2018, Snow was one of a small group of artists commissioned to make short films for IMAX.

FIGURE 84. Michael Snow, still from *La Région Centrale*, 1970.

In the ten-minute *Cityscape*, he employed a similar methodology as *Centrale*. This new work, filmed on Centre Island, displays the Toronto skyline. The camera pans slowly, returns to starting point and then moves rapidly and then even more quickly; the camera also pivots in the manner of the earlier film.

The purpose-built camera-activating machine entered into a new sphere of existence when it became *De La* (1971) and joined *Blind* and *Scope* in sculptural works that involve the participation of the spectator. In its second incarnation, a black-and-white live video camera is mounted on the original camera, and the machine now moves in orbit displaying the space in the room where the sculpture resides; its travels are captured on four monitors and images of the audience often swim slowly across the screen.

Another major piece involves the work of the members of the Group of Seven and Tom Thomson, who invented a new approach

FIGURE 85.
Michael Snow,
De La, 1971.

FIGURE 86. Production still of Michael Snow while making *La Région Centrale*, 1970.

to landscape painting that eschews the European tradition and established a distinctively new Canadian modernism in the arts. To create *Plus Tard*, Snow visited the National Gallery of Canada, photographed twenty-five paintings and placed each photograph in a heavy black frame. As an entity, these photographs, when hung together, create a new, alternative, gallery.

In describing this photo series, Snow has observed that a crucial aspect of them "is that each photo involves a different use of gesturing which came while shooting. The gestures were each enacted at different speeds, slow to fast, but also, for example, moving then hesitating, slow to fast, then moving again. Some photographs did not contain a gesture. The gestures were like painting brushstrokes in my concept."[4]

The language the artist uses here is very revealing. "Gesturing" or "the gesture" is, as we have seen, a term usually used to describe abstract expressionist art. By inserting that phrase into his discussion, Snow is suggesting that he is updating the paintings of the Group of Seven and Tom Thomson.

Snow is doing several other things. He intimates (correctly) that these legendary paintings are usually seen in a confined, somewhat backward way; they have become museum pieces that enshrine a now old modernism. They are often valued as the summation of Canadian painting and, as such, no room is left for other Canadian painters to create newer modernisms. By transferring the paintings into photographs, by the incorporation of gesture, and by including the museum walls against which the paintings are hung as parts of the photographs, Snow invites the viewers to reimagine and thus reinvent these master works. He admires the paintings, but he is intimating that they must be seen in a new way. If that occurs, there is the possibility for newer forms — still distinctively Canadian — to emerge.

Plus Tard is a work that has garnered immense praise and contempt. Ben Lifson in the *Village Voice* understood that this series of photographs was about "how we look at pictures.… Snow tells us things about how we *don't* look at exhibitions themselves. And details like light switches, exit doors, and shadows of walls … how the context of art creates the art, becomes part of it, and, when viewed by the artist, becomes art itself." Despite his sensitive response to how

FIGURES 87, 88, AND 89. Michael Snow, photos showing *Plus Tard*, 1977.

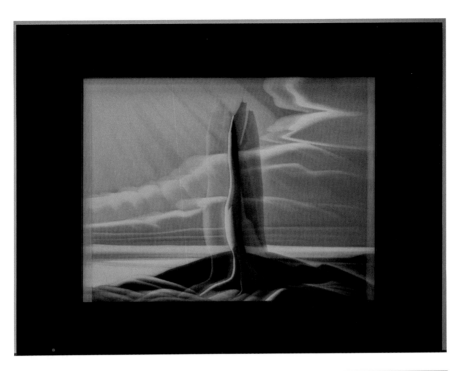

this series of photographs interact with each other, Lifson feels that it ultimately turns into an attack on Tom Thomson and the Group of Seven: "Much later, it implies, a Canadian has succeeded in transcending his predecessors' provincialism, and at their own game of landscape art to boot. It's mean-spirited work, as well as dull."[5] Adele Freedman in the *Globe and Mail* responded to this work in a completely different way: "The movement of the still camera during the exposure has made abstractions of images which were already abstractions of nature. Snow has painted over the originals using his camera as a paintbrush.... But there are temporal layers as well. Snow has been imposing himself again — overlaying the past with the present and making a new unity of what was formerly a collection of separate paintings."[6]

CHAPTER NINETEEN:
A GIANT SENTENCE

Upon finishing work on *NYEEC* in 1964, Snow wanted to make another film that explored the dialogue between sight and sound in the way that the cinematography of the stationary WW is challenged and disrupted by Ayler's music. In other words, he wanted to work again on the discrepancy between the two modes. He even made notes in 1963 envisioning a "dialogue" film. Plot elements were, as in *Wavelength*, to be ignored; the dialogue was to be as banal as possible so that the disjunctions/connections between word and sound could be explored without any unnecessary distractions. Jonas Mekas attempted to help Snow obtain a grant for this project but nothing materialized.

Six years later, the artist began work on *Rameau's Nephew by Diderot (Thanx to Dennis Young) by Wilma Schoen* (hereafter *Rameau*). The film, over four hours long, is built, according to Snow, like a "giant sentence."[1] The twenty-five scenes are of varying length — from three to fifty minutes. It is truly, as the artist once pointed out, a "talking picture."

The intellectual conceits behind the film are manifold and layered. First of all, Wilma Schoen ("beautiful" in German) is an anagram for Michael Snow. Dennis Young, the curator at the Art Gallery of Toronto who oversaw Snow's retrospective, had given the artist the Penguin edition of *Rameau's Nephew*. Denis Diderot was the editor and chief contributor to the *Encyclopédie*, wherein he used the opportunity to write many entries antagonistic to orthodox points of belief. The composer

Jean-Philippe Rameau was an expert on the theoretical aspects of harmony — Diderot was an admirer of his. Jean-François Rameau was petulant, jealous of his uncle, and never stuck to any project he initiated. The book is cast into the form of a dialogue with the "he" being the nephew and the "myself," the composer.

Diderot's *Rameau's Nephew* is to a large extent a Socratic dialogue with the older man taking on the role of the wise philosopher. In some ways, Michael Snow assumes the role of both the composer and the Greek philosopher in that he intends to educate his audience in the intricacies in the relationship between words and sounds. In this context, the viewer is the nephew.

Martha Langford has commented on this film's extraordinary range:

> *Rameau's Nephew* is episodic, situational, without plot or reprise. It is a long film — four and a half hours — but is cleanly divided into segments that take up various aspects of the theme. The players are mainly gifted amateurs, though Snow did engage professional actors for the so-called Fart scene, which involved learning to perform their lines backward. Elsewhere he featured already developed skills, such as the ability of the Canadian painter Dennis Burton to speak "Burtonish," a language based on English but different in its arbitrary fracturing of words and repurposing of punctuation, or [Snow's] own capacity to make music at the kitchen sink.

Rameau's Nephew, which is sometimes described as polyphonic in its musical sense, is generally analyzed as a "talking film." At this stage in his cinematic work, however, Snow was averse to any storytelling structure. His desire, frequently expressed, was to make image-sound compositions. If there is no obvious narrative, the "film's images — Snow's settings and framings — are unforgettable, for their colour, if nothing else. Holding this film together, leading the viewer from scene

to scene, are the extraordinary breadth of its variations on [its themes] and its sometimes mute comedy."[2]

As mentioned, Diderot used the vehicle of his encyclopedia to attack rigidly held belief systems, and in his film Snow takes issue with conventional views of the relationship between sight and sound. The artist is also taking the opportunity to make his film encyclopedic — it will deal with its chosen subject in a manner that covers it from almost every conceivable angle. However, the film ranges far beyond its initial premise to include discussion of illusion, allusion, the so-called real, so-called truth, and so on. In this sense, it becomes a springboard for Snow to discuss a wide range of issues that he had considered in his previous work. (Other works that are encyclopedic in that they conjoin a wide variety of images on a single plane include *8 x 10* [1969], *Press* [1969], *Field* [1973–74], and *Timed Images* [1973].)

In her assessment of the film, Regina Cornwell comments on the range of encyclopedic sounds it explores:

> The recorded sound is representational and abstract involving music, speech, animal calls, other outdoor as well as machine noises. Sync and non-sync sound are used. And there is a wide range of variation in the uses of sync sound: playing sync material backwards, as in [sequence] 12; recording undecipherable speech patterns as in sequence 9 (Burton), cataloguing sounds made through breath and speech exercises as in [sequence] 1 (Snow whistling) and [sequence] 15 (the embassy). It also records pissing and sink sounds.[3]

An early reviewer, Bill Auchterlone, described the structure of the film as a series of containers.[4] Put another way, as Cornwell suggests, the segments of *Rameau's Nephew* can be seen as a series of frames:

> [C]olour transparencies are used in a number of sequences. Sometimes they function to frame and to reframe the image.... Framed numbers appear in

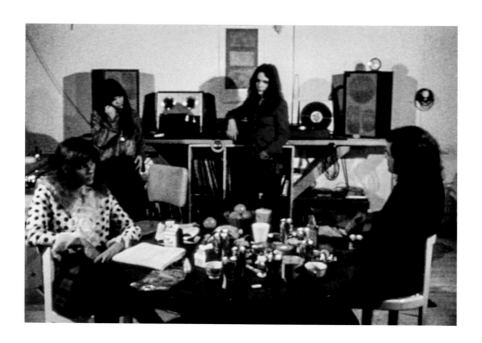

FIGURES 90 AND 91. Michael Snow, two stills from *Rameau's Nephew*, 1974.

several sections of the film.... And in the tradition of Boccaccio, stories are framed.... Tableaux, poses, events, standing out in time, become analogues for the practice of framing.[5]

For Snow, framing has always been a central issue: the frame is a form of container and a metaphor for the window-like structure of a canvas. In this film, he adapts various ways of inserting many kinds of frames as a way of controlling his speculations on the many ways that sound exists and functions.

Rameau is a pivotal work in Snow's career as a filmmaker because, with the possible exception of *NYEEC*, his earlier cinema had emphasized visual perception. With his return to Toronto and his much more active involvement in music making, Snow constructed a work that dealt with the complexities of sound making. The ambition of this project was significant. The scope of that artistic ambition had an impact on the scope of the work: its length is due in part to the fact that the artist tackles in a single work the nature of sound whereas visual perception had been dealt with in eleven previous films.

Hearing Aid (1976–77) is another bold attempt to redefine a genre — this time, sculpture. When this work was shown at the Vancouver Art Gallery as part of the 1978 *Another Dimension II* exhibition, Art Perry commented on how it "illustrates the extent to which contemporary sculpture has pushed its ability to comment on our space. At one time, sculpture was a static exercise in manipulation of marble and metal that drew concrete forms into our space. A twisted metal form was seen as visually occupying a pocket of space, and that's where our artistic curiosity ended."[6] The components of *Hearing Aid* are a metronome in a corner and then four cassette players arranged at increasingly long distances from each other. The work is played thus: #1 records the metronome playing; this recording — accompanied by the actual metronome playing — is then recorded by #2. This process continues until #4 is reached. The finished work consists of

the simultaneous playing of the four tapes and the metronome. The sound of #4 — the farthest from the metronome — is obviously more degraded than #1, the nearest.

In many ways, this work extends the issues treated cinematically in *La Région Centrale* to sculpture. Just as *Centrale* explores cinematic space in a novel series of camera movements, the use of the metronome and four tape recorders extends the kind of space in which a sculpture can exist.

CHAPTER TWENTY:
NO LONGER IN PLAY

During visits to Toronto in the 1960s, Snow had sometimes played with the Artists' Jazz Band (that included, among others, Gord Rayner, Graham Coughtry, Robert Markle, and Terry Forster). Upon his arrival back, he, as he recalled, rejoined that group. Having worked as a professional musician, Snow had some doubts about attaching himself to an amateur group. Then he found the experience magical:

> They didn't "know what they were doing" at first and didn't care. Now they know and don't care. The music always takes everybody by surprise. Chance + fate + skill.... The music grew until sometimes it wanted someone else to hear it. The process is spontaneous group composition.... The art-making-seeing-hearing experience can colour everything or transform anything. Art sense ebbs and flows but it rarely turns off.[1]

A bit later, at the invitation of the drummer Larry Dubin, Snow joined a group of experimental freestyle players. That led him, in 1974, to become one of the founders of the Canadian Creative Music Collective (CCMC), a free-music group (still active) whose mandate is to play improvised music. (Snow plays on the piano and synthesizer.)

FIGURE 92. CCMC at the Music Gallery, 1978. From left to right: Casey Sokol, Al Mattes, Nobuo Kubota, and Michael Snow.

For Snow, improvised music became (and remains) a form of the gesture practised by American expressionists and by himself in some of his early abstracts. According to him, it is really an outgrowth "from the ensemble style of early Jazz," in which the rhythm section members typically improvised (made up) their accompaniment parts.

FIGURE 93. CCMC in concert at Arraymusic, Toronto, 2015. From left to right: Michael Snow, Paul Dutton, John Oswald, and John Kamevaar.

FIGURE 94. Michael Snow, still from *Snow in Vienna* by Laurie Kwasnik, 2012.

Snow now returned to a schedule reminiscent of the early days of his marriage in Toronto. He and Joyce worked separately but discussed their work and provided each other with support and encouragement. He was often absent in the evenings because of music-making

activities. The couple shared some strong interests, such as protesting the appointment of an American, Richard Wattenmaker, as chief curator at the AGO; they were also actively involved in forming the Committee to Strengthen Canadian Culture.

But things did not fall into place. During the making of Joyce's narrative film about Tom Thomson, *The Far Shore*, conflicts between the couple increased markedly, and so, four years after moving back to Toronto, Michael and Joyce purchased a house at 497 Queen Street East as a place that Joyce could use as a studio and, when she wanted to, live. Michael recalls that they had debated whether having two places might be a solution. He also states that the purchase of the second house had been "part of us coming apart"; at that time, he and Joyce wondered whether "it might be a good idea for us to have two separate places that were complete, not that we were totally separating, but that we would try that." At that time, he recalls, "whatever balancing acts we were involved in [that] were working before," no longer were in play.[2] Reflecting further, he added: "We were just kind of going through the motions. It wasn't exactly boredom ... all I can say ... it was an imitation marriage."[3]

For her part, Joyce had reached breaking point regarding Michael's womanizing. She had tolerated such behaviour in New York City because, in a sense, she and Michael had been outsiders there and had to join forces in order to survive. This state of affairs obviously did not hold true in Toronto. Joyce may have felt emotionally stronger in her birthplace, but she still remained dependent on Michael. As she sensed his increasing detachment, she prepared to take steps to protect herself.

Joyce put it this way: "I had my husband on a pedestal. I got tired of having him on a pedestal. I started seeing him as a person and stopped elevating him. The more I changed my behaviour, the less he liked it. He said I was being very boring.... I couldn't stand it anymore ... Eventually I got the message: I'd been beating myself up for years, holding on to a marriage that was dead, that was killing me. I started to do things for myself."[4] In fairness to Michael, it should be pointed out that Joyce had resumed her romantic relationship with George Gingras in about 1975, just at the time she felt that her ties to her husband were disintegrating. However, his encounters with other women tended to

be of short duration. What had been a tolerable status quo in New York City slowly unravelled back in Toronto.

In 1982, while the couple were severing their ties with one another, they had to join forces because of a legal fracas. Sixteen years before, Joyce, while visiting Hollis Frampton, noticed two painted-on canvases in the garbage of her friend's building. They were the work of Frank Stella, who also lived there. Michael, who never looked at the canvases before 1981, agreed with Joyce to market the paintings. In 1982, the Mazoh Gallery in Manhattan placed them on sale. Stella, who was an international art star by this time, was outraged. He claimed that the canvases had been improperly removed — he had discarded them because they were water damaged and clawed by his cat. Selling such works, he felt, would be damaging to his reputation. When the case was heard in New York, the judge dismissed the case because it was a trivial misunderstanding the parties could settle between themselves. Stella, for the sum of one dollar, released Michael and Joyce from all actions, and Stephen Mazoh returned the paintings to Stella.[5]

The disintegration of the Snow-Wieland marriage took place in stages. They separated early in 1975, but only about four years later did Michael begin divorce proceedings when he informed Joyce that he wanted to marry Peggy Gale, fifteen years younger than he. The delays caused by changing the Wieland-and-Snow joint company into two separate ones and also selling off a number of small properties took a considerable amount of time. The final decree for their divorce was not granted until January 1990. Peggy and Michael married on April 12, 1990.

Peggy moved in with Michael in 1981. After two miscarriages, their son, Alexander, was born on November 24, 1982. The birth of that child caused untold grief to Joyce and brought back her earlier wish to have a baby and being unable to do so. Joyce also had mixed feelings about making the end of her marriage final. She was particularly concerned about the Newfoundland cottage, partly on the grounds that she did not want another woman inhabiting that space with Michael.

Joyce's strong negative feelings can be seen in *Untitled (Murderous Angel)* from 1981, in which the angel is slaying a man whose face bears a strong resemblance to Snow. Despite setbacks in their relationship,

Michael sought to maintain a friendship between himself and his ex-wife and occasionally visited her. There were times when they were both at the cabin in Newfoundland.

An important factor in Snow's return to Canada had been Marie-Antoinette and other members of his family — aunts, uncles, cousins. He also felt that a new creative energy had, in his absence, taken hold in Toronto. Michael drew a great deal of comfort from his family; Joyce felt isolated, although Marie-Antoinette and Denyse remained deeply fond of her.*

Despite personal difficulties, Snow's ability to uncover all sorts of new creative openings seemed endless. His time in Manhattan had unleashed many uncertainties about where he wanted to go — even if his projects were to be in a wide variety of genres. He was very certain of his art — and his ability to exploit his talents fully. In his marriage, that was not the case. He often felt guilty about his behaviour and found it difficult to sort out his feelings.

* Denyse Rynard emphasized this point in conversation with James King.

PART FOUR
1979–1994

CHAPTER TWENTY-ONE:
BETWEEN ALCHEMY AND CHEMISTRY

By 1979, Michael Snow had become the best-known living Canadian artist — nationally and internationally. In 1972 he had been awarded a Guggenheim Fellowship; ten years later, he was elected to the Order of Canada as an officer (he became a companion in 2007).[*] Such acclaim came with a price. More and more was demanded of Snow by the art world, and if he seemed to falter, even momentarily, he became subject to adverse criticism. His remarkable success with the WW figures may have worked against him. Could he produce something to rival those creations?

[*] He has subsequently received a number of distinctions: Chevalier de l'ordre des arts et des lettres, France, 1995; Governor General's Award in Visual and Media Arts, 2000; Queen's Golden Jubilee Medal, 2002; Prix Samuel-de-Champlain (France-Amérique) 2006; and the Gershon Iskowitz Prize, 2011.

Snow has received the following honorary degrees: UQAC (Université du Québec à Chicoutimi, 2016); UQAM (Université du Québec à Montréal, 2008); Université de Paris I, Panthéon-Sorbonne (2004); Emily Carr Institute, Vancouver (2004); University of Toronto (1999); University of Victoria (1997); Nova Scotia College of Art and Design, Halifax (1990); and Brock University (1975).

He was Professor of Advanced Film at Yale in 1970 and Visiting Professor at Princeton in 1988. His other visiting professors include: Visiting Artist/Professor at MAPS (Master of Art in Public Sphere); Ecole Cantonale d'Art du Valais, Sierre, Switzerland (February 2005, January 2006); Visiting Artist/Professor at L'école Nationale Supérieure d'Art de Bourges, France (December 2004, May 2005); Visiting Artist/Professor, Ecole Nationale Supérieure des Beaux-Arts, Paris, 2001; Visiting Artist/Professor, le Fresnoy, Tourcoing France, 1997–98; and Visiting Professor, l'Ecole Nationale de la Photographie, Arles France, 1996.

He was able to do so but the results were far different from the WW. Since he constantly took risks, some results were more successful than others. If this artist's works are his biography, they demonstrate that his search for the right forms to encapsulate his vision was a restless one, far-ranging and demanding.

Snow's undertakings after 1979 expressed many ideas and utilized many different media. It can be said that his work flowed in a number of directions. One of the charges sometimes directed against him is that his work is too pluralistic, too willing to embrace a wide variety of genres. This observation might hold true for some artists, but Snow has mastered many approaches to making art. Unfortunately, that ability has made him suspicious in the eyes of some critics.

Constant in the artist's works is a focus on the nature of the existence of an art object. Two works — twenty years apart — demonstrate this. *Painting* (*Closing the Drum Book*) from 1978 is a colour photograph in a wood frame on a wood base — the base adds a sculptural quality to the work. The very title of this work calls into question the nature of its existence. Of course, the artist had long been interested in investing photography with painterly qualities. In the title, Snow also alludes to his earlier abstract, *The Drum Book*. In what sense, then, is this photograph called *Painting* bidding farewell to the earlier canvas?

FIGURE 95. Michael Snow, *Painting (Closing the Drum Book)*, 1978.

What the title is asserting is that the artist has discovered an *equivalence* to his earlier practice as a painter. The surface of the photograph displays a composite made of hundreds of colour patches. These collaged elements form an abstract pattern that references a past in the history of painting and Snow's own abstract canvases while at the same time creating a new form of abstract representation. Snow put it this way: The surfaces "photographed existed but not in the same way as the people, buildings, nature, and so on that usually comprise the subjects of photography. In *Painting* you don't know how big [the painted surfaces] were and in fact ... you don't even know whether they were those colours. So there's a really peculiar representational problem because it is not a painting, it's made of photographs of paintings."[1]

Twenty years later, in *Immediate Delivery* (1998), a backlit photographic transparency with gels and metal, the artist presents a different

FIGURE 96. Michael Snow, *Immediate Delivery*, 1998.

solution to the problem he was tackling earlier. Backlit transparencies — often very large, as this one is — cause the viewers to see whatever is represented in almost abstract terms since they have moved into a different sphere of existence: their size has increased and they have become silhouettes, lit from behind. Rather than using colour patches, Snow built a brightly coloured, temporary sculpture from gels, electrical and masking tapes, wires, string, and clamps. Most of the elements were placed directly on or pushed to the front of the Plexiglas plane. When squeezed together and photographed on a 10 x 12.5 cm negative, the result becomes the equivalent of an abstract painting. (The squeezing process used here is reminiscent of that used in *Press*.) There is a further irony at work. Since the temporary sculpture was constructed from the elements used to make a light box, the resulting abstraction references the kinds of equipment used in its making.

Completed the same year as *Immediate Delivery*, *In Medias Res* (a huge uncropped colour photograph glued on Lexan) is placed on the floor so that the spectator must look down on it. The view is of a staged

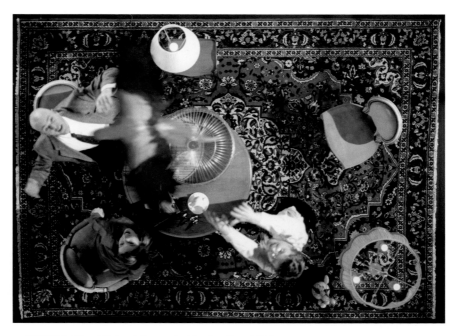

FIGURE 97. Michael Snow, *In Medias Res*, 1998.

incident wherein two men and a woman react with astonishment to the escape of a parrot. The man with the tie reaches up to capture the bird. However, the focus of the lens is on the Oriental carpet — exactly the same size as the photograph — beneath the three humans. The photograph shows three spaces: the carpet in focus at the bottom, the trio and the furniture slightly out of focus in the middle, and the bird distinctly out of focus at the top. Looking at this composition, the viewer is immediately aware of a strange sight as the bird threatens to enter his or her space. Less dramatic are the colours, although the multicoloured rug complements the colour of the bird. However, that similarity helps to underscore the fact that this picture of verisimilitude is anything but real because although the carpet, the three persons, and the bird may be "real," the photograph's complex layers create an abstract pattern. Here again, Snow attempts to inflect a photograph with painterliness. The spectator experiences the two-dimensional rendition of the three-dimensional in a moment of fixed time.

In 1992 Snow said, "[A]s art, the best photography I find lacking when compared to the best painting, but I've been attempting to balance the lack by adding the camera as a tool to the ones one might use in making painting and sculpture."[2]

The self-referencing work of art continued to be another preoccupation of Snow's. *Midnight Blue* (1973–74) inhabits four genres: sculpture, painting, photography, and pencil drawing. There is a ledge at the bottom made of sawed boards; the panel is a photograph of two blues and is obviously constructed of the same wood boards upon which the photograph rests; in the photograph is a burning candle; on the ledge is a small pool of real wax in front of the photograph of the candle. A frame, painted a light blue, surrounds the dark (photographed) blue. (The blue in the photo appears darker than the blue of the frame, but, in fact, the original blue photograph had the same tint as the light blue paint. It appears darker because it was photographed under low-light conditions.) Black diagonal lines are placed over the light blue and continue into the dark blue.

FIGURE 98. Michael Snow, *Midnight Blue*, 1973–74.

Midnight Blue looks like a fairly straightforward work until its component parts are examined: there is real wood and photographed wood; the two blues are the same but in two mediums and under

FIGURE 99. Michael Snow, *Blue Blazes*, 1979.

different light conditions; the candle may be photographed, but a piece of real wax has apparently fallen from it. The burning candle is visible, but, paradoxically, so is the wax into which it has been transformed. Here, the artist deftly merges reality with illusion. The colour photograph *Door* (1979) is the size of a real door, but the photograph is not of a "real" door because the presence of the hand holding the candle in the middle picture area destroys this illusion.

FIGURE 100. Michael Snow, *Black Burn Back*, 1974.

The door is also not "real" because the viewer becomes aware that it is a painting of a door.

Two other colour photographs — *Blue Blazes* (1979) and *Black Burn Back* (1979) — show, respectively, decisive moments in the burning of paper and black roofing material. These photographs document those instants in the life of the objects as they are destroyed. For Snow, capturing such moments represents the pure essence of photography.[3] With the creation of these works, fire became a major trope for Snow.

Prometheus stole fire to give it to mortal beings, and there is a sense in which Snow is an artist who brings light to mankind. In his work, the viewer is reminded that although fire has an alluring beauty, it both illuminates and destroys.

In his final show at the soon-to-close Isaacs Gallery in May 1991, Snow displayed a number of canvases that referenced the history of painting. (Sandy Simpson represented Snow for a short period of time after the Isaacs was shuttered. Since then, after that, he has not had consistent representation in Canada, but in 2004 the Jack Shainman Gallery in New York began exhibiting and selling his work.)

In her review of the show in the *Globe and Mail*, Kate Taylor was dismissive of this return to traditional painting:

> These works question art simply by making painted statements. *Guarded Painting*, for example, shows a museum guard standing beside a cordoned-off area. Inside that area, where the expensive painting should hang, a rectangular hole has been cut out of the canvas. In *Over the Sofa*, a painted shape is placed above a photograph of a living room, the wall space above the sofa bare, waiting for a piece of art to finish it off. These paintings of paintings may be funny, but they are essentially one-liners, and could be easily dismissed if they were not placed in the larger context of Snow's prolific and eclectic output.

Seeing one of these paintings in another exhibition led her to a slight change of heart. "*H.M. is Supposed to Have Said* features a monochromatic armchair facing a colourful abstract painting. H.M. is Henri Matisse, and he is supposed to have said that good art is like a comfortable armchair. The painting is still just a clever one-liner, but this context is kinder to it, placing it in the company of works that are capable of discussing, in a more sophisticated way, how we look

FIGURE 101. Michael Snow, *Painting at Night*, 1990.

at art."[4] In the *Financial Post*, Lisa Balfour Brown characterized these paintings "as re-cycled re-runs."[5]

Christopher Hume in the *Toronto Star* voiced sentiments similar to Taylor's and Brown's: "*Guarded Painting*, a particularly clever piece, includes a canvas with a security guard and a velvet rope painted on it. The work the guard watches and which the rope sets off is in fact a square cut out of the canvas. Though it's clear Snow is a virtuoso painter — he can do almost anything it seems — the bravura is not readily apparent in this show. The pieces are too laid back."[6] When the art journalist Adele Freedman confronted the artist about the complaint that these works lacked painterliness, he lamented, "It's so hard to do meaningful paintings anymore."[7]

In undertaking this new venture, Snow was trying to glance back at such earlier canvases as *A Man with a Line,* in which he conjoined abstract and representational elements. In each of these new works, there is a painting within a painting. In *Painting at Night,* two framed canvases are juxtaposed. The viewer might think at first that the image on the right is a view of the outside (in contrast to the "night" of the

abstract next to it); however, although the "outside" of the painting may be a window view, it is a view placed on a canvas.

At this time, the artist also moved in several new directions — and reinforced and reinvigorated other areas that he had explored previously. There are the holograms. There is a new approach to sculpture. There is a risk-taking public sculpture.

In revisiting some earlier preoccupations in *Parked* (1992), a small light box composition, he recalls the much earlier *Venetian Blind*. This work shows Snow "the actor" looking into the driver's seat window with his face pushed against the glass; he blocks the view behind him. The face pressed is obviously reminiscent of earlier compositions. This time, the actor is middle-aged, and his face seems to express awareness of that fact.

The slow-motion film *See You Later!/Au revoir* (1990), in which a man (Michael) gets up from his desk, puts on an overcoat, walks

FIGURE 102. Michael Snow, *Parked*, 1992.

FIGURE 103. Michael Snow, still from *See You Later!/Au revoir*, 1990.

in the direction of his secretary (Peggy Gale), says goodbye, and walks out the door depicts an action that occupies thirty seconds and extends it to seventeen minutes. This film becomes for Snow "an inner vision" in which the viewer sees inside "the time and space of a prosaic event" and is meant to arouse in him/her an awareness of "a tragic sense of mortality."[8]

The artist's description of this film could in many ways be applied to *Wavelength*. In *See You Later*, Snow invites the viewer to enter the interiority of an apparently mundane, everyday event and to ponder its significance. It also asks significant questions. How do time and space exist for us, especially if we stretch both beyond their usual duration? An act can take a few seconds, but does it have an inner life that can be explored?

Another film, *To Lavoisier, Who Died in the Reign of Terror* (1991), investigates a concern that intrigued Snow in the past: the haptic quality possible in cinema. Among the accomplishments of the chemist Antoine Lavoisier (1743–94) was uncovering the role of oxygen in

FIGURES 104 AND 105. Michael Snow, stills from *To Lavoisier, Who Died in the Reign of Terror*, 1991.

combustion. Snow had previously shown a great interest in the nature of fire, and this preoccupation drew him to the Frenchman.

The fifty-three minute *To Lavoisier* consists of a series of separate shots that are two to four minutes in duration. The scenes are of daily life. As Snow states, there is a concentration on the "extraordinarily textual vitality of the pictures themselves. The granular photochemical film surface and image are variously flecked, stained, throbbing, flaking, flickering, spotted, dotted bobbed, soaked or chipped.... These are purely photochemical effects — an homage to Lavoisier's place between alchemy and chemistry."[9] In demonstrating how the surface of film can be inflected with all kinds of visual effects, this film remains one of Snow's boldest, visceral experiments in cinema.

CHAPTER TWENTY-TWO:
THE EVERYDAY

For Michael, his second marriage allowed a domestic tranquility into his existence that he had never experienced in his first. Peggy, an independent curator especially knowledgeable about Canadian contemporary art and someone who, for the most part, specialized in time-based art, moving image work, and photography, shares many of her husband's interests; has a strong, intuitive grasp of his art; and is not hesitant to speak her mind when she disagrees with him. But she is not, like Joyce, an artist who, at some level, competes with another artist. Peggy remains deeply sympathetic to Joyce: "I'm surprised she put up with his shenanigans all those years."

The bond between the couple is based on a genuine change in Snow. Peggy recalls that the two were able to become a real pair, instead of just more ships in more nights, because Snow "really wanted to change. He was tired of [his previous sexual behaviour].… Both of us were quite surprised at how wonderful [their lives became]. [The decision to have a child] felt like something we wanted to do as a couple. We wanted to be a family. Both of us are rather traditional in certain substantial ways. I do the cooking and Michael cuts the wood in the summer and Aleck watches TV in Toronto."

Despite the fact that their lives now seem somewhat traditional and that Snow leads a more settled existence, all is not as it appears. Snow, to some degree, is performing. Peggy has a clear sense of the facade that

FIGURE 106. Peggy Gale, Michael Snow, and Alexander Snow. c. 2000.

her husband presents to the world: "Michael always presents himself as vague, blurry, absentminded, fumbling," she once observed accurately. "But there's nothing very casual about Michael."[1]

A good measure of the closeness of the couple can be glimpsed in *Conception of Light* (1993), a work consisting of two 183 cm colour photographs of eyeballs facing each other across the room of a gallery — one blue, the other brown. One early viewer was pleasantly astounded when encountering the piece: "There were these two big eyeballs looking at you. Who did they belong to?" The blue is Michael's, the brown Peggy's. One blow-up, Snow believes, would have looked merely analytical; two suggests a relationship. He thinks the blue in his eyes looks like something underwater whereas hers are floral. Peggy saw butterflies and feathers when she looked at hers whereas her husband's reminded her of crystal or quartz. Perhaps most important about these photographs is that they speak about a couple gazing into each other's eyes, seeing differences and then finding ways to connect with each other.

Conception can be read in another way also. It can be seen as a work that references a man who thought he was going emotionally blind but who has found a new way of seeing.

In 1994 a journalist visiting with Michael, Peggy, and Alexander observed how Michael Snow the famous artist had become Michael Snow the family man, one who endeavoured to be home by six during the week in order to watch *Star Trek* with his son. On Saturdays, the family shopped at the St. Lawrence Market. They spent part of each summer at the cabin in Newfoundland.

The ordinary has always been a part of Michael Snow. His second marriage simply brought him back into touch with that side. The fact remains that much of his life remains invested in his art, but, as an older man, he became more adapt at the art of everyday living.

FIGURE 107. Michael Snow at his cottage in Newfoundland, c. 1993.

CHAPTER TWENTY-THREE:
THE PRESENCE OF
THE ABSENT

Snow's interest in the differences between what we think we see and what we actually see — and on the nature of surface — is reflected in his turn to holograms. In this genre, of course, what seems present is actually absent. Michael Snow may be "present" in the hologram *Egg* (1985), but he is not "actually" there.

The artist had long been interested in experimenting with holography, and the perfect opportunity arose when he was invited to produce a group of works in this medium — *The Spectral Vision* — for Expo 86 in Vancouver. In *Egg*, the artist breaks an egg over a real frying pan; the egg is then caught in "illusory space" as it descends down to the pan.

In *Maura Seated* (1985), another variation is produced. From a distance, the viewer sees a three-dimensional geometrical structure made of Plexiglas. As they move closer, the horizontal plane of the structure is unclear. "Advancing further, one will see — often with some surprise — that the empty cubic volume contains the realistically convincing image of a seated woman who is looking at her reflection in a small mirror she holds in her hand. Moving optically around the image, the spectator will see that, astoundingly, the woman's reflection in the little mirror changes exactly as it would when seen from different positions in real life."[1] In film and photography, Snow argues, people are "ghosts" — representations that haunt the actual physical world from which they have been removed; in holography, they become "mummies embalmed."[2]

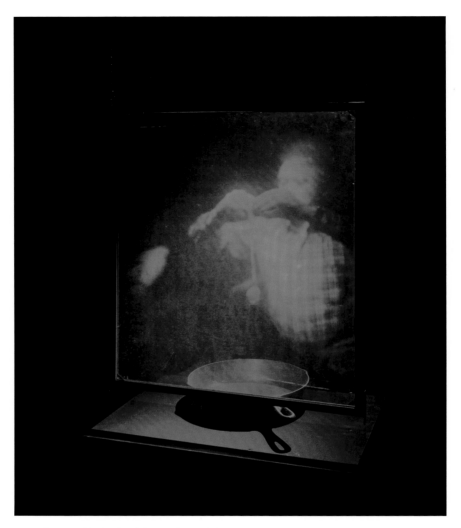

FIGURE 108. Michael Snow, *Egg*, 1985.

In the *Globe and Mail*, John Bentley Mays was intrigued by the eight "still-life tableaux, each one populated by the same cast of proletariat characters.... Walk by them, and these spectral images lose all their dumb ordinariness, and begin to move, quake, spring apart uncannily.... Snow here tames all the slick spookiness of more conventional holography, and puts it to work as one element in a brilliant, trenchant rethinking of the venerable still-life tradition, from the ground up."[3]

One visitor, René Blouin, perceived traces of autobiography in some of the works. "*Children's Parade*, for instance, the first work encountered by the viewer … is definitely informed by Snow's experience of raising his young son … [The ten holograms] offer a stylized history of transportation, with each tableau reflecting a different phase of human development through arrangements of toys." The same observer noted that "biographical sources" were also at work in *Sailboat (To Wieland)*, "a juxtaposition of three marine scenes executed in three different media — a back-lit transparency, a child's drawing and a hologram of a romantic marine painting, complete with gold frame. The iconography here certainly relates to early works by Toronto artist Joyce Wieland."[4]

The ambitious, multi-genre *Redifice* (1986) consists of nine holograms and twenty sculptural and photographic compositions, and is the most complex of the artist's holograms: it is a two-sided red wall (8 x 20 x 2 ½ feet) with rectangular openings. Nine openings are holograms — in one, the French flag thrusts itself out in space. Other openings have maquettes: one shows a woman entering an elevator.

Snow uses different forms of sequencing as in his earliest photographs, and explores, among other themes, fire and burning (as in *Midnight Blue*, *Blue Blazes*, and *Black Burn Back*). There is a crucial difference in *Redifice*, however. The viewer can look through the various openings in any sequence, and can, in a sense, discover a new work of art every time the work is explored. The idea of co-creation was present in many of Snow's earlier works but here it is dramatically underscored.

From 1974, the artist was preoccupied with red — the colour of passion and strong emotions, and, as can be seen in *Red*[5] of that year; burning is a recurring theme. Perhaps the colouring of *Redifice* references the possibility that the overall construction — it resembles an apartment building and its windows — could burn down. If that were to occur, it would become a "Red-ifice."

However, this work has many other meanings, as the artist has observed: "REDIFICE is a structure with many 'levels,' 'many rooms,' many 'windows.' Viewing REDIFICE becomes a narrative film, edited by the spectator, of 'frames, objects, scenes, and events that [could] take place in a 'high-rise': a classroom? A theatre? an operating room? a living room? a bedroom? an elevator?"[5]

FIGURE 109. Michael Snow, *Redifice*, 1986.

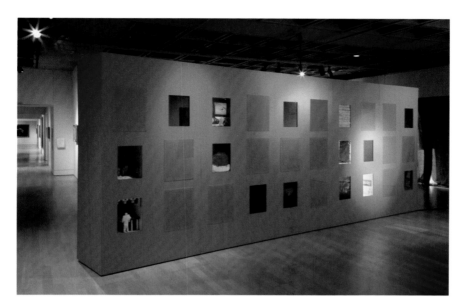

FIGURE 110. Michael Snow, *Redifice*, 1986.

Closely related to *Redifice* is *The Windows Suite* (2006). *Redifice* shows the wall of what could be a hotel, whereas *The Windows Suite* is placed into the windows of a hotel. In the latter work, seven sixty-five-inch video monitors are placed in seven windows (each of which is three feet wide by six feet tall) on the east facade of the Pantages Hotel in Toronto's theatre district. On these monitors, thirty-two different moving-image sequences unconnected to each other play in a two-hour-and-fifteen-minute loop. The scenes show events that could take place in a hotel room but many are pure abstracts. In one there is a fire.

Windows, looking at them and looking in them, are central to both works. In the later work, windows open and close; there are drapes, venetian blinds, and pull-down blinds; there is a jail window, a stained-glass window, and an ivy-covered window. The work, which can only be seen at night — it is visible from the street between 7 p.m. and 2 a.m. — is a fitting companion to the busy nightlife taking place around it.

In the *Globe and Mail*, Sarah Milroy reflected on the "incendiary variation [in which] a fire appears to burst forth in the hotel's lower

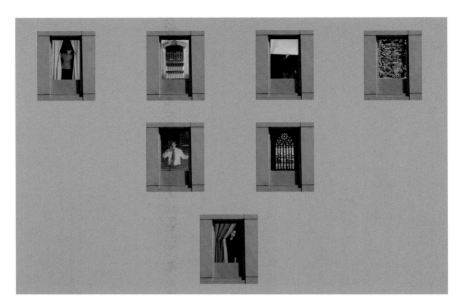

FIGURE 111. Michael Snow, *The Windows Suite*, 2006.

floors, making its way up inside the interior, only to be extinguished by the water jet of a free hose." She also observed that the piece reflects the "hotel's unique role as a kind of free zone in semi-nomadic metropolitan culture.... One of the successes, here, is the way the work changes our perception of the city around it. Snow's passages of abstract colour suggest a digitized version of Mondrian's *Broadway Boogie Woogie* [1942–43], but the hotel scenes blend in with the surrounding spectacle of the city ... watching, you wonder: is art imitating life, or is it the other way around?"[6]

New sculptures such as *Transformer* (1982) and *Core* (1984) occupy space in much grander, expansive ways than the previous ones. These pieces, and many others done in the early 1980s, also return to the themes of sight and blindness. For example, *Zone* (1982) is a Plexiglas wood structure with an eyepiece framed in rubber. When using the eyepiece, the viewer looks to the right and then the left and thus to the limits of the inside of the sculpture. That encounter — looking to

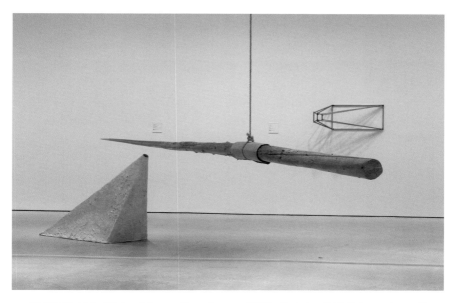

FIGURE 112. Michael Snow, *Transformer*, 1982. *Sighting* (1982) is on the wall to the right and *Monocular Abyss* (1982) on the left.

the boundaries of peripheral vision with each eye — is one shared with the artist, who obviously sees the same thing. This is a work of art that seeks to establish the sense of a shared experience — a form of bonding. The title refers to the fact that artist and audience have entered a zone in which they are equals. The simple, elegant aluminum bars in *Sighting* (1982), a three-dimensional rendition of a trapezoid, forces both eyes to make right-angled rectangles when viewed from the side. Again, there is the element of a joint encounter.

The same observation can be extended to the monumental *Seated Sculpture* (1982) that was constructed from three pieces of heavy steel plate; an industrial "break" was used to bend the metal. There are four components: a solid-looking rectangular form at the top; the much thinner platform that runs parallel to it underneath; a boxlike structure at one end upon which the "seated sculpture" can sit; and a thin piece of metal that connects the top, the bottom, and the seat. The seating space can be simply looked upon or can be sat upon. The latter option, Snow says, "is permissible and desirable. Sitting in the sculpture, one sees two rectangular plate arms or wings, which come from behind you

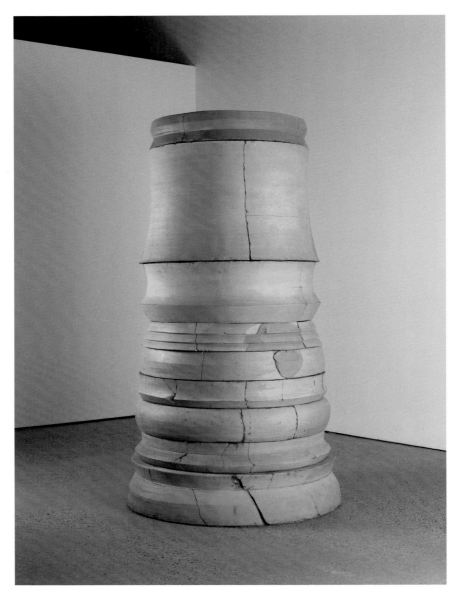

FIGURE 113. Michael Snow, *Core*, 1984.

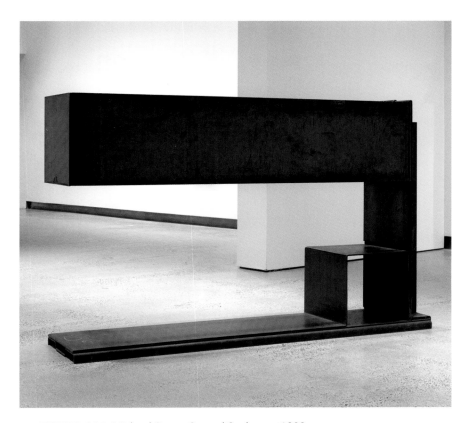

FIGURE 114. Michael Snow, *Seated Sculpture*, 1982.

and clasp in a rectangular overlapping about seven feet in front of you. The work directs you to be a part of it in order for you to see it."[7] The viewer becomes a "seated sculpture."

This sculpture, the creator, has said, "emanates the power that was used to make it."[8] This is exactly right. Since the surface of each part of the sculpture reflects the power of the material used, the initial impression is of hard material conjoined. This bestows a sense of great power contained, but that feeling increases markedly if one occupies the seat because the resulting sensation is of power obtained from entering into and becoming a part of this construction. The seat becomes a throne.

The unglazed ceramic *Core* (1984) — almost seven feet tall with a circumference of almost three feet — was created by a master

potter from a small-scale model made by Snow. In the firing process the piece exploded and had to be reconstituted when installed. This large object, Snow points out, is not a pot because "its design and the way in which it is made contain the means of its making, a circling circle."[9] Put another way, *Core* looks like a giant thimble, a device into which a finger is inserted. In walking around this monumental piece, the viewer beholds an object completely removed from what should be its ordinary space. Or it can be understood as a giant fragment of a Greco-Roman building. Martha Baillie has observed: "*Core* is mute. The beloved, impenetrable. *Core* divulges nothing about the inside shape of things. It offers a surface…. You could be in Mesopotamia or the twentieth century. With clay, time becomes Snow's subject, and the powerful allure of the invisible sets your mind in circular motion."[10]

In *Transformer* (1982), the space controlled by the huge pointed log becomes just as significant as the object itself. What exactly is being controlled? Whereas *Core* is self-contained, the opposite holds true of *Transformer*. This work, suspended horizontally, is always in the process of pointing away from itself if the thickest part of it is seen as its point of origin. That solid point is, as Snow points out, "natural and unrefined." As the piece moves to its narrow end, it is honed to a needle point and increasingly smoothed and sanded. A contrast has been established between the natural and the artificial.

"[T]his big pointer moves like a big compass," the artist observed.[11] One does not perceive a compass as threatening, but the narrow point could pierce an eyeball. This is another significant contrast the work establishes. *Transformer* is placed five feet above the floor so that it creates a relationship with a viewer of any height who approaches it. If one stands near the thick end, a sense of control or power might be an appropriate response. If one stands close to the thin tip, a sense of fragility might be the only response.

CHAPTER TWENTY-FOUR: AUDIENCES

Two major public commissions have allowed Snow to leave a visible imprint on Toronto.[*] The first, *Flight Stop* (1979), is a distinctively Canadian project. The work brings the iconic Canada goose from the outside world to inhabit the interior of a building. "There was all this empty air up there. I thought, what goes in the air?" Snow recalls.[**]

The title of the piece is slightly problematic because the geese have not stopped flying (although the leader is seemingly about to do so). Rather, the sixty fibreglass sculptures in three body sizes and several wing positions are in a permanent state of suspended animation.

This installation, which is located in the Eaton Centre in Toronto, depicts the flight of the geese from one end of the complex to the other and thus gives indoor space to these creatures in a way that would not occur in reality. The blending of "inside" and "outside" is an important aspect of this piece, which also suggests, covertly, that nature, even in an urban environment, is an important aspect of the inner Canadian identity.

[*] In 1978, thirty photo works were commissioned for the Government of Canada Building at Yonge Street and Sheppard Avenue in North York. Parts of this installation have been damaged or removed. In the same year, a complex installation was commissioned by Brock University, but only the photo mural portion has survived.

[**] Nowell (339–40) claims that the idea of geese came from Wieland and that Snow paid her five thousand dollars for the idea. Snow disputes this claim and does not recall any conversation with Wieland on this issue; he insists he did not make any payment to Wieland for this suggestion.

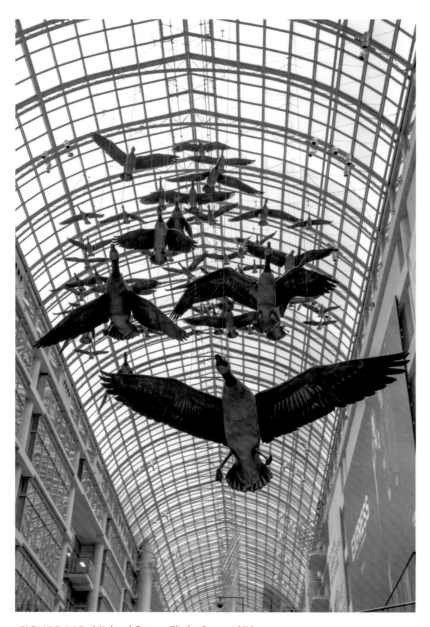

FIGURE 115. Michael Snow, *Flight Stop*, 1979.

With this work, Snow transformed the interior of the Eaton Centre into an enormous gallery, as Virginia Nixon pointed out in the *Montreal Gazette*. This installation is a work of art "capable of satisfying the public's rarely heeded desire for art they can understand. The only possible problem is that it looks so simple a lot of people may find it hard to think of it as art. It looks simple. Yet the way the birds manage to make their presence felt inside this enormous hall points out an extremely inventive designer."

A year after the installation, Beverly Bowen, a journalist from the *Toronto Star*, reported that the birds were moulting.[1] This prompted an angry letter from the artist to the newspaper:

> The work is not made of papier-mâché feathers; it is not now deteriorating and the only solution anyone has come up with is to remove the molting birds from the flocks has some relationship to the truth but implies a frivolity about the work and the problem that did exist on the part of both the makers and owners that is a bit insulting....
>
> In making them, we underestimated the extreme temperature changes where the sculpture is and the consequent extreme shrinkage of the photographic paper and a few months after the installation some of the photos begin to pull. We decided to take the sculptures down and repair them gradually.... These repairs were completed about two weeks ago and the entire group of 60 is now as it should be.[2]

In December 1982, when the Eaton Centre management tied red Christmas ribbons around the necks of the geese, Snow took them to court. At the one-day hearing, his attorney, Julian Porter, argued that the ribbons distorted *Flight Stop* and made the installation look ridiculous: "An artist is no bigger, no less, and no greater than his works of art. We want the ribbons off." The lawyer for the Eaton Centre countered: "We're not looking at somebody who has gone into an art

gallery and put a codpiece on the *David*." When an artist worked in the service of Mammon, he maintained, he had to take his chances. Justice Joseph O'Brien agreed with Porter and Snow: the ribbons were removed.

Snow's childhood cartoons are his first surviving works of art. Although he later showed little interest in this genre, the installation *#720 (Thanks to Robert Crumb)* (1988) demonstrates his admiration for the controversial, prolific, and usually vulgar American cartoonist. This work consists of three slide projectors, 240 35 mm colour slides, newspaper bundles, and wine crates. Each carousel is aimed at one of the three walls in the installation space; the newspaper bundles (of newspapers from the day before) are used as seats for the audience. Carousel number 1 displays copies of the image of page 1 of a four-page *Mr. Natural* comic; carousel number 2 contains eighty slides of page 2; carousel number 3 has slides of pages 3 and 4. Each slide is projected for ten seconds. The unsynced projectors play rhythms and perform as clocks. Mr. Natural remains static in each of the three series. Snow has said: "The constancy

FIGURE 116. Michael Snow, *#720 (Thanks to Robert Crumb)*, 1988.

of [Mr. Natural ruminating] is a very important part of the experience of seeing this very meditative work."[3]

Mr. Natural, who first appeared in 1967, is a mystic guru who pontificates on the evils of the modern world and offers mysticism and natural living as alternative lifestyles. He is always costumed as an Old Testament figure, with a long, flowing, white beard. In contrast to what he proclaims, Mr. Natural is a foul-mouthed, pleasure-seeking narcissist. The glaring contrast between what this character preaches and what he does allows Crumb to offer scathing critiques of all kinds of fads and belief systems.

In many ways, Crumb is a social artist; Michael Snow is not. In that sense, this is an unusual work in his canon. The three large projections force the viewer to look at what are intended as pieces of social commentary rendered in comic-book format. As such, social satire is part of the mix, but Snow is also highlighting Crumb's artistry and the genre in which he chooses to render it — this work has a strong formalist element. And that is perhaps the point: comic books have a unique way of organizing images, and Crumb is a master of this technique. Nevertheless, a strong element of satire (via Crumb) is present.

In 1989, Snow installed *The Audience* — two groups of huge sculpted figures — on the front of two corners of the Rogers Centre (called the SkyDome at that time). Snow had been among the members of the Public Arts Committee deciding on commissioned works, but he recused himself from all discussions of his submission.

The fourteen figures, which vary in size from ten to eighteen feet and are elevated sixty feet above ground level, look like they are made of bronze, but they are constructed of metallically painted fibreglass. They were made from wooden armatures (skeleton forms) to which was applied upholstery foam and burlap; to this, chicken wire was affixed. Then the fibreglass was applied.

Two gesticulating groups of spectators — shown on concrete bleachers — are responding to a sporting event. In this enormous piece of public statuary, these hooliganish figures confront the audience about

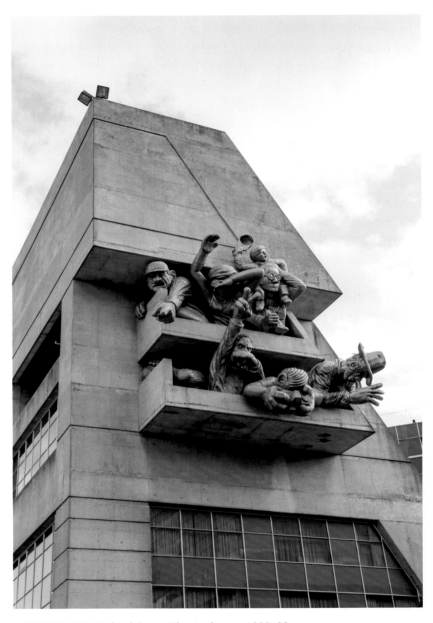

FIGURE 117. Michael Snow, *The Audience*, 1988–89.

to enter the amphitheatre. Are you like us? *The Audience* asks the new audience, What kind of a person are you? The piece asks the onlookers to determine who they are. Are they going to conduct themselves like the figures pointing and waving at them? Or are they different?

As Snow points out, these figures are unlike any stadium crowd (not necessarily at a sporting event) that ever existed because "each of the figures is directing his or her attention to a particular area: they're not looking at the same thing. They are mostly looking at 'you,' the spectator, and in many cases making judgments about you that are similar to the judgments that a fan at a baseball game, for example, will make." Moreover, each figure is directed to a particular location. One of the sculptural figures seems to call the person who has attracted his gaze an asshole. Various kinds of appraisals — positive and negative — are offered to members of the audience about to enter the stadium.

The artist sees *The Audience* as an outgrowth of his earlier, much more abstract "attention-directing" and "audience-inclusive" works, such as *Blind*.[4] *The Audience* can also be related to the artist's interest in what can be taken in by the eye (as in *Scope*), since the focus of each figure's eyes is a specific spot. To communicate properly with a figure, the spectator must locate that place.

Of course, there is also a strong element of satire in the piece. The figures are grotesque, almost macabre. What person would like to see themselves as such a creature? This large work may have a comic edge, but it is sharply observed, presenting in a very graphic way how members of an audience can share in an anti-social group mentality.

Even an early fan of Snow's, Robert Fulford, declared *The Audience* a total mess. Some saw the piece as condescending in nature — a well-born Torontonian looking down on those he perceived of a lower social class. In the *Toronto Star*, Christopher Hume expressed major reservations about the installation: "These latter-day gargoyles, each 6 metres high, wag their fingers, thumb their noses, point, laugh, groan, stare and generally appear to be having lots of fun at visitors' expense. The result is a work that turns the audience into the show. The watchers become the watched."

"They're silly gestures made monumental," Snow explains. "I tried to place them so they're looking right at you. The wagger, for example,

is wagging at the taxis and buses arriving at the hotel. It's related to some of my abstract sculpture in which the audience is involved."

Despite Snow's defence of it, the work has not been received well. Most see it as a caricature of those who attend events at the Rogers Centre, as Hume pointed out.

> While there's a good deal of humour in Snow's work, there's also something off-putting, even silly, about the sight of these grotesque characters leering down at the crowd. There's also a problem with the colour, a kind of high-gloss bronze, which doesn't give the figures enough of a chance to stand out from their surroundings. Originally, the sculptures were to be bronze but because of cost and time required, that idea was abandoned. Instead, they are carved from a kind of Styrofoam and coated in a bronzed resin. Although they will develop some patina over time, they'll never look like the real stuff.[5]

The video maker Lisa Steele saw it another way: "Snow was using high art referencing in a low art context." The artist had a similar interpretation: he once compared it to a Bernini sculpture in front of a cathedral in Rome. He also alluded to its resemblance to Picasso's *Demoiselles d'Avignon*, "a direct-address thing, a brothel scene — they're all appraising you … In the sixties, I was interested in underground comics — Robert Crumb — but this is more like Daumier."

Five years after expressing disdain for *The Audience*, Hume linked it to *Colin Curd*: "Though I'd never seen the painting before, it was familiar. Then I realized it could be *The Audience*.... It has the same cast of characters."[6]

Three years later, "lightness of hand and wit," as Adele Freedman put it, was (briefly) bestowed on the grounds of the Confederation Life Building at the corner of Mount Pleasant Road and Jarvis Street in the

form of Snow's *Red Orange Green*, a stainless-steel sculpture of three interpenetrating two-dimensional trees placed on a traffic island. The title, as Freedman explained, refers "to the seasons in the life of a tree, the stop-and-go phases in the life of a street, and the branching of roads. In short, it embodies a kind of conceptual complexity otherwise missing on the site."[7] Nicholas Bradbury in the *Toronto Star* was appreciative of the shapes created "within the boundaries of these tree forms." These spaces contained "images not only of branches and leaves, but of the immediate surrounding — steps, of an escalator perhaps, the three circles of a traffic light, and a woman, perhaps on her way to work in one of the buildings nearby."

Snow has never been an arrogant or self-satisfied person or artist, but he has the capacity to enjoy his own work, take pride in it, and share that enthusiasm with others. This observation holds particularly true of the three public works described in this chapter.

PART FIVE

1994–
PRESENT

CHAPTER TWENTY-FIVE: BLOCKBUSTER

After his AGO retrospective in 1970, Snow had a large one-man show at the Pompidou Centre in Paris (1978–79). Two years earlier, both his films and a selection of ten photographs had been given retrospectives at the Museum of Modern Art in New York. There were also major shows at Tokyo's Hara Museum of Contemporary Art (1998) and the San Francisco Art Institute (1992).

Dwarfing these exhibitions was the enormous retrospective in 1994 of Snow's work hosted jointly by the Art Gallery of Ontario and the Power Plant. Retrospectives are tumultuous events, emotionally and professionally, for most artists. The worry of not being able to live up to all the attention bestowed is an understandable reaction since in a retrospective, the whole of an artist's career is put on show. The exposure that such an exhibition brings is enormous; the effect is not always positive, though — it can, in fact, be brutal. Inevitably, the display will prompt the question: When seen together, do the pieces show enough richness, variety, and interest to be assembled together and do they hold up?

The idea for the *Michael Snow Project* originated in 1983 when Louise Dompierre curated a WW exhibition for the Agnes Etherington Art Centre at Queen's University. When she became head of the Power Plant in Toronto in 1986, she approached the AGO's Dennis Reid and Philip Monk. The *Project* was postponed twice but came to fruition in 1994. Snow, of course, got caught up in the preparations to such an extent that he could not begin any new projects for two years.

Right now [March 1994], with everything coming to-
gether at once, it's hysteria. There are so many events
and receptions that there's been some confusion with
the mailing list. All my personal guests — includ-
ing my 90-year-old mother and her friends — were
mistakenly invited to a media preview instead of the
AGO's members' preview.

Rumour has it that Jean Chrétien [the prime
minister] might come to the members' preview, and
I invited these people because I'm sure they'd like to
be at a party with [him]. It's just one more thing to
take care of.

But having to deal with problems like that is ex-
tremely gratifying.

As Deirdre Hanna pointed out, "Canadians aren't known for
recruiting superstars from their peers. Yet the *Michael Snow Project*
[celebrates] one artist who is still very much alive and well in Toronto."[1]

The *Project* was arranged in three sections: history, theory, and
practice. At the AGO, Reid's "Exploring Space and Contour" took
the viewer from the last WW works back to *Jazz Band*. When he
walked backward through his early career, the artist liked what he
saw. Pleasantly surprised, he observed that most of it held up. Monk's
"Around *Wavelength*" consisted of ten sculptures from 1967 to 1969.
The Power Plant was filled with Dompierre's "Embodied Vision" which
included *Egg, Venetian Blind,* and *Core.*

In the *Globe*, John Bentley Mays was enthusiastic about the artist
but disapproving of the venture:

The Michael Snow Project is a blockbusterish exercise
which curators Dennis Reid and Philip Monk (at the
AGO) and Louise Dompierre (at The Power Plant)
should never have talked themselves, or allowed
themselves to be talked, into doing. Nor do I have
any doubt that Snow, after the flashbulbs and cham-

pagne corks stop popping, will regret having been an accomplice in his own embarrassment.

The basic problem is blood simple. Michael Snow is a genius. But as this exhibit illustrates with the force of a kangaroo punch, he has only occasionally seen fit to pull his high imaginative powers fully together, and create films and photographic installations as joyously brilliant as any art done by a Canadian in this century. Had the curators drawn a clear line in the dirt, and not let anything cross over it that did not come up to Snow's best, the exhibit would have been smaller, but would also have glinted with diamond-like fire. As we have it, the sprawling Project has all the visual charm of a lawn sale.[2]

Susan Walker's sensitive piece in the *Star* carried the headline, "Blizzard of Snow Ahead," while *Time* remarked that the "whole is greater than the sum of the parts."[3] The remaining critics were favourably impressed, although a feminist collective calling itself Snow Job Inc. began a spray-painting campaign to expose the *Project* as a "Wank-o-Rama." They did not appreciate the stylized WW and argued that women's bodies were being commodified. They added penises to the WW on some of the posters advertising the exhibition.

In the end, there was much acclaim for the show, and despite some negative criticism, Snow's reputation was boosted. In 1994, he was sixty-six years old but he had no thoughts of retirement or slowing down. In the following years, he would produce a wide array of new, groundbreaking work in photography, transparency, sound installation, public sculpture, cinema, photography, and book illustration. His domestic life was tranquil and happy, and the inner desire to create had become even stronger. His curiosity remained one the strongest elements in his character, and he was relentless in pursuing its leads.

CHAPTER TWENTY-SIX:
SOUND SHAPING

From the time of Snow's boyhood, various forms of jazz have been a mainstay in his life. He began with Dixieland and then shifted to various forms of progressive jazz. Upon his return to Canada, he became involved, mainly through the CCMC but also with the Artists' Jazz Band, with improvised music making. Playing with the CCMC gives him enormous pleasure. A journalist, expecting to hear blues or bebop, described his reaction to hearing Snow with Paul Dutton at the Rivoli on Queen Street:

> Snow sat down at the piano, Dutton stood off to one side at a microphone. Dutton started to vocalize — I don't mean sing, exactly, though many of the sounds were pitched — and Snow started to play. He played with his hands, with his fists, with his elbows. He played directly on the strings of the piano. He put coins into a metal pie plate, put the plate inside the piano, and continued playing. His legs were extraordinarily expressive — they snaked about under the piano; they curled around each other in a tight embrace; they danced. Dutton howled, gurgled, slurped, rasped and sometimes seemed to be making two different sounds at once. There were moments, I

thought, when the two of them sounded like a full orchestra. I asked Dutton later how they possibly knew what to with each other. "It's a bit like fucking," he told me. "You get used to your partner."[1]

After 1994, one of the most significant changes in Snow's artistic practice was the integration of his music or sound with his visual art. Of course, he had done this before in *NYEEC* and *Rameau's Nephew,* but, in works such as *Piano Sculpture* (2009), for instance, he brings the two forms into conjunction in a new way by his use of improvised music. "The piano playing gestures are related to gestures used" in making visual art.[2]

Earlier, in the seventies, Snow created three sound installations: *Correspondance* (1970), *Hearing Aid* (1976 [discussed in chapter nineteen]), and *Tap* (1969/72). *Correspondance* consists of an unframed black-and-white photograph (120 x 150 centimetres), an audio tape, and a tape player. The photograph is an enlargement of two actual badly typed letters superimposed on each other. The tape is a recording, played loudly in the same way that the letters have been enlarged.

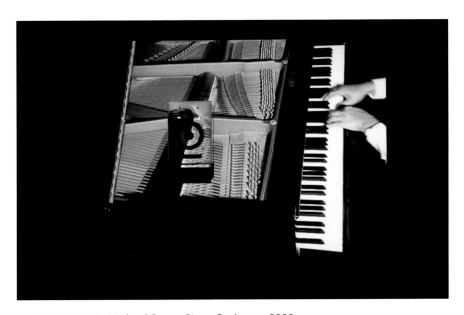

FIGURE 118. Michael Snow, *Piano Sculpture*, 2009.

One of the letters contains the acceptance of an invitation; in the other, its author comments on the availability of a film. The question posed to the viewer is: Why are the two pieces of correspondence imposed upon each other? And why can the sound of the typewriter that made the two letters be heard? What is the link (correspondence) between image and sound?

In *Tap,* a framed black-and-white photograph, a framed typewritten text on paper, a loudspeaker, documents, an audio tape, and player (not visible) are all found on different walls in a multi-roomed gallery. The large framed photo shows hands holding a microphone; the typewritten text discusses *Tap* from different perspectives and mentions that the sound of fingers tapping on a microphone (on the concealed tape) is part of the work. The use of typewritten text and tapping sounds is found in both works.

While these early works have a strong formal structure, improvisation is in many ways the raison d'etre in Snow's musical pieces, particularly after 1999. *Piano Sculpture* (2009) is both a sound installation and a video installation. It consists of four simultaneous projections (each two metres wide) on the four walls of a gallery. Each projection is an overhead shot of a grand piano showing the entire keyboard and interior (strings and hammers). Tiny loudspeakers are placed in each image on the strings and hammer. Each of these projections is a looped, fifteen-minute recording of a piano performance by Snow, who describes how each part is "different, [although] they all (in varied ways) use the same vocabulary of piano effects. The core effects are achieved by somewhat aggressive gestures performed by the pianist." These gestures (e.g., hammering, carving, sawing, scraping, polishing) are "directly related to gestures made by the hands in making an object (a sculpture!)."[3] What the artist is asserting is that the movements he is employing come from the plastic arts and are related to jazz riffs and the gesture in abstract expressionism. There is, therefore, an intentional linking of visual art to musical expression.

Improvisation is central to the performance of this piece because the position of each spectator-auditor determines what is heard; these are not, according to Snow, concordant harmonic connections but the simultaneity of a family of gesture-related sounds.

CCMC's music is really, as Snow claims, "sound shaping."

> We don't play "notes" as much as invent sound qual-
> ities. No prior thematic arrangements are made; we
> just play, and the music is always new and continues
> to be surprising to us. Group improvisation is as
> much in-the-moment as any activity can be. It's all
> action/reaction, there's no time for thinking. One is
> simultaneously understanding (or misunderstanding)
> where the music has just been, where it is "now," and
> where your contribution may be taking it. It took me
> twenty years before I realized that there was a connec-
> tion [to] the democratic ensemble playing of the ear-
> ly New Orleans jazz that had so moved me all those
> years before.[4]

The artist is well aware that "the theme-and-variation principles"
have often been a staple in his visual art (the WW works, for example).
"I don't think that this interest comes from jazz. Rather, jazz is one of
the manifestations of an innate propensity I have in general."[5]

Snow realizes that CCMC music does not appeal to most people:
"One of the problems is that our music is extremely complicated. And
this is going to be insulting in a way, but a lot of people sit on the familiar
— especially rock 'n' roll, but it's all based on thump, thump on the bot-
tom and screaming on the top. We shift the orchestral layers all over the
place, and you really have to be as adventurous as we are to listen to it."[6]

Improvisation is a challenging prospect in the visual arts, although
Snow remembers that the film stock used for *Wavelength* was outdated
and that therefore the results could not be predicted; different types of
film were also employed. In speaking of his visual art, he feels that it is
sometimes best to classify it as "experimental" as well as "conceptual":
the artist's mind may be in a state of flux in which it improvises, but
work on a painting, sculpture, photograph, or installation has to be
carefully calculated.

One carefully thought-out musical production is an elaborate hoax. *The Last LP* (1987), subtitled *Unique Last Recordings of the Music of Ancient Cultures*, supposedly presents the last music of lost cultures. Of course, the pieces are not genuine, but the exploration of the theme of loss is real. Not only does the content signal this concern, so too does the medium — it speaks of (what seemed imminent then) the approaching obsolescence of vinyl as the CD format began to dominate recorded music. The jacket, designed to look like a UNESCO-sponsored recording of ethnic music, displays a photo of an ancient clay tablet and a photograph of Dr. Mischa Cemep (Snow), the ethnologist who has collected the various recordings and written the extensive, scholarly notes — a mix of accurate and false information — provided for each of the eleven tracks:

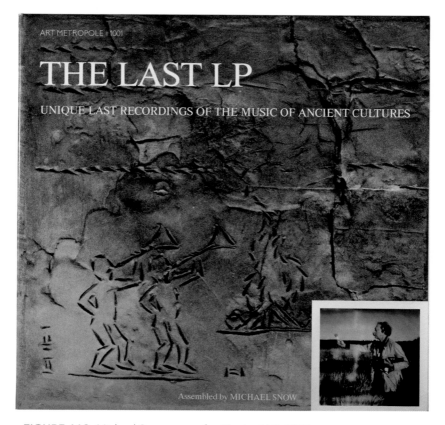

FIGURE 119. Michael Snow, cover for *The Last LP*, 1987.

- "Wu Ting Dee Lin Chao Cheu (Announcing the Arrival of Emperor Wu Ting)," performed by Orchestra of the National Music Institute, Seoul, Korea.
- "Si Nopo Da (By What Signs Will I Come to Understand?)," performed by Tribe of Niger, S.E. Africa.
- "Ohwachira, Water ceremony," performed by Miantonomi and Cree Tribespeople.
- "I Ching Dee Yen Tzen (The Strings of Love)," performed by Tam Wing Lun on the Hui Tra.
- "Full to the Brim," recorded in Varda, Carpathia, Romania.
- Speech in Klogen performed by Okash, Northern Finland.
- "Mbowunsa Mpahiy," performed by Kpam Kpam Tribe, Angola, West Africa.
- "Quuiasukpuq," performed by Tornarssuk Tribe, Siberia.
- "Amitabha Chenden Kala," performed by Monks of the Kagyupa Sect, Bhutan.
- "Roiakuriluo," performed by Sabane in Elahe, Brazil.
- "Raga Lalat," performed by Palak Chawal, Benares, India.

The introduction to the fourth selection includes these observations: "Unlike other pieces on this record, this haunting music was recorded right in Toronto where the record was produced. In a fascinating piece of international detective work, a group of musicologists (one each from Spain, Iran, USA) searched, first in China then in Vietnam, Korea and Japan for a remaining player of the HUI TRA, an ancient Chinese three-stringed instrument (note the resemblance to the English word 'guitar')."[7]

All the playing of the various instruments and singing were made by Snow using multi-tracking recording. As he points out, "There is also a text printed backwards, which explains the whole thing is a construct and that I played all the parts."[8] The teasing playfulness of *The Last LP* extends to all CCMC activities.

CHAPTER TWENTY-SEVEN:
A NEW PAINTERLINESS

In *Michael Snow/A Survey* (1970), Snow had inserted family photos that occupy a significant part of that publication. Over thirty years later, he revisited the genre of the photo album in *Scraps for the Soldiers* (2007). In 1978, when he became the executor of the estate of Dimple Snow, his father's sister, he found in her flat a collection of photographs assembled from 1914 to 1921 inserted into a thirty-two-page scrapbook called *Scraps for the Soldiers: Items of Interest to our Soldiers in the Great War, selected and arranged by their friends at home* and published by the department store T. Eaton. Co. The title may be gender neutral but presumably most of those purchasing the album would have been the mothers, wives, and sweethearts of those serving overseas. The title implies that a person filling an album would send it to a soldier serving in England, France, or Belgium.

However, Dimple obviously never sent it to either of her two brothers, Gerald Bradley and Geoffrey, who served in the war. Instead, she used the blank volume in which to place photos she took of friends and summer holiday spots. She may have purchased the album without any patriotic intent, seeing it merely as a conveniently sized volume to store photos. The viewer can construct a narrative by looking at the photos, but each person's narrative will be different.

The selection processes for these two albums are quite different. In *A Survey*, Snow took the opportunity to construct a family history

FIGURE 120. Michael Snow, *Scraps for the Soldiers*, 2007.

through photographs, whereas his aunt may not have had a conscious ordering methodology. In any event, both albums were intended as pieces of non-fiction reporting, and, in both cases, a fictional process takes over because both Snow and his aunt presumably privileged some photos over others — some were obviously omitted. In the case of *A Survey*, some pictures are larger and thus more attention-grabbing than others.

In *Scraps for the Soldiers*, the authorial presence of Michael Snow can be seen in the introductory remarks he affixes to the first page. His aunt created the album; he preserved it. She may have been the original artist, but he is the work's guardian angel. This project also demonstrates how important ancestry — family connections — remains for Snow.

From 2017, Snow has been engaged in a similar project, entitled *My Mother's Collection of Photographs*, that will contain over three-hundred entries. The artist explains that his mother "carefully kept the many wonderful photographs by the Lévesque and Denechaud sides of her family as well as some interesting images from the Snow side. She made many notes as to the identity of these people who were

photographed, as well as the date the photo was taken, the location and the circumstances of the photograph." These photographs, "are so beautiful and so historic that I wish to share them with others."

Since 1994, Snow has revisited many earlier themes, but there is a marked change in how this new material is packaged. Almost always, it returns, perhaps more directly than before, to the notion of painter-liness. A good example of this is the installation *The Corner of Braque and Picasso Streets* (2009), which allows a view of the exterior of a building, pedestrians, and car traffic to be transmuted into cubist-like images. This work was first shown in Barcelona as a homage to the first years of cubism, created during the period in which Picasso lived in or near that city. Snow used plinths and made a wall of stacked white boxes with the fronts at various angles from the wall. Then a video camera was placed outside near the gallery and aimed at a street corner from a height of two storeys. The unaltered images of what happens on the street is then projected onto the front of the plinths,

FIGURE 121. Michael Snow, *The Corner of Braque and Picasso Streets*, 2009.

which create a geometrical, cubist-like breaking of surface pattern. For example, when someone walks across the street, they move from planar surface to planar surface.

Although the fact that *The Corner* presents images that are broken up might be the first thing that a viewer notices about the work, this fragmentation is not the only important aspect of the piece. Central to this work is the sculptural conceit behind it. Looking at it, the viewer is aware of the segmentation but is also conscious of the various depths established by the boxes. Here again, the artist is playing with the surface of an image, and the viewer is aware of the various arrangements that have been used to fragment the image: the result looks more like a cubist sculpture than a cubist painting.

Texture and surface are the principle concerns in *Localidade* (2011), a work reminiscent of an earlier work, *Place des peaux* (1998); in both, as Snow observes, coloured transparencies "are meant to be walked into." The earlier work extends the "abstract color planes" of *Morningside Heights*"[1] and is meant to be walked into and through. The thirty-four frames, each holding a different colour transparency, are suspended. There are two sources of illumination — spotlights

FIGURE 122. Michael Snow, *Localidade*, 2011.

FIGURE 123. Michael Snow, spread from *Illuminations*, 2012.

in one section of the wall and another set in the opposite. "Walking amongst the work's planes, one will experience an almost infinite variety of color mixing in the combination of projections, seeing through the transparencies themselves and the colored shadows they cast."[2] In *Localidade*, thirteen gels are suspended from a transparent fishing line, and two movie lights shine from one end of the gallery.

In the book of illustrations *Illuminations* (2012), the artist's hand holds up strips of small transparencies to remind the viewer of the surface of the coloured strips and their thinness. The addition of the artist's hands reminds the reader that the artist is manipulating the strips and that the arrangement is anything but makeshift.

These four projects are extremely painterly, especially in the use of colour values; they also play with notions of abstraction. In each, textures and colours are manipulated in ways that are reminiscent of the manner in which colours were deployed by Snow early in his career in various forms of abstract painting.

CHAPTER TWENTY-EIGHT:
REPEAT OFFENCES

There are other returns to the history of art in Snow's later work. *Repeat Offender* (1986) *La Revue* (2006), *Powers of Two* (2003), and *Paris de jugement Le* (2003) — the latter is closely related to *VUE3UV* (1998) — juxtapose the artist's twenty-first century sensibility with that of masterpieces from the late nineteenth century. Compositions by the likes of Ingres and Monet were deemed by some in their own time to be controversial because of the way in which the female nude was represented in their works. There is an obvious difference between representing the body nude and representing it naked. In the former, the aim of the work showcases the beauty and integrity of the human body; in the latter, the sexual availability of the subject is usually foregrounded.

"Repeat Offender" is the title of a photo spread in *Penthouse* in July 1982. Snow reproduced these images in black-and-white in the autumn 1986 issue of *Communiqué*, guest edited by Elke Town; he entitled his work *Repeat Offender*. The piece is concerned with the interplay between mass media and appropriation. Twenty years later, in *La Revue* (2006), Snow framed the four magazine spreads from *Penthouse* so that the "centrefold roll" is emphasized. Snow's source is pornographic: the title refers to the second appearance of the model Cami O'Conner in the magazine but it also suggests that she has masturbated repeatedly.

Both publications received a number of complaints because readers felt that Snow's pieces seemed merely to reproduce a piece

FIGURE 124. Michael Snow, *Repeat Offender* in *La Revue*, 1986–2006.

FIGURE 125. Michael Snow, *Powers of Two*, 2003.

FIGURE 126. Michael Snow, *Paris de jugement Le*, 2003.

FIGURE 127. Michael Snow, *VUE3UV*, 1998.

of pornography for which the American magazine was infamous. However, when Snow photographed the colour images in black and white, he deliberately allowed the images to be grainy and slightly out of focus — and printed backwards. In inserting these four pages into *Photo Communiqué*, he "played (seriously) with the gesture of

hiding [an] illicit magazine that you want to read inside an issue of a beyond-reproach journal, which is visible to others."[1]

There is no question that in both *Photo Communiqué* and *La Revue* the female model is the subject of the male gaze, although the woman in two instances has a defiant look. In another, she is putting on lipstick (presumably to enhance herself for the benefit of a male onlooker); in the final image, as she touches her pudenda, she seems lost in reverie. She may be thinking of having intercourse with a male partner, but that cannot be ascertained.

Snow's *Repeat Offender* not only gives this *Penthouse* centrefold a new incarnation, it also places it in an entirely different context. The removal of colour might suggest that the glamorization of the female subject in *Penthouse* is problematic, and the fact that the new images are shoddy perhaps hints that the viewer is looking at something smutty.

However, the form of *Repeat Offender* goes well beyond this by calling attention to the fact that this is a mass-produced object that many people can gaze upon — that there is absolutely nothing personal in that representation. In that sense, glamour is removed from the representation of the model, and the viewer has to construct a different kind of relationship with the black-and-white photographs.

Two readers wrote to *Photo Communiqué* voicing their anger about the publication of *Repeat Offender*. Snow was not completely dismissive of their concerns. In one reply, he wrote, "Your observation that 'the content of art is far more important than technique' has some sense to it, but surely you would agree that some action has to be taken in relation to some material in order that *anything* be made." Here, he is subtly defending form over content, but he is also suggesting that censorship of what can and cannot be depicted is dangerous in a free society. First, he discusses the formalist issues:

> An experience of the work would include an examination of what is actually on the page. Since I feel sure you are not capable of seeing all of what's there, we're at odds from the beginning. The inter-relationship of actual ink-on-paper forms with the traces of what was

once before the two cameras constitutes for me a pret-
ty interesting dialogue.[2]

He then turns to the issue of content:

> "Snow's garbage delivers a clear message that women
> are pieces of meat to be consumed under the guise
> of art. This is pure exploitation." Such a comment is
> rather extreme but has a certain *déjà entendu* quality
> and it sent me back again to look at what was printed,
> to look at the categories "garbage," "meat," and "ex-
> ploitation" this time.[3]

In arguing that the minds of beholders can see very different
things, the artist is pleading for tolerance. Although he makes it quite
clear that he is thoroughly familiar with critical and theoretical writings
about the objectifying male gaze, he is asserting that the issue is much
more complex than his detractors insist. Indeed, in *Powers of Two*, he
investigates the female gaze and, by implication, asks how it differs
from its male counterpart.

Like *Two Sides to Every Story* and *Cover to Cover*, the colour photograph
on cloth *VUE3UV* (1986) is a two-sided work printed on a trans-
parent veil.* As Snow explains, this work's title "is ideally presented
with the second three-letter repeat of the sequence V U E reversed,
this making a compound of *view* (this way and that way) with *veuve*
('widow' in French)." The spectator inspecting the work and hoping
for a front view of the young woman is sorely disappointed since front
and back are identical.

The form of *VUE3UV* is a trap. The photograph remains a photo-
graph: what is there is "the almost-nonexistence of the photograph or

* *Shade* (1979), the large black-and-white transparency (122 x 107 centimetres),
 is similar in methodology.

the non-existent woman."[4] In addition to rendering the erotic body paper thin, "the artist destroys the temporal lapse between the moment the shot was taken and the present, when it is seen. This confusion," Arnaud observes, "is *transferred* to the naked body that seems to erupt like an apparition into the room where the observer finds himself."[5]

A different aesthetic governs *Paris de jugement Le* (2003), although it resembles *VUE3UV* in its presentation of rear views of three nudes. Here, three women are placed in front of a reproduction of Cézanne's 183 x 244 cm *The Large Bathers* (1900–1906) at the Philadelphia Museum of Art. Snow considered the Cézanne deplete of eroticism, and he wanted to juxtapose it with the backs of the three women he considered sexually attractive.

As Snow knew, Cézanne did paint a depiction of *The Judgement of Paris*, and in his title he referenced the myth wherein Paris had to decide which of the goddesses Aphrodite, Hera, and Athena was the most beautiful. He chose Aphrodite because she bribed him with Helen, the wife of Menelaus, and thus began the Trojan War. As in *Venetian Blind*, the view of the spectator is hindered. In the earlier work, the viewer is not able to see tourist spots; in the new work, a monumental painting is blocked from view. The spectator, put into the place of Paris, must decide whether he prefers the flesh of the three ladies or the painting — the distinction can be said to be between nude bathers and naked women.

The immense double-sided transparency *Powers of Two* is composed of four panels suspended so that a viewer can easily pass from one side to another — each side is identical. The transparency allows the room in which it is hung and gallery-goers to be replicated on either side. Since the viewers are reflected in *Powers*, they become part of the art object and a co-conspirator with Snow in voyeuristic activity. More significantly, the viewer can look through the transparency to viewers on the other side — in this sense, the transparency is a pure image residing in real space.

In a bedroom, a man, his face hidden, lies on top of a woman; the clear implication is that his penis is inside her. She looks out toward the audience. Her face seems to have a triumphal expression, but remains difficult to read. Has she somehow obtained — through her body

— some sort of control over the man? That is a strong possibility. There is another conceivable reading. In place of the male gaze, we have here the female gaze: one of power and control.

In this group of photographs, actual touching and the invitation to touch are shown. At the same time, however, Snow plays with the surfaces — the flesh — of these works: a double-sided transparency, a two-sided veil, a comparison of the skin of nude models to a reproduction. The "subject" of these compositions and their "framing" become synonymous. There are always two sides to every story.

Snow is making a distinction between libidinal desire as a feeling and libidinal desire transferred into a work of art. The former phenomenon can be undisciplined, an expression of all kinds of conflicted, id-driven emotions; the second must be harnessed in a work of art. This dissimilarity can be made clearer by looking at the lithograph *Projection* (1970), a work in which a man with an erect penis grips and stands next to a WW. This image was originally intended for *NYEEC* and then cut out. The title can also refer to a movie projection.

Underneath the image is this text:

TITLE. EXCUSE. EXPLANATION. RATIONAL-IZATION. EQUIVALENT ANALYSIS. DEFENSE. EXTENSION. COMMENTARY (SUB-TITLE) PROJECTION OF A FRAME FROM A 1964 FILM TO A 1970 LITHOGRAPHIC PRINT. PRESENT FUCKS PAST. WHITE INKS. BLACK PAPER. LIGHT FUCKS DARKNESS. WET FUCKS DRY. SOFT FUCKS HARD. MALE CHAUVINIST PRINT. THE KING WOMAN *MEATS* HER MAKER. A SYMBOL MINDED EXAMPLE. CUNTLESS PRICK. PRINTS = FAKE FUCK. ENLARGEMENT ART HARD-ON/ CUT-OUT; PRESENCE MAKES ABSENCE. TOKEN, POKIN' FLAT FUCK. ART OF LOVE, MUSE POSED. PRINTER COURSE. 16 MM 8" X 5"; 18" X 13½"; 24 X 20" LAY.

This piece of writing is meant to look jumbled — almost as if it is composed helter-skelter. This not the situation, however. The text makes links between *NYEEC* and the lithograph, between complex and simple-minded symbols, between sex acts and printing processes, between male power and female power. The lithograph, however, privileges its image over its words because the image is enacted in a way that subsumes the text into a simply stated but visceral representation of sexual desire.

Two decades earlier, in 1979, Amy Taubin, in writing about the WW and also about *Two Sides to Every Story* (1974), was acerbic:

> [T]here is only one side to this story. It is the story of male dominance and female submission. It is not 'every' story but the particular story that is told by male artists in their representations of women. For 40 minutes the filmmaker gives orders to a young woman.... She aims to please. And although she is instructed to carry this colored sheet here and that one there, the principal object displayed is her person ... [the film] is a sexist one-liner. Its gestures towards formalism cannot disguise the reactionary and offensive story it tells.*[6]

Taubin's point is well argued, but it must be noted that Snow is interested in examining the dynamics in male-female relationships and is quite capable of showing himself (and other men) as the victims of their own lustful desires. In such exchanges, women often find ways of obtaining control. In this sense, the artist simply depicts a reality: the shifting balance of power in the battle of the sexes.

Taubin's comment on *Two Sides* was voiced when the film was shown as part of the *Re-Visions* exhibition at the Whitney in the autumn of 1979. In *Flash Art*, Jonathan Crary concentrated on

* It was part of the *Re-Visions* exhibition (the first show at that gallery devoted solely to film and video; it included six artists).

the film's revolutionary achievements, particularly its "Janus-like three-dimensionality":

> Even though [this piece is] a self-reflexive meditation on the making of a film, it contains a surplus content; as in his other work, Snow delivers more than he seems to promise. Within the flow of his structural discourse are narrative elements that can be read as veiled self-portrait. On one side of the screen we see Snow seated, impassive like a magus, giving instructions which his assistants execute. He faces the other camera like a chess player taking on both sides of his game, responding to each of his moves with a countermove, like a man trying to outfit his own image in a mirror.[7]

John Locke in *Parachute* commented on other aspects of the film's formalist achievements: "Another director might have made two dull films using this set up, but not Snow. The action between the cameras is precisely organized so that the experience … is amazingly rich." He was also taken with the film's commentary on surface and framing — the "strongest, most lucid statement about the two-dimensional existence of screen images that I have seen."[8]

Snow's fascination with the notion that "there are two sides to every story" can be seen in the photograph *Imposition* (1976), where he placed four horizontal images one over the other and then displayed them vertically. The first shows an empty alcove, in the second a sofa has been added to the alcove, in the third a naked man and woman sit on the sofa, and in the fourth the same man and woman are clothed. The title refers to two impositions: spectators must tilt their heads to view the image. In image 4, the man and woman tilt their heads, perhaps because they are viewing the horizontal image of themselves in images 1 to 3, in the same direction as the viewer.

As Jean Arnaud has pointed out, this process is even more complicated:

FIGURE 128. Michael Snow, *Imposition*, 1976.

There is first an imposition on the viewer to emulate the characters in order to see the photograph in the right direction, for it is installed vertically. Thus both the characters in the image and the viewers tilt their heads. Second, the reflective glass that covers *Imposition* hangs slightly in front of the photograph, and the reflection of the viewer remains the final superimposed image. You see yourself imitating the two young adults, *in and in front* of the box, in and [in] front of the photographic space. When you stand before *Imposition*, you no longer know who's imitating whom: the image stares at you, but the emulation seems to be reversed, and reality surpasses fiction. In this baroque work, seeing means activating the image in ways other than through looking: the viewer moves in space in order to move through time by crossing through the mirror.[9]

Of course, the reflection of the viewer is a key element in an earlier work, *Authorization*, but in *Imposition*, when the four layers are placed one on top of the other, they are difficult to distinguish, and, so, they compete for attention. As the eye tries to separate the four and isolate one, the ghostly images of the other three impede any such attempt. Snow has argued that painting can have a similar layering, although he acknowledges that photography more readily lends itself to this kind of procedure.

Another technique in imposition is used in the gallery installation video *SSHTOORRTY* (2005). The title refers to the layering of the word "short" over the word "story." The incident depicted is fairly straightforward: a man (an artist) arrives at an apartment and presents the woman who answers the door with a painting; the couple walk into the room where the husband is; the artist hangs the picture on the wall, whereupon the husband says he will drink to the painting but not to the artist. When the artist asks why, the husband says that he is aware that the artist has been "fooling around" with his wife. "That's more than you're doing," retorts the artist. The angry husband throws wine

FIGURE 129. Michael Snow, still from *SSHTOORRTY*, 2005.

on the face of the artist, who, turning, removes the painting from the wall and hits the husband over the head with it. The artist, followed by the upset wife, goes to the door and exits.

There had been latent narrative in some of Snow's earlier films, but here he decided to make a film that told a story. The surprise here is that the film, as shot and edited, was cut in half and the two imposed on the other. This doubling is looped and can be viewed repeatedly. "As the work becomes more purely artifice — a construction — and less a 'real narrative event,' Snow observes, "it becomes what 'really' is."[10] Of course, what really is remains unstable and, in a sense, unknowable.

CHAPTER TWENTY-NINE: RESHAPING FRAGMENTS

The digital Betacam video *Corpus Callosum* (2001) is about another kind of transformation and, as Snow puts it, is "a tragicomedy of cinematic variables."[1] This piece is also about shaping. The corpus callosum is the central area in the brain that passes messages between the two hemispheres. This is an appropriate title because this film is about binaries in which "real" people are shown: what they see and what the audience sees shifts. The film has two main characters, male and female, and the film features a series of tableaux in which these two are depicted in various guises.

This animated film reminded the critic John Pruit of Snow's very first film: *A to Z*. He also saw the film "reaching back" — an approach opposite to the forward zoom in *Wavelength*. In speaking about "The Living Room," a twenty-minute portion of *Corpus*, he pointed out that, reminiscent of *Wavelength*, "there will eventually be a metal chair and images that recall Snow's early Walking Woman series."[2] He also linked "The Living Room" to van Eyck's *The Arnolfini Portrait* (1434) and Velázquez's *Las Meninas* (1656). "All three works portray full figures within a room and all have on the rear wall a small mirror which gives us a glimpse of the reverse view."[3]

One observer has pointed out that *Corpus* continued the artist's "exploration of the nature of mind and perception, this time focusing on the ways the brain manipulates information to create images. Here, he worked with a computer programmer to generate images of people

FIGURE 130. Michael Snow, still from *Corpus Callosum*, 2001.

in a Toronto office that stretch, squeeze, distort and randomly vanish." Snow has also observed: "*Corpus Callosum* actually ends with a little sketch I did when working at Graphic Films in 1955 … so in a way it was a return to animation."[4]

There are more instances of Snow shaping and reshaping the history of painting. In *D'abord Alcibiade et puis …* (1996), Snow took a photograph of an unfinished painting by Jacques Réattu (1760–1833) in the museum in Arles that bears the artist's name. The museum is located in a small back street of Arles and was originally the Grand Priory of the Knights of the Order of Malta.

There are various accounts of how the Greek statesman Alcibiades died. According to Plutarch, assassins surrounded the villa in Phrygia where the Greek hero was living with his mistress; the residence was set on fire and seeing no chance of escape, Alcibiades, dagger in hand, confronted his assassins and was killed by a shower of arrows. Réattu shows the aftermath of his subject's death.

According to legend, the legs of the fallen hero were painted in about 1868 by Elizabeth Grange, the painter's daughter and heir. If this

FIGURE 131. Michael Snow, *D'abord Alcibiade et puis ...*, 1996.

is true, she must have decided to leave the left-hand side of the painting incomplete. Snow filled in some of the unfinished, sketched-in portions — the negative space behind one of the figures, a horse blending into the dome of a helmet, the curve of muscle on a soldier's torso. In amplifying the painting, he paid close attention to the French artist's colour values (especially the reds) and the shapes devised by his predecessor but he added an "abstract" element in the manner he made his alterations. "I'm glad you asked about this one," he once told a journalist. "Because I lived through the age of abstract painting, I could see it in a way Réattu couldn't."[5] In other words, Snow could conceive of a new way to finish the painting that the nineteenth-century artist could not.

Like Réattu's daughter, Snow completed only a portion of what was unfinished; he then photographed the resulting image in the way the painting hangs in the gallery. He then photographed the resulting image off-centre so that the viewer "sees" what does not exist: the "completed" framed painting hanging in a gallery; the product is a digital photograph

that is framed, but the outer and inner frames are at variance with each other. The resulting work changes the essential nature of the surviving painting by enhancing it in a way that does not exist at Arles. The viewer is also looking at a photograph of a photograph of a painting. Where, the artist asks, does the "reality" of this object exist?

Related to *Mort* is an early work *Times* (1979), a work as elaborate as *Mort*. For the earlier work, Snow painted an abstract. This photograph shows that framed painting hanging on a white wall. Unlike a photograph in an exhibition catalogue, the floorboards occupy a substantial amount of space at the bottom of the image; the abstract is deliberately at variance with the photograph, which is placed in a wooden frame.[*]

The pattern made by the planks of wood in *Times* echoes three patches of colour in the background of the abstract. There are other instances of the manipulation of surface in this image: in the photograph, the painting seems to float above the floor and, as it does so, it leaves its shadow on the white wall and the floorboards. At the centre of the abstract is a transparent grey square that seems to reside spatially in front of the three shapes behind it.

One commentator has suggested that the "made-to-fit painting" and floor motif "not only echo each other but are also rendered in importance, a gesture that challenges the primacy of painting as a medium in the field of representation.… More abstract than representational, *Times* presents a highly cerebral exercise to the viewer, as decoding each layer of the composition brings a new level of awareness how visual perception operates."[6]

The photograph is even more complex than suggested above because the abstract painting purpose-made for this photograph was very small (about 20 x 25 centimetres) and all the other components in the resulting image are in proportion to it. However, the photograph gives the impression of a large abstract painting hanging in the gallery. There is a further complexity: the centre square of the abstract is at variance with the outward frame and so the resulting image is lopsided.

[*] Martha Langford has suggested that the off-kilter technique may be indebted to Malevich in a composition such as *Painterly Realism of a Peasant Woman in Two Dimensions* (1915), where the lack of confinement of the red — its ability to extend into the white — gives it far more power than if it was simply positioned neatly against the white.

FIGURE 132. Michael Snow, *Times*, 1979.

What *Mort* and *Times* share is Snow's propensity to question the status of the works of art he creates. In *Times*, he deliberately compares the reality of the abstract to the reality of photography. The attempt is not to privilege one over the other as much as to show the connections between the two. He never forgets his commitment to painting and his wish to infuse his photographs with painterly qualities, and *Mort* amply demonstrates the artist's abiding love for painting as a genre.

CHAPTER THIRTY:
NEW-FOUND THINGS

In the summer of 2017, at Toronto's Prefix Institute of Contemporary Art, four early videos by Snow were shown as a unit in a work entitled *Newfoundlandings*. (The title suggests that the artist is a stranger who has landed in Newfoundland; it also refers to the fact that all four pieces — *Sheeploop* [2000], *Solar Breath [Northern Caryatids]* [2002], *Condensation [A Cove Story]* [2009], and *In the Way* [2011] — investigate land from varying perspectives.) This installation, undertaken by Prefix in co-operation with the artist, provides a new context in which to view these four pieces and, in the process, reimagines and reinvents them.

The no-sound, fifteen-minute *Sheeploop* is, as the artist observes, classically pastoral, much in the manner of a painting by Constable. Snow set up his video camera on a tripod quite distant from the grazing animals who move in and out of the frame. Then, the lead sheep walks casually out of the frame and then back into it. After that, the entire flock slowly follows its leader out of frame and thus create a perfect "organic loop." The sixty-two minute *Solar Breath* records a phenomenon the artist has witnessed only a few times in thirty years at his remote Newfoundland cabin:

> Near sunset the wind blows the single curtain on a
> window in the room, each time with varying style

and force and then, mysteriously, sucks the curtain back to make it smack against the pane of a non-existent window (or at least a non-visible window, because the window appears to be open). Each time the curtain slaps loudly … it stops, and stays still, for surprisingly long periods of time. Each time it does so a different beautiful static composition of folds is manifested, hence the caryatids in the title.[1]

These compositions are, of course, forms of the gesture in painting — and are equivalents to the broad strokes one finds in a Pollock.

The ten-minute Blu-ray projection *Condensation* also highlights the weather near Snow's cabin by showing giant cliffs descending to the sea. The title refers to the fog, mist, rain, and clouds that constantly shift and change; it also indicates the condensed use of time.

FIGURE 133. Michael Snow, still from *Sheeploop*, 2000.

FIGURE 134. Michael Snow, still from *Solar Breath (Northern Caryatids)*, 2002.

FIGURE 135. Michael Snow, still from *Condensation (A Cove Story)*, 2009.

Hundreds of sequences were shot using a digital camera with a time-lapse mechanism attached, which had the camera, for instance, taking a picture every ten seconds. The most interesting of these sequences were computer-assisted to become twenty-four projected frames per second. The sequences were also composed to dissolve from one to the other, in the same way the actual weather events do.[2]

The twenty-three-minute *In the Way* (2011) is projected onto the floor and shows a rocky, muddy road that gradually gives way to wild grasses and flowers; the camera moves at varying speeds and invites the viewer to travel with it and, in a sense, join it on its journey.

Sheeploop is quiet, reflective and serene; the same can be said for *Solar Breath*, although the sound of the curtain hitting the frame is present — in fact, the sound creates its own irregular, pleasing rhythm. The manipulated transitions in *Condensation* provide the viewer with a series of awe-inspiring views of the collisions between the weather elements and the sky and the mountains — the effect is similar to looking at a series of Turners (as opposed to the Constable-like *Sheeploop*). The action in *In the Way* is frenetic — this is a very high-intensity promenade.

These pieces represent very different "takes" on the rugged Newfoundland landscape. (In that sense, they share an affinity with *La Région Centrale* — all five works can be said to be investigations of the Canadian Wilderness.) At the installation in Toronto, *Sheeploop* was by itself in an anteroom. The gallery in which the other three works were shown is arranged so that a member of the audience enters a large gallery where *Solar Breath* is placed on the extreme right corner with some chairs in front of it. The clear invitation is to sit there. Once in place, *In the Way* is in back of the viewer, who must turn around to look at it. Immediately, two actions are in conflict — the slow pacing of one work versus the quick speed of the other. Then, the viewer looks across to the left side of the room to view a

large screen where a variety of painterly, sublime landscapes merge slowly and majestically into each other.

In this installation, the pastoral (*Sheeploop*) in its small space invites the audience into a larger one. Once there, the domestic (*Solar Breath*), the hectic (*In the Way*), and the sublime (*Condensation*) confront the viewer. And, as is to be expected, there is no guideline of any kind to how to respond and so each visitor will obviously make a different decision and so act as a co-creator with the artist.

CHAPTER THIRTY-ONE:
SMOKE AND MIRRORS

This book has suggested that Michael Snow's existence as an artist inhabits his life. From his young manhood, the truth of his life resides there, even if truth — as he constantly observes — is an impossible entity to capture. The lives of many artists are histories of their work. This observation is especially true for Snow.

Nevertheless, he has sometimes hinted at the "real" Michael Snow. However, although he has often used himself as the "model" for some of his photographic works, pieces such as *Authorization* or *Venetian Blind* cannot be read autobiographically. There are some pieces, though, where the artist seems to present momentary glimpses into his inner life. The acrylic on canvas *Derma* (1990) is one such piece.

The nude male, his back to the viewer, tentatively touches (or attempts to touch) what looks like a canvas containing a brightly coloured abstract (highly saturated oranges, yellows, blues, reds). Immediately, this becomes a work-within-a-work — a self-reflective piece in which a canvas is depicted. The title refers to skin, but does it refer to the skin of the abstract or the accentuated, burnished skin of the male figure? If so, what is the relationship between the two? This acrylic can be read as a commentary on the process that the artist goes through to create. He must make a distinction between life and art and recognize that the two may interact but always remain separate from each other. In that sense, there is a poignancy to the fact that the two remain distinct. The human figure may wish to enter the world of art and become an artifact, but

FIGURE 136. Michael Snow, *Derma*, 1990.

he cannot do so. In "The Circus Animals' Desertion" and "Sailing to Byzantium," W.B. Yeats had voiced similar sentiments.

The oil *Biograph* (1991) is divided into two canvases. On the left-hand side, Michael Snow, glimpsed through a camera, is taking a picture — one in which presumably his representation will be captured. However, the image on the right defeats this expectation. That image — an arrangement of the same colours as its companion — is a grid-like abstraction. The artist, it would seem, puts himself into his art but the transformation that occurs is difficult to discern. The artist may be present in his work, but he constantly reconfigures himself.

The C-print *Smoke and Mirrors* (1994) shows Michael Snow, dressed very much as he is in the earlier image, again taking a photograph: this time, the upper portion of his body is encased in a circle, but the entire image is in the process of burning and thus being obliterated.

The term "smoke and mirrors" refers to a complicated act of subterfuge that diverts attention from what is really happening. Here, not only do we not see the photograph taken by Michael Snow but he is also displaying his image being burnt — about to disappear. In this sense, the artist is hinting that his intent is to conceal his real identity and may take elaborate, complicated steps to do so. If there is a "truth," it may be inaccessible.

FIGURE 137. Michael Snow, *Biograph*, 1991.

FIGURE 138.
Michael Snow,
Smoke and Mirrors,
1994.

Snow returned to the WW format in *Adam and Eve* (1997) in which his face is that of the famous figure but the resulting image shows a blend of male and female. Here, Adam and Eve are conjoined in a Michael Snow who is presented in a Janus-like manner. This may be a clue to seeing Michael Snow as a composite of opposites.

Still Living (9 x 4 Acts, Scene 1) (1982) — an edition of ten portfolios each containing nine pages and thirty-six images shot with a Polaroid SX-70 — depicts a series of "incidents" (Snow's terminology) in which various objects belonging to the artist are rendered as still lifes; thus, the photographs, taken at the Newfoundland cottage, provide a taxonomy of the artist at that moment in his life. "The simple elegance of these arrangements," Adelina Vlas has observed, "lends these images a theatrical quality, as their presentation follows a narrative established by the artist."[1]

FIGURE 139. Michael Snow, page from *Still Living (9 x 4 Acts, Scene 1)*, 1982.

Snow has compared his use of the still life tradition here to Chardin's *Attributes of Music* (1765), in which the artist employs musical instruments, books, and sheets from a composition in a careful arrangement with a deliberately limited colour range. Sound may be absent but is strongly implied. If the various parts were arranged together in *real life*, music could be played. A similar methodology is used by Snow in *Still Living* so that each "miniature assemblage" contains various "actors" to suggest movement and *real life*. "The actors are not at all still," as Snow points out.[2] His ambition became focused in an attempt, as Snow put it, "to indicate the merging of textural, painting, sculptural, theatrical and photographic concerns." In other words, these various images and their interactions with each other, are attempts to encapsulate the Michael Snow who has used a plurality of genres in his career. He may have accomplished a great deal but he is "still living" and, presumably, still striving.

In an article in *Vanguard*, Christopher Dewdney paid close attention to "how each" of the images in *Still Living* "are grouped in such a manner that they are denuded of their previous contexts and are assembled in a new grammar of identity…. Many of the 'scenes' are the enactment of highly personal, compulsive dramas of anthropomorphism. Many are rigorously humorous, some are darkly ironic. Highly complex, each photograph is a theatre of connotation."[3]

Perhaps the life of this artist is captured in the presentation of the objects which, by metonymy, are him. His aura can be felt, but what that aura is cannot be stated with any degree of certainty. These photos are allegorical in that the series of objects shown represent or stand in for the artist — especially the twists and turns in his imagination. However, the arrangement of objects might not seem at first glance to relate to each other but are interconnected in the creator's imagination. The result is a deliberately constructed puzzle that the viewer is invited to put together. Again, however, there are hints but no certain truths.

As a young man, Snow, upon discovering that his destiny was to become an artist, tentatively explored that world and then became completely engaged with it. Fully energized, he found more and more ways to make

FIGURE 140. Michael Snow, *Ocul*, 1954.

art. He moved to New York in order to test himself in that challenging environment. He returned to Canada, where he constantly found — and continues to find — new ways to express his creative energy. This is an unfolding process. Central to all his work from the beginning is the notion of seeing — what do we behold when we use our eyes?

In a commencement address in 2016, Michael Snow, reflecting on his career, said, "En somme, parlant de la foundation de mon travail comme artiste, je crois que je peux dire qu'il y a eu deux grandes influences sur mon travail et ma carrière. La première était Elzéar Lévesque, et la deuxième Pablo Picasso."[4] [In short, speaking of the beginning of my work as an artist, I think I can say that there were two great influences on my work and my career. The first was Elzéar Lévesque, and the second was Pablo Picasso.]

Michael Snow is a firm believer in ancestry as the key to understanding someone's life and career and, in paying tribute to his maternal grandfather, he is acknowledging this. He is also calling attention to the fact that his surname might be Anglo-Saxon but that his mother was Quebecois.

FIGURE 141. Craig Boyko, *Michael Snow*, 2012.

The choice of Picasso might seem an odd one, but one of Snow's first surviving pieces of art is based on his response to an article in *LIFE* magazine on the great Spanish painter. Moreover, Picasso worked in a wide variety of genres and was always open to various kinds of experimentation during his long career. The same observation can be made about Michael Snow.

In his talk, Snow defined himself as a Canadian artist, one whose talents derive in large part from circumstances of birth. However, he went on to align himself with an artist known for his protean accomplishments. Put another way, Snow is a Canadian artist who dared to tackle many genres and in many different ways.

The outer events in Snow's existence — his lives as man and artist — have been described in this narrative, but the inner life can only be discerned in the works. There the inner man can be seen, the artist whose entire career has been a succession of daring experiments.

ACKNOWLEDGEMENTS

For assistance in researching and writing this book, I wish to thank the following who spoke with me about Michael Snow: Robert Fones, Peggy Gale, Denyse Rynard, and Georgine Ferguson Strathy. Sarah Milroy suggested I write a life of Snow, and I am grateful to her for gentle prodding. Mani Manzini, Snow's assistant and collaborator, has helped me in many ways.

I am deeply indebted to the writings on Snow, especially the work of Regina Cornwell, Louise Dompierre, R. Bruce Elder, Adele Freedman, Robert Fulford, Gerald Hannon, Martha Langford, David Lancashire, Annette Michelson, Dennis Reid, P. Adams Sitney, and Adelina Vlas.

Amy Furness at the Art Gallery of Ontario provided excellent guidance to using the Snow fonds. I am especially grateful to AGO archivist Marilyn Nazar for her kind, generous assistance.

Allison Hirst, as always, has been an exemplary editor: thorough, intuitive, and kind. Dominic Farrell has carefully, precisely, and intuitively copy-edited my manuscript.

My greatest indebtedness is to Michael Snow, who opened the doors to his home and his studio to me, answered all my many questions, read three drafts of this book, and, in every conceivable way, helped me to understand the complexities of his many lives and works.

SHORT TITLES

AGO
Michael Snow fonds at the Art Gallery of Ontario.

Almost
Michael Snow Almost Cover to Cover. Essays by Catsou Roberts, Martha Langford, A.L. Rees, Amy Taubin, Malcolm LeGrice, and John Pruitt. London: Black Dog Press, 2001.

Baird
Daniel Baird. "Riffing: Jazz Inspired Michael Snow, the Most Influential Canadian Artist of All Time, to Explore the Unexplored," *The Walrus* (March 2011).

Collected Writings
Michael Snow. *The Collected Writings*, ed. Louise Dompierre. Waterloo: Wilfred Laurier University Press, 1994.

Cornwell
Regina Cornwell. *Snow Seen: The Films and Photographs of Michael Snow.* Toronto: Peter Martin Associates, 1980.

Dompierre
Louise Dompierre. *Walking Woman Works.* Kingston: Agnes Etherington Art Gallery, Queens University, 1983.

Freedman
Adele Freedman. "The Disappearing Man," *Canadian Art* (Spring 1994).

Hannon
Gerald Hannon. "Provocateur (Profile of Michael Snow)," *Toronto Life* (April 1994).

Lancashire
David Lancashire et al., ed. *The Michael Snow Project: Music/Sound, 1948–1993*. Toronto: Knopf, 1994.

Lind
Jane Lind. *Joyce Wieland: Artist on Fire*. Toronto: Lorimer, 2001.

Nowell
Iris Nowell. *Joyce Wieland: A Life in Art*. Toronto: ECW, 2001.

Photo-Centric
Adelina Vlas, ed. *Photo-Centric*. Essays by Vlas and Michael Snow. Philadelphia: Philadelphia Museum of Art, 2014.

Reid
Dennis Reid et al., ed. *The Michael Snow Project: Visual Art, 1951–1993*. Toronto: Knopf, 1994.

Sequences
Michael Snow. *Michael Snow — Sequences — A History of His Art*. Barcelona: Ediciones Poligrafa, 2015.

Survey
Michael Snow. *Michael Snow/A Survey*. Toronto: Art Gallery of Ontario, 1970.

Touching
Jean Arnaud. "Touching to See," *October* 114 (Autumn 2005).

NOTES

Introduction

1. Michael Snow, "Michael Snow," *evidence* 2 (Spring 1961), unpaginated.
2. Michael Snow, "Artist Statement" (1967), reprinted in *Collected Writings*, 26.
3. John Bentley Mays, "'It's Often Necessary,' Snow says, 'To Define Your Own Direction,'" *Globe and Mail*, December 1, 1984.
4. Michael Snow, interview with Nicole Gringas, *Art Press* 234 (April 1998), 21.
5. Malcolm Turvey, "The Child in the Machine: On the Use of CGI in Michael Snow's **Corpus Callosum, October* 114 (Fall 2005), 29.
6. Robert Fones, "Michael Snow's Bent: Image Distortion in *1956*," *Ciel Variable* 100 (Spring 2015), 65.
7. Catsou Roberts and Michael Snow, "An Intercontinental Collage," *Almost,* 12.
8. Christopher Dewdney, as quoted by Susan Walker in "Blizzard of Snow Ahead," *Toronto Star*, March 5, 1994.
9. Baird.
10. Hannon.
11. Kate Taylor, "In the Eye of a Snow Storm," *Globe and Mail,* March 12, 1994.
12. Baird.

Chapter One: Origins

1. Denyse Rynard, interview with James King, March 12, 2017.
2. Convocation Address, Université du Québec à Chicoutimi, April 2016.
3. Ibid.
4. Rynard interview.
5. Convocation Address.
6. Hannon.
7. *Survey*, 127.

Chapter Two: Conversion

1. Lancashire, 36.
2. Freedman.
3. Michael Snow, quoted in Manny Farber, "The Arts: Farewell to a Lady," *Time* (Canadian Edition), January 24, 1969, 17.

Chapter Three: Jazz Band

1. Lancashire, 45.
2. Hannon.
3. Ibid.
4. Snow in conversation with Louise Dompierre, October 4, 1982. Taped interview.
5. See Hajo Düchting, *Paul Klee: Painting Music* (Munich: Prestel, 2016).
6. Ibid., 13–14.
7. "Ontario Society of Artists Uncovers New Talents," *Canadian Art* 9 (Summer 1952), 170–71.
8. Georgine Ferguson Strathy, interview with James King, July 12, 2017.
9. Snow, interview with Dompierre.

Chapter Four: A Man Drawing Lines

1. Hannon.
2. Ibid.
3. Snow, interview with Dompierre.

4. Ibid.

5. Ibid.

6. Ibid.

7. Lancashire, 58.

8. *Sequences*, 65.

9. Michael Snow, letter to his parents, January 16, 1955. MS: AGO.

10. John Grande, "The Michael Snow Project," *ETC* 27 (1994), 1–4.

Chapter Five: Intimations

1. Snow, interview with Dompierre.

2. Peter Goddard, "Remembering Toronto's 1960s Spadina Art Scene," *Canadian Art* (July 2014).

3. Michael Snow quoted in *Isaacs Seen: 50 Years on the Art Front; A Gallery Scrapbook*, ed. Donnalu Wigmore (Toronto: Justina M. Barnicke Gallery, Hart House, 2005), 40.

4. *Isaacs Seen*, 9.

5. Typescript is dated January 6, 1955. AGO.

6. Hannon.

7. Barrie Hale, *Toronto Paintings 1953–1969* (Ottawa: National Gallery, 1972), 57.

8. Alex K. Gigeroff, "Nude Controversy Painters Outline Personal Attitude," *Varsity,* January 10, 1955.

9. Lotta Dempsey, "Person to Person," *Globe and Mail*, February 16, 1956.

10. Les Lawrence, "Open Up New Gallery," *Varsity*, February 3, 1956.

11. *Sequences,* 59.

12. Hannon.

Chapter Six: Gestures

1. Hannon.

2. Ibid.

3. Nowell, 133.

4. Hannon.

5. Lancashire, 63–64.

6. *Sequences,* 65.
7. Robert Fulford, "World of Art: Cool and Playful," *Toronto Star,* March 4, 1961.
8. *Sequences,* 65–66.
9. Paul Duval, "Accent on Art: Intent and Serious," *Toronto Telegram,* March 18, 1961.
10. Elizabeth Kilbourn, "Coast to Coast in Art: Toronto-Hamilton," *Canadian Art* 18 (May–June 1961), 184.
11. Robert Fulford, "World of Art: Snow Explored Edge of Art," *Toronto Star,* March 7, 1959.
12. "CJBC Views the Shows, Excerpts." MS: AGO.
13. Kilbourn, 184.
14. *Dennis Burton: A Retrospective* (Oshawa: Robert McLaughlin Gallery, 1977), 88.

Chapter Seven: Drawn Out

1. "About Michael Snow," *Paintings, Sculptures, Drawings by Michael Snow* (Toronto: Greenwich Gallery, 1956).
2. Pearl McCarthy, "Art and Artists: Younger Group Rising Over Weary Sterilities," *Globe and Mail,* October 20, 1956.
3. Robert Fulford, "Triple-Threat in Abstracts," *Mayfair* 30 (June 1956), 51–52.
4. Robert Fulford, "World of Art: Cool and Playful," *Toronto Star,* March 4, 1961.
5. *Sequences,* 65.
6. Robert Fulford, *The Best Seat in the House: Memoirs of a Lucky Man* (Toronto: Collins, 1988), 93, 94.

Chapter Eight: A Lot of Near Mrs.

1. Kathe Gray, "Michael Snow: An Interview with the Artist," *Ontarion* 116, issue 2 (January 17–23, 1995).
2. *Collected Writings,* 10.
3. Reid, 114.
4. Michael Snow to Linda Milrod, February 5, 1979. MS: Agnes Etherington Centre.

5. *Sequences*, 79.
6. Reid, 61.
7. *Sequences*, 79.
8. Gray.
9. *Sequences*, 80.
10. Freedman.
11. Robert Fulford, "World of Art: Snowgirl," *Toronto Star*, March 17, 1962.
12. "A Lot of Near Mrs.," in *Collected Writings*, 19.
13. Fulford, *Toronto Star*, March 17, 1962.
14. Nowell, 184.

Chapter Ten: Cool City

1. Jed Perl, *New Art City: Manhattan at Mid-Century* (New York: Vintage, 2007), 379.
2. Hannon.
3. Michael Snow to Av Isaacs, November 26, 1963, Isaacs archive, York University.
4. Nowell, 192–93; *Sequences*, 123.
5. Lancashire, 64.

Chapter Eleven: Eye and Ear Control

1. Jonas Mekas, "Movie Journal," *Village Voice,* May 2, 1963.
2. P. Adams Sitney, *Visionary Film: The American Avant-Garde, 1943–2000*, 3rd ed. (New York: Oxford University Press, 2002), 160.
3. Leah Sandals, "Déja Viewed: Michael Snow on Looking Back, and Ahead," *Canadian Art* (September 2016).
4. *Collected Writings*, 288.
5. *Collected Writings*, 25.
6. Michael Snow in conversation with James King, January 24, 2018.
7. hollisframpton.org.uk/bio.htm.
8. A.L. Rees, "Working Both Sides of the Street: Film and Art in Michael Snow," in *Almost,* 80.
9. Ibid., 78.

Chapter Twelve: More Snowgirls

1. Marjorie Harris, "The Snow Man's Woman," *Commentator* 8, no. 6 (June 1964), 15–16.
2. Harry Malcolmson, "Art and Artists," *Toronto Telegram*, December 24, 1965.
3. Gray.
4. Mays, "Walking Woman Returns," *Globe and Mail*, February 11, 1994.
5. *Sequences,* 82.
6. Isaacs to Snow, October 14, 1963, Isaacs archive, York University.
7. Snow to Isaacs, no date, Isaacs archive.
8. Isaacs to Snow, June 10, 1964, Isaacs archive.
9. Snow to Isaacs, no date, Isaacs archive.
10. Stuart Preston, "Bring the Past to the Bar of the Present," *New York Times*, February 2, 1964.
11. Natalie Edgar, "Reviews and Previews: New Names This Month," *Art News* 62, no. 10 (February 1964), 18.
12. Emily Genauer and John Gruer, "Art Tour: The Galleries — A Critical Guide," *New York Herald Tribune*, February 1, 1964.
13. Donald Judd, "In the Galleries: Michael Snow," *Arts Magazine* 38 (March 1964), 60–61.
14. *Sequences,* 85.
15. *Collected Writings,* 18.
16. Elizabeth Kilbourn, "Snow's Achievement," *Toronto Star*, April 25, 1964.
17. Robert Fulford, "On Art: Some Canadian Painters — Like Michael Snow — Have to Quit Canada," *Maclean's*, March 7, 1965, 55.
18. Jill Johnson, "Reviews and Previews," *Art News* 64 (January 1966), 16.
19. Amy Goldin, "In the Galleries: Michael Snow," *Arts Magazine* 40 (February 1966), 65.
20. Malcolmson, "Art and Artists," *Toronto Telegram,* December 8, 1965.
21. Malcolmson, "Art and Artists," *Toronto Telegram,* April 16, 1966.

22. Kay Kritzwiser, "Snow's Walking Woman Walks Again," *Globe and Mail*, April 9, 1966.

23. *Almost,* 23.

24. Amy Taubin, "Re-viewing Revisions," *Soho Weekly News*, May 10, 1979.

25. Mays, "Walking Woman Returns," *Globe and Mail*, February 11, 1984.

26. Gray, 29.

Chapter Thirteen: Wavelengths

1. *Collected Writings*, 288.

2. Ibid., 289.

3. Elizabeth Legge, *Wavelength* (London: Afterall Books, 2009), 14–15.

4. Michael Snow in conversation with James King, January 12, 2018.

5. *Sequences,* 123.

6. Publicity blurb, AGO.

7. Hollis Frampton, *Artforum,* 1970.

8. *Photo-Centric*, 8.

9. Cornwell, 66–68.

10. As quoted by Cornwell, 66.

Chapter Fourteen: New Surfaces

1. Gene Youngblood, *Los Angeles Free Press,* 1970.

2. Ibid.

3. Manny Farber, "The Ten Best," *Artforum*, 1970.

4. *Sequences,* 132.

5. P. Adams Sitney, *Visionary Film: The American Avant-Garde, 1943–2000* (New York: Oxford University Press, 2002), 348.

6. *Sequences,* 337.

7. Ibid., 257.

8. Ibid.

9. John Perrault, "The Act of Seeing," *Village Voice*, February 8, 1968.

10. Hilton Kramer, *New York Times*, February 10, 1968.

Chapter Fifteen: Canadians in Manhattan

1. Lind, 143.
2. Ibid., 156.
3. Ibid., 248.
4. Ibid.
5. Hannon.
6. Snow, interview with King, January 12, 2018.
7. Virginia MacDonnell, "The City of Snow," *Harvest Journal of Creative Culture* (Winter 1993–94).
8. Robert Enright, "The Lord of Missed Rules: An Interview with Michael Snow," *Border Crossings* 26, no. 2 (May 2007).
9. Nowell, 300.

Chapter Sixteen: The Presence of the Past

1. *Survey,* 4.
2. Ibid., 127.
3. Ibid., 4.
4. Gene Youngblood, "Icon and Idea in the World of Michael Snow," *artscanada,* no. 140–41 (February 1970), 2–14.
5. Ross Mendes, "Thinking Man," *Canadian Forum* (April/May 1970), 63.

Chapter Seventeen: The Painterly Photograph

1. *Photo-Centric,* 59.
2. Ibid., 54.
3. Ibid., 53.
4. "Pierre Théberge: Conversation with Michael Snow," in *Collected Writings,* 196.
5. Walter Benjamin, quoted in "The Work of Art in the Age of Technological Reproducibility: Second Version," in *Selected Writings,* vol. 3, ed. Howard Eiland and Michael W. Jennings (Cambridge: Harvard, 2002), 104–5.
6. Amy Taubin, "Doubled Visions," *October* 4 (Fall 1977), 10.
7. Peter Schjeldahl, "The Content Information," *New York Times,* November 26, 1972, 17–18.

8. *Sequences,* 197.

9. Ibid., 287.

10. John Russell, "Venice Resurgent," *Sunday Times*, June 28, 1970.

11. *Sequences,* 287.

12. Ibid., 181.

13. Ibid.

14. Ibid., 193.

15. Arnaud, 11.

Chapter Eighteen: The Canadian Wilderness

1. Lind, 201.

2. Louis Marcorelles, "Concrete Cinema," in *Living Cinema: New Directions in Contemporary Film-Making* (New York: Praeger, 1973).

3. Annette Michelson, "About Snow," *October* 8 (Spring 1979), 120.

4. *Sequences*, 214.

5. Ben Lifson, "Ménage à Trois," *Village Voice*, July 4–14, 1981.

6. Adele Freedman, "High School a Snow Job from Snow," *Globe and Mail*, December 15, 1979.

Chapter Nineteen: A Giant Sentence

1. *Sequences,* 139.

2. Martha Langford, "Rameau's Nephew by Diderot, 1972–74," *Michael Snow: Life and Work* (Toronto: Art Canada Institute, 2014), online book, aci-iac.ca/art-books/michael-snow/key-works/rameaus-nephew-by-diderot.

3. Cornwell, 130.

4. Bill Auchterlone, "Review — Artfilms," *Arts Magazine* (October 1975), 1.

5. Cornwell, 123.

6. Art Perry, "Sculptors Add Another Dimension to Art," *Vancouver Province,* January 19, 1978, 23.

Chapter Twenty: No Longer in Play

1. "The Artists' Jazz Band Live at the Edge," in *Collected Writings,* 182.
2. Snow, interview with Jane Lind, April 13, 1999.
3. Hannon.
4. Nowell, 358–59.
5. Nowell, 405–8.

Chapter Twenty-One: Between Alchemy and Chemistry

1. "Pierre Théberge: Conversation with Michael Snow," in *Collected Writings,* 196.
2. In the catalogue to his exhibition at Galerie Claire Burrus, Paris.
3. Michael Snow in conversation with James King, January 24, 2018.
4. Kate Taylor, "Art About," *Globe and Mail*, May 10, 1991.
5. Lisa Balfour Brown, "Is Flurry Over Artist Snow Deserved?," *Financial Post*, January 22, 1994.
6. Christopher Hume, "Snow's Back and in Good Humour," *Toronto Star*, May 18, 1991.
7. Freedman.
8. *Sequences,* 147.
9. Ibid.

Chapter Twenty-Two: The Everyday

1. Peggy Gale, interview with James King, August 20, 2017.

Chapter Twenty-Three: The Presence of the Absent

1. *Sequences,* 245.
2. Ibid.
3. Mays, *Globe and Mail*, August 20, 1987.
4. René Blouin, "Ghost Lustres: Michael Snow's Holographic Visions at Expo 86," *Canadian Art* (Summer 1986), 57.
5. Exhibition notes by MS for the exhibition at Isaacs in October–November 1987. MS: AGO.

6. Sarah Milroy, "Forecast: Snow," *Globe and Mail*, September 26, 2006.

7. *Sequences,* 260.

8. Ibid.

9. Ibid.

10. Martha Baillie, "Michael Snow and Helplessness," marthabaillie.ca (blog), February 25, 2013.

11. *Sequences,* 260.

Chapter Twenty-Four: Audiences

1. Beverly Bowen, *Toronto Star*, March 22, 1980.

2. Michael Snow, "Snow's Flock Isn't Moulting," *Toronto Star.*

3. Note written for James King on January 24, 2018.

4. *Sequences,* 338.

5. Christopher Hume, "The Audience Pokes Fun at Fans," *Toronto Star*, May 23, 1989.

6. Christopher Hume, "A Chance to Measure Snow's Depth," *Toronto Star,* March 13, 1994.

7. Adele Freedman, "Less Than Meets the Eye," *Globe and Mail*, September 19, 1992.

Chapter Twenty-Five: Blockbuster

1. Deirdre Hanna, "Michael Snow: Goosing the Mainstream," *NOW* 13, no. 27 (March 3–8, 1994), 24.

2. John Bentley Mays, "The Real Diamonds Get Snowed Under," *Globe and Mail*, March 12, 1994.

3. *Time*, April 25, 1994.

Chapter Twenty-Six: Sound Shaping

1. Hannon.

2. Michael Snow: note written for James King, January 24, 2018.

3. *Sequences,* 179.

4. Ibid., 308.

5. Ibid.

6. Hannon.
7. Michael Snow, album cover.
8. *Sequences*, 318.

Chapter Twenty-Seven: A New Painterliness

1. *Sequences*, 123.
2. Ibid.

Chapter Twenty-Eight: Repeat Offences

1. *Sequences*, 221.
2. Michael Snow, *Photo Communiqué* (Spring 1987), 3.
3. Ibid., 44.
4. *Sequences*, 289.
5. *Touching*, 7.
6. Taubin, "Re-viewing Revisions," *Soho Weekly News*, May 10, 1979.
7. Jonathan Crary, review of *Re-Visions*, *Flash Art* 92–3 (October–November 1979), 22.
8. John Locke, review of *Re-Visions*, *Parachute* 16 (Fall 1979), 54.
9. *Touching*, 7.
10. Ibid.

Chapter Twenty-Nine: Reshaping Fragments

1. *Sequences*, 151.
2. *Almost*, 131.
3. Ibid., 139.
4. Baird.
5. Emily Landau, "The Amazing Adventures of Michael Snow: An Uncensored History of Toronto's Most Notorious Art Star," *Toronto Life*, March 2013.
6. *Photo-Centric*, 14.

Chapter Thirty: New-Found Things

1. *Sequences*, 168.
2. Ibid., 177.

Chapter Thirty-One: Smoke and Mirrors

1. *Photo-Centric*, 15.
2. *Sequences,* 210–11.
3. Christopher Dewdney, "Review of Michael Snow at the Isaacs Gallery," *Vanguard,* February 1983, 36.
4. Convocation Address, Université du Québec à Chicoutimi, April 2016.

SELECTED
BIBLIOGRAPHY

MICHAEL SNOW: WRITINGS

BIOGRAPHIE of the Walking Woman/ de la femme qui marche 1961–1967. Brussels: La Lettre Volée: 2004.

Michael Snow/A Survey. Toronto: Art Gallery of Ontario, 1970.

The Michael Snow Project: The Collected Writings of Michael Snow. Foreword by Louise Dompierre. Waterloo, ON: Wilfrid Laurier University Press, 1994.

Bruce Jenkins and Michael Snow. *Michael Snow — Sequences — A History of His Art*. Ed. Gloria Moure. Barcelona: Ediciones Poligrafa, 2016.

"Paper Trail." *DOXA* (May 2010).

BOOKS AND ARTICLES ABOUT MICHAEL SNOW

Arnaud, Jean. "Touching to See." *October* 114 (Autumn 2005): 5–16.

Baillie, Martha. "Snow and Helplessness." *Martha Baillie* (blog). February, 25, 2013. marthabaillie.ca/?page_id=830.

Baird, Daniel. "Riffing: Jazz Inspired Michael Snow, the Most Influential Canadian Artist of All Time, to Explore the Unexplored." *Walrus*, March 2011.

Bellour, Raymond. "Layers of Images." *Critical Inquiry* 43, no. 3 (Spring 2017): 617–49.

Blouin, René. "Ghost Lustres: Michael Snow's Holographic Visions at Expo '86." *Canadian Art*, June 1986.

Bradbury, Nicholas. "Michael Snow's New Creation Is No Ordinary Chestnut Tree." *Toronto Star*, June 30, 1992.

Cornwell, Regina. "Michael Snow: The Decisive Moment Revisited." *artscanada*, April/May 1980.

———. *Snow Seen: The Films and Photographs of Michael Snow*. Toronto: Peter Martin Associates, 1980.

———. "Two Sides to Every Story." In *Michael Snow: Almost Cover to Cover*, edited by Catsou Roberts and Lucy Steeds, 120–27. London: Black Dog Publishing, 2001.

Cornwell, Regina, Kathryn Elder, R. Bruce Elder, Jonas Mekas, Steve Reich, Bart Testa, and Jim Shedden, eds. *The Michael Snow Project: Presence and Absence; The Films of Michael Snow 1956–1991*. Toronto: Knopf, 1995.

Cousineau-Levine, Penny. *Faking Death: Canadian Art Photography and the Canadian Imagination*. Montreal and Kingston: McGill-Queen's University Press, 2003.

Déry, Louise, Michael Snow, Erik Bullot, Jacinto Lageira, and Stépanie de Loppinot. *Michael Snow: Solo Snow*. Montréal: Galerie de l'UQAM, ABC Art Books Canada, 2011.

Dewdney, Christopher. "Michael Snow at the Isaacs Gallery." *Vanguard*, February 1983.

Dompierre, Louise. "Embodied Vision: The Painting, Sculpture, Photo-Work, Sound Installation, Music, Holographic Work, Films and Books of Michael Snow from 1970 to 1973." In *The Michael Snow Project: Visual Art, 1951–1993*, edited by Dennis Reid, Philip Monk, Louise Dompierre, Richard Rhodes, and Derrick de Kerckhove, 388–477; 509–22. Toronto: Art Gallery of Ontario, The Power Plant, and Knopf Canada, 1994.

———. *Walking Woman Works: Michael Snow 1961–67; New Representational Art and Its Uses*. Kingston: Agnes Etherington Art Centre, Queen's University, 1983.

Düchting, Hajo. *Paul Klee: Painting Music*. Munich: Prestel, 2016.

de Duve, Thierry. "Michael Snow: The Deicitics of Experience and Beyond." *Parachute* (April/May/June 1995).

Elder, R. Bruce. "Michael Snow's Presence." In *The Michael Snow Project: Presence and Absence; The Films of Michael Snow,*

1956–1991, edited by Jim Shedden, 94–139. Toronto: Art Gallery of Ontario, The Power Plant, and Knopf Canada, 1995.

———. "Sounding Snow: On Text and Sound in Michael Snow's Rameau's Nephew by Diderot (Thanx to Dennis Young) by Wilma Schoen." In *The Michael Snow Project: Presence and Absence; The Films of Michael Snow, 1956–1991,* edited by Jim Shedden, 140–95. Toronto: Art Gallery of Ontario, The Power Plant, and Knopf Canada, 1995.

Enright, Robert. "The Lord of Missed Rules: An Interview with Michael Snow." *Border Crossings* 26, no. 2 (May 2007).

Farber, Manny. "The Arts: Farewell to a Lady." *Time* (Canadian Edition), January 1969.

Fones, Robert. "Michael Snow's Bent*:* Image Distortion in *1956,*" *Ciel Variable* 100 (Spring 2015): 62–71.

Freedman, Adele. "The Disappearing Man." *Canadian Art*, Spring 1994.

———. "Less Than Meets the Eye." *Globe and Mail*, September 12, 1992.

Fulford, Robert. "About Michael Snow." In *Paintings, Sculptures, Drawings by Michael Snow*. Toronto: Greenwich Gallery, 1956.

———. "Apropos Michael Snow." In *Michael Snow/A Survey*, by Michael Snow, 11–13. Toronto: Art Gallery of Ontario, 1970.

———. *The Best Seat in the House: Memoirs of a Lucky Man.* Toronto: Collins, 1988.

Gigeroff, Alex. "Nude Controversy Painters Outline Personal Attitude." *Varsity,* January 11, 1955.

Goddard, Peter. "Remembering Toronto's 1960s Spadina Art Scene." *Canadian Art*, July 2014.

Gray, Kathe. "Michael Snow: An Interview with the Artist." *The Ontarion*, January 1995.

———. "Walking Through the Snow: An Interview with Michael Snow." *Spill*, February 2–15, 1995.

Hale, Barrie. *Toronto Painting 1953–65*. Ottawa: National Gallery of Canada, 1972.

Hannon, Gerald. "Provocateur." *Toronto Life,* April 1994.

Hardman, Meg, Joan Murray, and Jennifer C. Watson, eds. *Dennis Burton Retrospective*. Oshawa: Robert McLaughlin Gallery, 1977.

Harris, Marjorie. "The Snow Man's Woman." *Commentator* (June 1964): 14–16.

Hoberman, J. "Michael Snow." *Artforum*, April 2014.

Johnson, Ken. "Being and Seeing." *Art in America*, July 1994.

Judd, Donald. "In the Galleries." *Arts Magazine*, March 1964.

Kellman, Tila L. *Figuring Redemption: Resighting Myself in the Art of Michael Snow*. Waterloo: Wilfrid Laurier University Press, 2002.

Lancashire, David. "Blues in the Clock Tower." *The Michael Snow Project: Music/Sound, 1948–1993*, edited by Michael Snow, 32–77. Toronto: Art Gallery of Ontario, The Power Plant, and Knopf Canada, 1994.

Landau, Emily. "The Amazing Adventures of Michael Snow: An Uncensored History of Toronto's Most Notorious Art Star." *Toronto Life*, March 2013.

Langford, Martha., ed. *Image and Imagination: Le Mois de la Photo à Montréal*. Montreal and Kingston: McGill-Queen's University Press, 2005.

———. *Michael Snow: Life and Work*. Toronto: Art Canada Institute, 2014.

———. "Michael Snow: Screen Writing." *Switch* 3 (Spring 2010): 8–15.

———. *Scissors, Paper, Stone: Expressions of Memory in Contemporary Photographic Art*. Montreal and Kingston: McGill-Queen's University Press, 2008.

Leclerc, Denise, and Pierre Dessureault. *The 60s in Canada*. Ottawa: Publications Division, National Gallery of Canada, 2005.

Legge, Elizabeth. "Taking It as Red: Michael Snow and Wittgenstein." *Journal of Canadian Art History* 18, no. 2 (1997): 68–91.

———. *Wavelength*. London: Afterall Books, 2009.

Lind, Jane. *Joyce Wieland: Artist on Fire*. Toronto: Lorimer, 2001.

MacDonnell, Virginia. "The City of Snow." *Late Harvest Journal of Creative Culture* (Winter 1993–94): 34–35.

Marcorelles, Louis. "Concrete Cinema." In *Living Cinema: New Directions in Contemporary Film-Making*. New York: Praeger, 1973.

Michelson, Annette. "About Snow." *October* 8 (Spring 1979): 111–25.

———. "The Sound of Music: A Conversation with Michael Snow." *October* 114 (Autumn 2005): 43–60.

———. "Toward Snow." *Artforum*, June 1971.

Monk, Philip. "Around Wavelength: The Sculpture, Film and Photo-Work of Michael Snow from 1967 to 1969." In *The Michael Snow Project: Visual Art, 1951–1993*, edited by Dennis Reid, Philip Monk, Louise Dompierre, Richard Rhodes, and Derrick de Kerckhove, 388–477; 509–22. Toronto: Art Gallery of Ontario, The Power Plant, and Knopf Canada, 1994.

Morris, David. "The Idea of Snow." *Literary Review of Canada*, November 1994.

Nasgaard, Roald. *Abstract Painting in Canada*. Vancouver: Douglas & McIntyre; Halifax: Art Gallery of Nova Scotia, 2008.

Needham, Gerald. "Michael Snow at the Isaacs Gallery." *artscanada*, December/January 1980.

Nixon, Virginia. "Geese Fly in Toronto Gallery." *Montreal Gazette*, August 25, 1979.

Nowell, Iris. *Joyce Wieland: A Life in Art*. Toronto: ECW, 2001.

O'Brian, John, and Peter White, eds. *Beyond Wilderness: The Group of Seven, Canadian Identity, and Contemporary Art*. Montreal and Kingston: McGill-Queen's University Press, 2007.

Perl, Jed. *New Art City: Manhattan at Mid-Century*. New York: Vintage, 2007.

Perrault, John. "The Act of Seeing." *Village Voice*, February 8, 1968.

Perrin, Peter. "*Cover to Cover*: A Book by Michael Snow." *artscanada*, October–November 1976.

Pruitt, John. "About Thirty Years Ago: Michael Snow's 1972 Solo Exhibition." In *A Principality of Its Own: 40 Years of Visual Arts at the Americas Society*, edited by José Luis, Falconi, and Gabriela Rangel. Cambridge, MA: Harvard University Press, 2006.

Prytula, Karen. *The Journals of Allen Snow*. Kanata: 2012.

Rees, A.L. "Working Both Sides of the Street: Film and Art in Michael Snow." In *Michael Snow: Almost Cover to Cover*, edited by Catsou Roberts and Lucy Steeds, 76–89. London: Black Dog Publishing, 2001.

Reid, Dennis. "Exploring Plane and Contour: The Drawing, Painting, Collage, Foldage, Photo-Work, Sculpture and Film of Michael Snow from 1951 to 1957." In *The Michael Snow Project: Visual Art, 1951–1993*, edited by Dennis Reid, Philip Monk, Louise Dompierre, Richard Rhodes, and Derrick de Kerckhove, 388–477; 509–22. Toronto: Art Gallery of Ontario, The Power Plant, and Knopf Canada, 1994.

———. "The Meeting Place." In *Toronto Suite*, edited by Michael Torosian. Toronto: Lumiere Press, 1988. ccca.concordia .ca/c/writing/r/reid/reid001t.html.

Reid, Dennis, Philip Monk, Louise Dompierre, Richard Rhodes, and Derrick de Kerckhove, eds. *The Michael Snow Project: Visual Art, 1951–1993*. Toronto: Art Gallery of Ontario, The Power Plant, and Knopf Canada, 1994.

Rhodes, Richard. "Michael Snow: The Public Commissions." In *The Michael Snow Project: Visual Art, 1951–1993*, edited by Dennis Reid, Philip Monk, Louise Dompierre, Richard Rhodes, and Derrick de Kerckhove, 388–477; 509–22. Toronto: Art Gallery of Ontario, The Power Plant, and Knopf Canada, 1994.

Roberts, Catsou, Martha Langford, A.L. Rees, Amy Taubin, Malcolm LeGrice, and John Pruitt, eds. *Michael Snow: Almost Cover to Cover.* London: Black Dog Publishing, 2001.

Rockman, Arnold. "Michael Snow and His Walking Woman." *Canadian Art*, November/December 1963.

Sandals, Leah. "Déja Viewed: Michael Snow on Looking Back, and Ahead." *Canadian Art*, September 2016.

Sitney, P. Adams. *Visionary Film: The American Avant-Garde, 1943–2000.* New York: Oxford University Press, 2002.

Sloan, Johanne. "Conceptual Landscape Art: Joyce Wieland and Michael Snow." In *Beyond Wilderness: The Group of Seven, Canadian Identity, and Contemporary Art*, edited by John O'Brian and Peter White, 73–84. Montreal and Kingston: McGill-Queen's University Press, 2007.

Taubin, Amy. "Doubled Visions." *October* 4 (Fall 1977): 33–43.

———. "Re-viewing Revisions." *Soho Weekly News*, May 10, 1979.

————. "Soho Arts." *Soho Weekly News*, November 11, 1976.

Théberge, Pierre. *Michael Snow.* Tokyo: Hara Museum of Contemporary Art, 1988.

Turvey, Malcolm. "The Child in the Machine: On the Use of CGI in Michael Snow's *Corpus Callosum." October* 114 (Fall 2005): 29–42.

Vlas, Adelina, ed. *Photo-Centric.* Philadelphia: Philadelphia Museum of Art, 2014.

Wees, William C. "Prophecy. Memory and the Zoom: Michael Snow's *Wavelength* Revisited." *Ciné-Tracts* 14/15 (Summer/Fall 1981): 78–83.

Wigmore, Donnalu, ed. *Isaacs Seen: 50 Years on the Art Front; A Gallery Scrapbook.* Toronto: Justina M. Barnicke Gallery, Hart House, 2005.

Young, Dennis. "Origins and Recent Work." In *Michael Snow/A Survey,* by Michael Snow, 15–16. Toronto: Art Gallery of Ontario, Isaacs Gallery, 1970.

Youngblood, Gene. "Icon and Idea in the World of Michael Snow." *artscanada,* February 1970.

INDEX

Page numbers in bold indicate where works of art are reproduced.